D1288469

American Twentieth-Century

Watercolors

AT THE

Munson-Williams-Proctor Arts Institute

American Twentieth-Century
Watercolors
AT THE
Munson-Williams-Proctor Arts Institute

Mary E. Murray

With contributions by

Gail Levin

Joan M. Marter

Paul D. Schweizer

Roberta K. Tarbell

Bert Winther-Tamaki

American Twentieth-Century Watercolors
at the Munson-Williams-Proctor Arts Institute
is published in conjunction with the exhibition of the same title.
Mary E. Murray, *Curator*

Bullock & Gilroy Business Resource Group is proud to join with Munson-Williams-Proctor Arts Institute
as the exclusive area sponsor of this major exhibition.

The exhibition is funded in part by a grant from the National Endowment for the Arts, a federal agency.

EDITOR Kathryn Grover

DESIGNER Catherine D. Brown Graphic Design, Utica, New York

PRODUCTION Michele Murphy

PRINTER Brodock Press, Utica, New York

PHOTOGRAPHY Gale R. Farley, Utica, New York, catalog numbers
1, 2, 4, 6, 7, 10, 11, 14, 17, 18, 19, 20, 22, 23, 24, 26, 27, 28,
30, 31, 33, 34, 35, 38, 40, 41, 42, 43, 44, 45, 47, 48, 49, 50
David Revette, Syracuse, New York, catalog numbers
3, 5, 8, 9, 12, 13, 15, 16, 21, 25, 29, 32, 36, 37, 39, 46

Library of Congress Cataloging-in-Publication Data

Munson-Williams-Proctor Arts Institute.
American Twentieth-Century Watercolors at the Munson-Williams-Proctor Arts Institute
/ Mary E. Murray; with contributions by Gail Levin ... [et al.].
p. cm.
Published in conjunction with an exhibition held at the Museum of Art,
Munson-Williams-Proctor Arts Institute, Utica, N.Y., April 30–July 10, 2000,
the William A Farnsworth Library and Art Museum, Rockland, Me., Oct. 29, 2000–Feb. 4, 2001,
and the Muscarelle Museum of Art, College of William and Mary, Williamsburg, Va., Mar. 3–Apr. 29, 2001.
Includes bibliographical references and index.
ISBN 0-915895-22-6 (alk. paper)
1. Watercolor painting, American--Exhibitions. 2. Watercolor painting--20th century--United States--Exhibitions.
3. Watercolor painting--New York--Utica--Exhibitions. 4. Munson-Williams-Proctor Arts Institute--Exhibitions.
I. Murray, Mary E. (Mary Elizabeth), 1960- II. Levin, Gail, 1948- III. Munson-Williams-Proctor Arts Institute. Museum of Art.
IV. William A. Farnsworth Library and Art Museum. V. Joseph and Margaret Muscarelle Museum of Art. VI. Title.

ND1808 M86 2000
759.13'074'74762--dc21 99-089947

Munson-Williams-Proctor Arts Institute
310 Genesee Street
Utica, NY 13502-4799
315-797-0000
www.mwpi.edu
All rights reserved.
Printed in the United States of America.

Table of Contents

Foreword

This catalog reaffirms the Munson-Williams-Proctor Arts Institute's commitment to an ambitious initiative begun in the mid-1980s to publish scholarly catalogs of the most noteworthy parts of its varied and extensive collection. The first publication in this series, a comprehensive catalog of the museum's nineteenth and early-twentieth-century stoneware was a groundbreaking contribution to the field of American ceramic studies. It gained widespread acceptance among collectors, museum professionals and historians. Two years later, in 1989, a study was published on one hundred of the Institute's most important American paintings. Seventy-two scholars and museum professionals contributed interpretative entries to this effort. In 1994, the museum produced a catalog of fifty-eight of its finest eighteenth, nineteenth and early twentieth-century American drawings. This publication accompanied an exhibition of the works, which traveled to six other museums throughout the United States. The next title in the series, *Masterpieces of American Furniture from the Munson-Williams-Proctor Institute,* appeared in 1999. This was the first systematic study the museum has published of its important collection of nineteenth-century American furniture. It documents the pioneering role the Institute has played in collecting, researching and interpreting this material.

Why American watercolors now? In the early stages of organizing the drawing exhibition it became apparent to Mary Murray, the Museum's Curator of Modern and Contemporary Art, that the collection had noteworthy strengths in both the traditional drawing media of graphite, charcoal, crayon, chalk, and ink, as well as in watercolor. The decision was made to limit the drawing exhibition to works executed in the former media and to set aside the finest watercolors for a separate, complementary exhibition and catalog.

It is my hope that this publication will provide new levels of awareness and appreciation of the Institute's watercolor collection, which has grown over the years through astute purchases and the taste and generosity of our patrons and friends. Like the other books and catalogs in the series, it puts into intellectual circulation a collection of works, fragile by nature, that deserve to be known by a wider audience. Readers should be aware that in certain instances works featured in the catalog do not represent the full extent of the museum's holdings by a specific artist. While scholars, collectors, and museum professionals are already familiar with a number of the watercolors, others are published here for the first time.

I am deeply grateful to Ms. Murray for the effort she has devoted this project over the past several years, and extremely proud of the result. Her enthusiasm for the watercolor collection is evident on every page of this catalog. Ms. Murray's sensitive reading of the works and the thoroughness of her scholarship is a model of its kind. She was assisted by several distinguished scholars whose special knowledge of a particular artist substantially increased the usefulness of the text. The staff of the Williamstown Art Conservation Center also deserves recognition for the technical assistance they provided throughout this undertaking.

It is my hope that the information brought to light in this handsome catalog, together with the sheer delight that comes from a thoughtful and concentrated engagement with the watercolors themselves, will instill a sense of awe and wonder at their beauty and technical virtuosity. In a larger sense I hope that the catalog and exhibition, along with the interpretive programs offered in conjunction with it, will serve as a reminder of the important role art has to play in the society that increasingly learns, stores and generates knowledge through visually based media.

PAUL D. SCHWEIZER
Director and Chief Curator

Acknowledgments

The production of the catalog and exhibition for *American Twentieth-Century Watercolors at the Munson-Williams-Proctor Arts Institute* was made possible by the generous assistance of many people to whom I am grateful. Throughout the project I worked very closely with Leslie Paisley, Paper Conservator at the Williamstown Art Conservation Center, and thank her for her unfailing guidance, good judgment, and support. I also would like to thank the guest authors, Gail Levin, Joan Marter, Paul D. Schweizer, Roberta Tarbell, and Bert Winther-Tamaki, whose expertise about the subjects on which they wrote makes a substantial contribution to this project. Thanks to editor Kathryn Grover for her conscientious reading of the catalog manuscript and to photographers Gale R. Farley and David Revette for their fine work.

I would like to thank Mr. Will Barnet, whose work *Fine Friends* is included in the exhibition, for meeting with me on more than one occasion to discuss his work. It was a sincere honor and pleasure. Many other artists' family members graciously assisted my efforts, for which I am most appreciative: Helen Dickinson Baldwin, daughter of Edwin Dickinson; Earl Davis, son of Stuart Davis; and David Loeffler Smith (and his wife, Jean), son of Jacob Getlar Smith. James Lowery and Virginia Lowery, children of donor Mrs. James Lowery, as well as their cousins, Leiter and Ricky Doolittle, were also very helpful.

In researching the catalog, I received support from numerous libraries and archives. I am especially thankful to Cynthia Barth, Head Librarian at the Munson-Williams-Proctor Arts Institute, and to her staff, Michael Schuyler and Mary Powroznik, and former assistant Colleen Kehoe. I extend thanks as well to Frederick Bauer, Reference Librarian, SUNY Institute of Technology, Utica/Rome; Judith Throm, Chief of Reference Services, Archives of American Art, and the staff of the Archives at the Washington and New York branches; Frank Lorenz, Archivist, Hamilton College; Susan K. Anderson, Archivist, Philadelphia Museum of Art; Nancy M. Shawcross, Curator of Manuscripts, University of Pennsylvania Library; Karen Schneider, Librarian, The Phillips Collection; Corinne Woodcock, Director, and Sylvia B. Evans, Archivist, The Demuth Foundation; and, at the Wadsworth Atheneum, Eugene Gattis and Ann Brandwein, Archives, and John Teahan and Cheryl O'Neill, Library. Numerous Museum of Art interns assisted with catalog research: Rachael Buffington; Tonia Capuana; Amanda Fairchild; Bryan Fox; Amy Miller; Jennifer Palladino; Heather Pautenaude, and Abby Perkins.

In addition, I would like to acknowledge the many colleagues in museums, academia, galleries and arts organizations who generously shared information with me: David Bancroft, National Endowment for the Arts; Eric Baumgartner, Director of American Art, and Linda Swanson, Hirschl and Adler Galleries, Inc.; Michael Culver, Curator, Ogunquit Museum of American Art; Amy Ellis, Assistant Curator, Wadsworth Atheneum; Nancy S. Jackson, Registrar, Tacoma Art Museum; Arlette Klaric, Associate Professor, Buffalo State College, SUNY; Marilyn S. Kushner, Department Head, and Jennifer Noonan, Department of Prints and Drawings, the Brooklyn Museum of Art; Kristen McKinsey, Lakeview Museum of Arts and Sciences, Peoria, Ill.; James Martin, Director of Analytical Services and Research, Williamstown Art Conservation Center; William Meek, Harmon-Meek Gallery, Naples, Florida; James Rondeau, former Assistant Curator of Contemporary Art, and Edward Russo, Associate Registrar, Wadsworth Atheneum; Michael A. Tomor, Chief Curator, Southern Alleghenies Museum of Art at Loretto; Sean Ulmer, Assistant Curator, Herbert F. Johnson Museum, Cornell University; Nancy Weekly, Chief Curator, Burchfield-Penney Art Center; Barbara A. Wolanin, Curator of the Office of the Architect, United States Capitol; and Sharon Worley, Curator, Cape Ann Historical Association.

At the Munson-Williams-Proctor Arts Institute, I have the good fortune to work with dedicated and supportive colleagues who assisted in producing the exhibition and catalog: Robert Baber; Bonnie Conway; Elena Lochmatow; Marcia Menuez-Commerford; Adrienne Nardi; Jim Quinn; Eric Ramirez-Weaver; Debora Winderl Ryan; Joseph Schmidt; Lisa Schmidt; Paul D. Schweizer; Anthony Spiridigloizzi; and Nancy Jean Spondello. I am indebted to Marianne Corrou for her assistance in innumerable ways and extend very special thanks to Michele Murphy, Publications Manager, and Catherine Brown, consultant graphic designer, who were unfailingly patient and creative during the production of the catalog and other printed matter.

MARY E. MURRAY
Curator of Modern and Contemporary Art

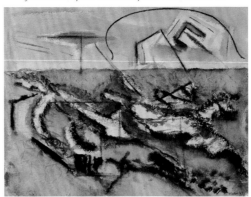

American Twentieth-Century Watercolors
AT THE MUNSON-WILLIAMS-PROCTOR ARTS INSTITUTE

Mary E. Murray, *Curator of Modern and Contemporary Art*

"The American painter takes to watercolor like a duck to water. He has found it the ideal medium for expressing the ... national temper. ... The American painter, stymied perhaps by oil and tempera, nevertheless has developed over watercolor a command both of complicated technique and of deep, complicated expression. The oil medium is too static to express American restlessness."

JAMES W. LANE
"Aquarellia Americana," *Art News* February 15-28, 1942

During the first half of the twentieth century critics characterized watercolor as "the American medium," its spontaneity and quick expression a perfect metaphor for the driving, modern spirit of the United States.[1] "It is no accident that more American artists use water color more effectually to set down their reactions to the world about them than they do oils," wrote Helen Appleton Read. "The medium lends itself to native traits of spontaneity and haste and impatience with theorizing. It is the most direct means of setting down a visual impression."[2] Similarly, artist Jacob Getlar Smith wrote, "Perhaps this twentieth century of ours, an era of streamlining, speed and impatience, does not lend itself to relaxed contemplation and protracted effort." Getlar further noted, "Perhaps, too, our national temperament, an energetic one that equates time with money, considers brevity a virtue and cooling the heels a nuisance, should be interpreted by an art that best mirrors these qualities."[3]

The association of watercolor with American dynamism reveals, however, only part of the story. Alan Burroughs captured the spectrum of approaches to twentieth-century watercolor in his catalog essay for the 1942 Whitney Museum of American Art's exhibition *A History of American Watercolor Painting*. Citing John Marin and Charles Burchfield as the preeminent watercolor artists of the day, Burroughs argued that the two "appear to have chosen the medium for opposite reasons." In Marin, Burroughs saw "quick visualization," while in Burchfield he found a "slow

manipulation." "Between them," Burroughs declared, "they sum up the scope of modern watercolor techniques. ... Infinite variations are possible between these modes of painting."[4] Burroughs' formulation encapsulates the inherent contradictions in trying to categorize the practice and reception of watercolor in the United States during the past century — the fuzzy lines that have divided "amateur" and "serious" practitioners, traditional and novel approaches to materials, technique, and subjects, and the perception of the medium as metaphor for national identity. Twentieth-century American watercolor is, in short, a medium fraught with contradictions.

Artists working in water media during this century can be placed, at some level, in two general camps.[5] The more traditional one emphasized technique and relied upon familiar subject matter. Emulating American painter John Singer Sargent (1856-1925), this group has been comprised of purists who tended to identify themselves as watercolorists, belonged to organizations such as the American Watercolor Society, the New York Water Color Club, or regional societies and participated in those groups' large annual exhibitions.[6] Founded in late 1866 as the American Society of Painters in Water Colors, the American Watercolor Society was organized to promote the practice and acceptance of watercolors at a time when such works were perceived as minor or preparatory for oil paintings. Since its inception the society has held an annual exhibition of works by its members at the

National Academy of Design (now the National Academy Museum), exhibitions that were instrumental in spawning the American Watercolor Movement, which flourished between 1870 and 1885. The New York Water Color Club was founded in 1890 as an organization more inclusive of women watercolorists, and the two groups merged in 1941.

The annual group exhibitions of these two organizations were consistently reviewed by the art press until 1958, although critics did not necessarily praise them. In its critique of the 1912 American Water Color Society's exhibition, *The Art Review* stated that the work had devolved into "a boarding school diversion for girls."[7] A 1914 notice characterized the Twenty-fourth New York Water Color Club exhibition as "cloying." "Many of the works are triumphs of technical skill and true representations of what the artists saw," this newspaper critic noted, "but they are all seeing the same things, and there is no more inspiration than the 'Oh, isn't it beautiful!' of the Sunday school picnic."[8] Similarly the New York *Tribune,* reporting on the New York Water Color Club exhibition for 1921, found that most of the artists bestowed commendable technique "upon miscellaneous and rather unimportant subjects."[9] Twenty-five years later Judith Kaye Reed, writing for *The Art Digest* about the Watercolor Society's Seventy-ninth Annual Exhibition, observed somewhat blandly that technical fluency prevailed over creative interpretation: "Familiar subjects — wet streets, snowy streets, tumble-down houses, bright landscapes, rugged coasts, flowers — are largely painted in much the same alert, descriptive manner."[10] *Art News* was harsher in its critique: "The show was, of course, conservative, but perhaps on the whole things were carried a little too far. Pictures with a touch of imagination were few and far between. The general background was one of last century left-overs, hackneyed themes, and sentimental color."[11]

The other camp of American twentieth-century watercolorists has been composed of artists, often ones who might be considered primarily oil painters or sculptors, who used watercolor primarily as it suited their needs. In his slim but prescient 1922 survey *American Water-Colourists,* A. E. Gallatin eschewed an encyclopedic approach in favor of a examining a select group of artists (Winslow Homer, Maurice Prendergast, John Marin, Dodge MacKnight, Charles Demuth, and the youthful Charles Burchfield) whose work, he felt, "reveals a personal expression, as well as at least something of the spirit of modernity."[12] It is to their credit, he suggested, that these artists were *not* members of the American Watercolor Society. Gallatin singled out painters

who were not married to technique. Charles Burchfield, one of the century's most celebrated watercolor artists, was very unconventional in his methods (cat. nos. 7, 8, 24, 39). In 1927 his friend Edward Hopper wrote, "Gouache, the medium that is used in most of [Burchfield's] pictures has been so long the pet medium of commercial art, and so long scorned by the purists of water color, that it has been almost dismissed as a means of aesthetic expression. Burchfield has used it with such frankness and daring that he has overturned all our old notions of it."[13] As a mature artist Burchfield mixed several media in a single painting so that gouache and transparent washes were extensively interwoven with crayon, graphite, and other drawing materials. His pioneering use of gouache enabled later artists to choose it for its body and quick-drying properties (this is the era preceding acrylic paints). In the 1942 *International Exhibition of Watercolors* at the Art Institute of Chicago, for example, Frederick Sweet could observe that "opaque mediums continue to be popular, while transparent tones are often used in conjunction with pen and ink, more in the nature of a wash drawing than of a pure water color in the conventional Sargent tradition."[14]

Artists from this second camp may have exhibited their work with the American Watercolor Society, but it is more probable that they participated in the works-on-paper annuals at the nation's largest museums.[15] While the formats of these exhibitions varied from institution to institution (the Whitney Museum of American Art preferred invitation to juror; the Art Institute of Chicago featured particular artists; the Brooklyn Museum and the Art Institute had international exhibitions), during the first half of the century painters (or their dealers) nationwide avidly entered their work; John Marin, at seventy-seven years old, submitted a watercolor to the Pennsylvania

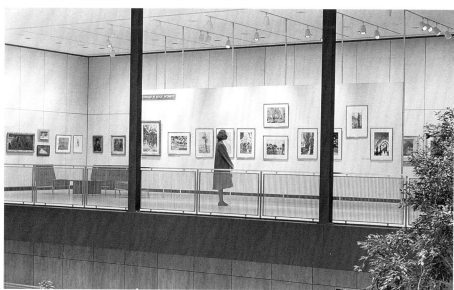

A museum visitor views Charles Burchfield watercolors in the Edward W. Root Bequest Exhibition, *November 5, 1961 to February 24, 1962.*

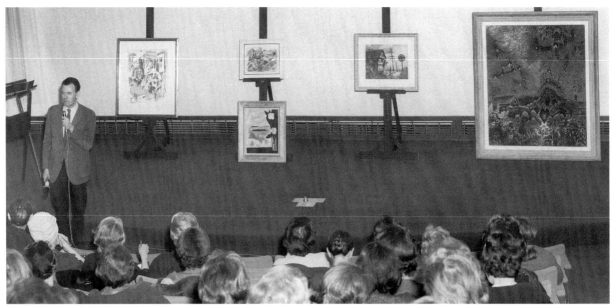

Easton Pribble, School of Art faculty member, presents a lecture on twentieth-century painting, including John Marin's Middle Manhattan Movement *(cat. no. 19) and Charles Burchfield's* The Sphinx and the Milky Way *(cat. no. 39), March 17, 1965.*

Academy's forty-fifth works-on-paper show in 1947 (cat. no. 25). Critics, however, weren't necessarily any kinder to participants than they were to those in the American Watercolor Society exhibitions, particularly as the century progressed. In 1946 Thomas Hess was impressed by neither technique nor subject matter in the Whitney Museum's annual exhibition of sculpture and works on paper. "The genre landscapes [are] painted without thought or skill," he wrote scathingly about the watercolors. "Someone should tell these painters that even though this is a glorious old country the mere act of using it as a subject does not make a glorious picture."[16]

It is tempting to dismiss the American Watercolor Society branch of watercolor practice as minor and illustrational, but therein lies one of the medium's contradictions. Inventive, sensitive artists participated in American Watercolor Society or New York Water Color Club exhibitions and received praise from the same critics who found their colleagues wanting.[17] E. P. Richardson wrote that the American Watercolor Society exhibitions "helped lend dignity" to the genre and created an atmosphere of acceptance for watercolors.[18] The legacy of this strain of watercolor painting by midcentury can be found in the serious efforts of artists such as Adolf Dehn, Dong Kingman, and Jacob Getlar Smith, all of whom exhibited in national museum works-on-paper annual exhibitions and also wrote "how-to" books that are laced with personal comments about subject matter choices and techniques (cat. nos. 31, 40, 41, 21, and 32). Thus, and perhaps more to the point, dividing watercolor artists into two groups is too neat a dichotomy, a simplistic reading of the century's activity. In such a division, where does one place the dean of American painting, John Marin, who employed traditional watercolor technique to realize his modernist interpretation of the American landscape? Georgia O'Keeffe and Charles Demuth similarly married traditional paint handling with stylistic innovation and challenging subject matter.[19] As Burroughs noted in 1942, "infinite variations" were possible between "quick visualization" and "slow manipulation."

In addition to its potential for spontaneity, watercolor was celebrated as expressly American because it was freer than oil painting from association with European art. In 1922 Gallatin had praised Winslow Homer and John Marin as "two of the greatest painters which this country has produced ... both [are] essentially American, both as regards to ancestry and freedom from the influence of foreign masters."[20] Yet American art museums at the turn of the twentieth century strove to establish credibility as cultural centers primarily by accumulating old master European oil paintings. It is small wonder, then, that when Gallatin wrote his survey he noted that few American watercolors could be found in public collections and that the Pennsylvania Academy of the Fine Arts and the Art Institute of Chicago actually had none "of distinction."[21]

American critics who followed Gallatin similarly promoted native artists working in their native medium, although the presumed superiority of European work often infused their writing with the tone of an apologia. In his introduction to the 1923 Kraushaar Galleries exhibition *Watercolors by Gifford Beal, Maurice Prendergast, William Zorach, Reynolds Beal, and George Luks,* Guy Pène du Bois dismissed assumptions that watercolor was a "light medium" and maintained the exhibiting artists were equally capable in watercolor as oil because "the medium ... does not affect the man."[22] Holger Cahill noted the popularity of the watercolor medium with American artists in the checklist for the Downtown Gallery's March 1931 exhibition *Masters of Water Color,*

which featured work by Charles Demuth, Preston Dickinson, George "Pop" Hart, John Marin, Charles Sheeler, Abraham Walkowitz, and William Zorach. "It has been the practice of European artists to use the oil medium for their more serious efforts," Cahill wrote. "This has led European writers on art to believe that water color is a lesser medium, limited in range, and that it is not as durable as oil." To this Cahill essentially replied, "Rubbish."[23] The checklist for the 1933 Addison Gallery of American Art exhibition *Water Colors by Twelve Americans* announced, "It is the opinion of a large number of connoisseurs that America's greatest contribution to the development of the plastic arts has been in the field of water color painting." The Addison show offered visitors an opportunity to judge for themselves by presenting a selected group of artists representing "traditional and contemporary schools."[24]

Watercolor was equally prized as a medium of choice for Americans because of its portability. It was thus well-suited to painting landscapes, a genre intimately tied to national identity in the United States. Sherman Lee, for instance, described watercolor as the best medium for quick sketches of people, "scene reporting," or capturing fleeting atmospheric effects.[25] Few critics, however, acknowledged the challenging nature of the medium. Watercolor is portable and artists readily used it to paint *en plein air*, but it is equally true that watercolor demands great control and planning and is practiced as much in the studio as it is outdoors.[26] To be spontaneous with the medium, artists must have great mastery over it. They must determine the color scheme prior to painting in order to layer transparent washes from light to dark. It is, therefore, not spontaneous in the way that oil painting might be; corrections are much more exacting. And artists did make corrections. Burchfield made the analogy between his painting process and the creative process of the writer or composer: "They work over it, delete things and add things. ... I mean you start a picture and I don't know how it's going to come out."[27] And while he preferred to paint on site because it afforded him a truer experience, Burchfield often worked in the studio on his landscape compositions.

Prompted no doubt by a spirit of nationalism in the face of international crisis, the early 1940s might be seen as the apogee of widespread appreciation for watercolor in the United States. In 1941 the Metropolitan Museum of Art hosted the *Special Loan Exhibition of Contemporary American Watercolors,* and Sherman Lee wrote his dissertation, "A Critical Survey of American Watercolor Painting."[28] The following year the Whitney Museum of American Art organized *The History of American Watercolor Painting.* In his catalog essay Alan Burroughs concluded that the medium in the nineteenth and twentieth centuries had shown itself to be "adaptable, expressive and popular," technically consistent, and deserving of an "independent and respected place in contemporary art."[29] Burroughs typically held Winslow Homer up as the paragon of mastery of the medium in the United States; Marin and Burchfield, in his view, represented the best of contemporary qualities.

In spite of these laudatory remarks, critics and curators alike began to challenge the notion of watercolor as a national medium in the mid-1940s. In the introduction to the checklist for the Art Institute of Chicago's twenty-first *International Exhibition of Watercolors,* Frederick Sweet argued that it was futile to define native characteristics for the medium. He attempted nevertheless to describe general trends in subject matter and painting styles, the limited influence of Surrealism, the inclusion of only a few abstractions, and the welcome return of "honest interpretations of American life and American country or city surroundings, with emphasis placed on good painting rather than on descriptive realism."[30] In 1945 Lloyd Goodrich followed the Whitney Museum's historical survey exhibition with *American Watercolor and Winslow Homer* at the Walker Art Center; the show later traveled to the Detroit Institute of Arts and the Brooklyn Museum. Goodrich's thesis was "to show the development of the naturalistic tradition in American watercolor as represented by some of its leading artists," namely Homer, Prendergast, Marin, Hopper, Burchfield, Dehn, and Marsh.[31] In his thoughtful review of the exhibition E. P. Richardson, like Sweet, concluded that "there is no ... discernible watercolor tradition, either in style or outlook, in America ... it is the painters who make the medium, not vice versa."[32]

With this institutionalization of the medium's history and the establishment of a contemporary canon[33] came increasingly skeptical critical reception to other artists' efforts. Maude Riley, reviewing the 1945 Whitney Museum's annual exhibition of sculpture and works on paper, admired paintings by Burchfield and Marin but generally found the watercolor section uninspired. "[The Annual] has no feeling of urgent new thought about it," she wrote in *Art Digest.*[34] In her more positive notice about the Pennsylvania Academy of the Fine Arts' *Forty-sixth Annual Exhibition of Watercolors and Prints,* Dorothy Drummond commented on international influences evident in the work, such as Eastern "color and mysticism," as well as a "gray" cast stemming from the artists having exhibited "experimental studio expressions rather than pictures studied for effect or for sale."[35] Drummond further noted the show included a resurgence of realism, but a "new realism" tempered by the influence of abstraction. Thomas Hess applauded the new, non-objective watercolor paintings with "exceedingly rich and complex metaphorical subject matter." "For all the seeming prominence of radical art there are really only about seventy-five works which can be considered at all experimental. ... The surrealists and the so-called fantasists are almost entirely neglected, as are the 'pure' non-objective painters," Hess noted. Yet Hess saw a different future for them, and he conjured up a more traditional artist whose work failed to gain acceptance to the Whitney's 1946 annual to illustrate the point. "It is difficult to understand how our little painter did not get his watercolor, which was probably titled *Sunset and Riptide at Sconset,* in the

show. He may make the grade next year. But he had better hurry. For despite the fact that the avant-garde is still in a minority, it is getting recognition from the Whitney in advantageous hanging space, and is growing rapidly each year."[36]

Hess's prognostications were timely. By 1950 the contradictions surrounding the medium of watercolor grew increasingly apparent and signaled the irrevocable rift between popular and critical reception to it. Henry McBride's tour of the 1950 Whitney Museum's annual mentioned a "distant little upstairs gallery where some of the better watercolors could be seen hobnobbing together as though they were a *salon d'honneur*," but he pronounced the rest of the show "tiresome."[37] The American Watercolor Society's ninetieth annual exhibition in 1957 was the last to receive reviews from several art publications, and during the 1960s there were just two more indexed notices.[38] The Whitney Museum staged its last annual exhibition with the word "watercolor" in its title in 1958, but it did reprise the subject in *Masters of American Watercolor* in 1962. Reviewer Valerie Peterson suggested that the museum was grasping for something comforting and familiar in the stormy early 1960s in its preoccupation with abstraction and Pop art. She described the show as "a lace collar and long white gloves affair … [that] picks the winners from a ballot-box stuffed with sure things … [and] shows how little the state of the American watercolor has changed since it became a state."[39] Shortly thereafter, in 1963, the Brooklyn Museum's watercolor exhibition, one of the longest-running in the country, ceased.[40] In her well-argued essay about watercolor in twentieth-century United States, Barbara Dayer Gallati contended that traditional watercolor was developed and sustained for a time by a critical language based in nineteenth-century rhetoric about the medium and national identity. Watercolor was not capable of growing out of a traditional mode because "writers subordinated the role of the artist in the creative process and also absolved themselves of the responsibility of analyzing subject matter in any detail. In this regard the message was truly the medium."[41]

Serious watercolor practice would seem to have been equally the victim of Action Painting, the postwar style named in 1952 by critic Harold Rosenberg. "At a certain moment the canvas began to appear to one American painter after another as an arena in which to act — rather than as a space in which to reproduce … an object — actual or imagined," Rosenberg wrote. "What was to go on the canvas was not a picture but an event."[42] Ironically, then, it was the emergence of the first painting style to be defined as wholly of the United States — alternately known as Action Painting, Abstract Expressionism, or the New York School — that signaled the demise of the "American Medium." Action painting's very name implies the spontaneity that was once the province of watercolor. For the artist of a traditionalist bent, for whom "the message was truly the medium," postwar

painting in the United States dismantled criteria of skill, beauty, and every other aesthetic judgment, including craftsmanship, on which conventional watercolor practice was founded. But other prejudices, especially regarding intent and scale, abounded. Valerie Peterson dismissed watercolor, noting "how small a medium it is and how reticence and control protect it from the madness of modernity."[43] Small, reticent, and intimate did not fit the perception of postwar American painting as forceful and grand. "The conventions of Abstract Expressionist painting — large brushstrokes, for example, whose appearance indicates that they were laid on the canvas rapidly — have come to stand for spontaneity and even masculine force," Ann Gibson has argued. "The canvases' large sizes have come to embody Abstract Expressionism's control of its environment. They are the signs of its authority."[44] Gibson and other scholars are re-examining the formation of these conventions to demonstrate that a great deal of artistic activity, including the practice of small-scaled watercolors, flourished outside these narrow definitions. The reality, once again, contradicts critical perception.[45] Jeffrey Wechsler has argued convincingly that spontaneous effects afforded by water-soluble media made them ideal for experimentation in automatism, a practice of painting without forethought to delve into one's subconscious, the source of uncensored, uncivilized, and honest motivations. During the 1940s American artists such as William Baziotes (cat. no. 38) engaged in this practice following the example of war-displaced Surrealists from Europe. Watercolor epitomizes the modernist dictum "truth to materials," Wechsler has noted, in that surface and material are completely integrated: "In its purest form, watercolor is nothing else if not a stain."[46] Similarly, Lisa Mintz Messinger has written that the Abstract Expressionists discovered essential qualities of painterliness and personal iconography through their experiments on paper.[47] There is now a growing appreciation for the invigorating contributions that Abstract Expressionist artists made to watercolor by taking great liberties with it.

By the 1960s the large national museum annuals that featured watercolors by non-watercolor artists no longer existed. This is not to say that artists ceased working in water-based media, but the genre ceased to be sustained as a collective movement. It was, in fact, superseded by other forms of works on paper, namely printmaking. Before 1960, printmaking, like watercolor, was a relatively intimate undertaking in the United States. After Tatanya Grossman, founder of the U.L.A.E. (Universal Limited Art Editions) workshop on Long Island, convinced Jasper Johns, Robert Rauschenberg, and other artists that creating fine art lithographs would be commercially advantageous, a veritable boom in the production of fine prints — lithography in particular — erupted as other studios, such as Tamarind and Gemini, emerged. These studios quickly developed reputations for technical wizardry, to the extent that Rauschenberg could produce the life-sized lithograph,

Booster, at Gemini in 1967.[48] The highly technical demands of lithography were in the hands of master printers, so artists did not need to be responsible for "craft" in the same way traditional watercolorists had to be. Moreover, for artists of a Pop sensibility, the qualities of reproducibility and large scale (in emulation of advertising and billboards) in graphic media made printmaking inherently relevant to their aims, in a way that watercolor was not. It can be argued, then, that printmaking in the 1960s became the new "American Medium."[49]

Building the Collection

American Twentieth-Century Watercolors celebrates and pays homage to the generosity of enlightened patronage, a quality that built the Munson-Williams-Proctor Arts Institute as a whole and its watercolor collection in particular. This patronage shaped the tone and character of the Museum's collections in such a way that the watercolors largely date to this century. While the country's oldest public institutions were chartered in the nineteenth century, the Munson-Williams-Proctor Institute was not founded until 1919, and its acquisitions program did not develop in a methodical way until 1947, with the appointment of Harris K. Prior, director of the Community Arts Program, precursor to the Museum of Art.[50]

Prior worked closely with consultant Edward Wales Root (1884-1956), son of statesman Elihu Root and a collector of American painting and works on paper. The Root homestead is at Hamilton College, in Clinton, New York, ten miles from Utica; Edward Root taught art appreciation at Hamilton between 1920 and 1940. He and his wife, Grace Cogswell Root, divided their time between Clinton and New York City. As a young man early in the century, Root began collecting the work of the "Eight," eight artists who exhibited together in 1908 at the MacBeth Galleries, New York, to protest the exclusive practice of juried exhibitions at the National Academy of Design.[51] As the decades passed, Root remained current with artistic trends. In the first third of the century, for example, he bought primarily representational works by artists such as Charles Demuth (cat. no. 10), Edward Hopper (cat. no. 16), Reginald Marsh, or John Carroll, but by the 1940s Root began to collect non-objective works by the likes of Richard Pousette-Dart (cat. no. 45), Sonja Sekula (cat. no. 43), Norman Lewis, Jackson Pollock, and others.

With the exception of sculpture, Root acquired works in all media — oil paintings, watercolors, drawings, and prints — and his watercolor purchases did not follow a pattern. He acquired watercolors by Maurice Prendergast and Edward Hopper before he bought an oil painting by each of them, but this was not a typical practice; Root did not generally buy watercolors as a means to familiarize himself with an artist's work prior to making the more serious purchase of an oil painting. He met George Luks in 1909 and bought ten small oils sketches of Paris and the portrait *The Pawnbroker's Daughter* (MWP Arts Institute) within the next

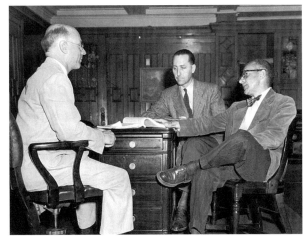

Thomas Brown Rudd, President, Munson-Williams-Proctor Institute; Harris K. Prior, Director, Community Arts Program; William C. Palmer, Director, School of Art, in Mr. Rudd's office, 1951

three years; only in the 1920s, as Luks' proficiency with the medium increased, did Root buy the artist's watercolors *A Daughter of the Mines* (cat. no. 13) and *Miners' Shacks, Pottsville* (cat. no. 18).[52] Similarly Root bought the Peppino Mangravite gouache *New England Bacchanal* (MWP Arts Institute) after he purchased three oil paintings by the artist.[53] In 1946 he also bought both an oil painting and a watercolor simultaneously from solo gallery shows by William Baziotes and Charles Howard (cat. nos. 30, 38).

From its inception, the Institute benefited from its affiliation with Edward Root. He was extremely generous with his time, connections to artists and dealers, and gifts of art works. Root donated works on paper in 1949 and 1953 and subsequently bequeathed a large portion of his holdings to the museum; these works entered the permanent collection in 1957. *American Twentieth-Century Watercolors at the Munson-Williams-Proctor Arts Institute* is a testimony to Root's taste and discriminating eye: twenty-five (or half) of the paintings in the exhibition were once in his collection.[54]

The watercolor collection reflects the largesse of other donors as well. In addition to the Root collection, nearly one-quarter of the paintings in *American Twentieth-Century Watercolors* were donated by collectors, artists, and artists' estates. Among the first works to enter the Museum of Art's permanent collection was Arthur B. Davies's *Park at Blois* (cat. no. 14), one of three gifts from Cornelius N. Bliss in 1941; the Davies works are especially prized because the artist was a native son, born in Utica in 1862. In the early 1960s, after the Institute received the Edward Root bequest, it continued to feel his presence in the gift of two Edward Hopper watercolors (cat. nos. 17, 27) from Fred L. Palmer (1901-84). Palmer, a public relations executive and arts patron, graduated from Hamilton College in 1923 and was among the first students to take Edward Root's art appreciation course. From Root Palmer adopted an interest in American art and in the work of Hopper in

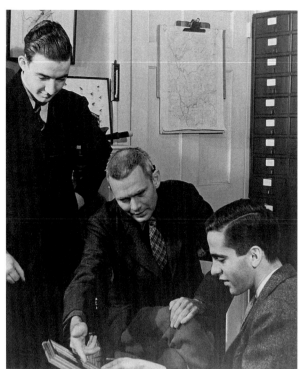

Edward W. Root with students at the Root Homestead, Hamilton College, Clinton, New York

particular. Another generous patron, Mrs. James Lowery, began making donations to the museum in the early 1960s as well. A long-standing supporter, Mrs. Lowery gave works of art in a variety of media over a twenty-year period. Her gifts included two watercolors, the striking *Red Tulips* by Charles Demuth (cat. no. 15), and a Vermont landscape by Henry Schnakenberg (cat. no. 20). Dr. and Mrs. Stephen J. Walker were other local patrons whose 1984 gift included Dong Kingman's *Side Street, Chinatown* (cat. no. 41). And as the catalog for *American Twentieth-Century Watercolors* was going to press, the museum received from the David Anderson Gallery, Buffalo, the gift of a Paul Jenkins watercolor from 1961. Jenkins, who was once represented by Anderson's mother, Martha Jackson, created abstract veils of layered transparent washes, thus infusing the tradition with a new approach to materials and themes.

The museum has benefited, too, from donations by artists or their estates. In the 1980s William C. Palmer, founding director of the Institute's School of Art (no relation to Fred L. Palmer), made a large gift of his works with the understanding that most would be sold to support the Institute. Some of Palmer's paintings and drawings, however, were reserved for the museum's collection, including the expressive *Hop Poles* (cat. no. 42). Gifts from artists' estates tend to reflect the museum's earlier patronage. In 1979 Felicia Meyer Marsh, widow of Reginald Marsh, bequeathed several works to the museum that supplement the permanent collection's already deep holdings of Marsh paintings and works on

paper (see cat. no. 26). Similarly, the Dorothy Dehner Foundation for the Visual Arts recently donated several works on paper by Dehner, including an untitled watercolor (cat. no. 46). The museum had bought Dehner's *Dance* (cat. no. 49) in 1957, so the foundation's recent gift makes an interesting comparison in both subject matter and handling of materials to this earlier purchase. In 1998[55] the museum also received a large donation of works by American artists from Jean and David Loeffler Smith. Included were an Edwin Dickinson watercolor (cat. no. 12), a rare piece because the artist did not work in the medium extensively, and two watercolors by Smith's father, Jacob Getlar Smith (cat. nos. 21, 32).

The museum has built on the strength of these gifts with select purchases. Under Palmer's leadership, the Institute's School of Art sustained an active visiting artists program in the 1940s and 1950s. During these short residencies artists gave lectures, performed technical demonstrations, and created small exhibitions. From these shows, the museum sometimes made acquisitions, which is how the works by Will Barnet (cat. no. 47) and Dong Kingman (cat. no. 40) entered the permanent collection. The museum also is dedicated to acquiring works from the School of Art faculty, Edward Christiana's *Winter Sun and Kids* (cat. no. 37) being among the first such purchases. The museum also bought work from touring temporary exhibitions; in the early 1950s it acquired two John Marin watercolors in this manner (cat. nos. 19, 25) and bought a significant early work by Stuart Davis (cat. no. 3) from the fiftieth anniversary Armory Show exhibition in 1963. Purchases for the twentieth-century collection tend not to be retrospective but, in Root's spirit, works by living artists. Two key exceptions in the 1990s are Marguerite Zorach's *Autumn in the Country* (cat. no. 4) and Bob Thompson's *Stagedoom* (cat. no. 50).

American Watercolors: Recent Exhibitions

In publishing fifty of its outstanding watercolors, the Munson-Williams-Proctor Arts Institute not only extends its own series of collections catalogs, but it also adds to a host of similar art museum studies that document a resurgence of interest in such material. Since the publication of Theodore Stebbins's groundbreaking assessment, *American Master Drawings and Watercolors,* (1976)[55] and Marjorie B. Cohn's 1977 study, *Wash and Gouache: A Study of the Development of the Materials of Watercolor,*[56] numerous museums have examined or re-examined their collections and, in the past two decades, have exhibited and published their holdings of American works on paper, often with a special emphasis on spectacular and splashy watercolors. For the country's venerable institutions, such as the Wadsworth Atheneum, the Museum of Fine Arts, Boston, the Brooklyn Museum of Art, the Metropolitan Museum of Art, or the Worcester Art Museum, these projects have provided an opportunity to showcase outstanding late-nineteenth-century

compositions by Winslow Homer, John Singer Sargent, and other watercolor artists of the period.[57]

From within this collection of exhibitions there have emerged several projects that examine aspects of the medium's history in more detail, including monograph shows of John Marin, Winslow Homer, Charles Burchfield, and Edward Hopper.[58] In addition, several recent studies have analyzed watercolor as practiced in the twentieth century: *Watercolors from the Abstract Expressionist Era* (1990); *The Modernist Tradition: American Watercolors, 1911-1939* (1991); and *Abstract Expressionism: Works on Paper, Selections from the Metropolitan Museum of Art* (1992).[59] *American Twentieth-Century Watercolors at the Munson-Williams-Proctor Arts Institute* joins these efforts in examining artists' practices with water-soluble media during the past one hundred years.

Selecting Works for the Exhibition

The Institute's collection of watercolors is well respected within art historical circles, and many — particularly works by Edward Hopper, Charles Burchfield, and John Marin — have been published in catalogs produced by other institutions. The museum nevertheless determined that *American Twentieth-Century Watercolors at the Munson-Williams-Proctor Arts Institute* should represent the collection at its finest and has therefore included several works that may already be well known. In addition, a special effort has been made to extend the traditional canon to include the work of artists whose skill in the medium is of a high level but who, due to vagaries of taste and scholarship or the artist's limited experimentation with the medium, have otherwise not had the exposure they deserve. Similarly, for the sake of balance and to keep the exhibition a manageable size, not all the works by artists with multiple paintings in the museum's holdings are included in the exhibition.

A second goal of the project was to gain greater intellectual control of the watercolor collection through the careful scrutiny and focused attention that producing an exhibition and catalog entail. In many instances, the museum's records of specific works were incomplete or outdated, so this project offered an opportunity to learn more about the role of watercolor in each artist's oeuvre as well as to reconstruct each painting's history of exhibition, publication, and ownership. Tracing the watercolors' exhibition records has been an especially important conservation exercise to determine the degree to which the images have sustained exposure to light over the years. Indeed, the conservation of these watercolors was another central goal of the exhibition. In August 1997 Williamstown Art Conservation Center Paper Conservator Leslie Paisley made an on-site assessment at the museum to survey the works under consideration for *American Twentieth-Century Watercolors*. This study accomplished several important aims: Paisley wrote a preliminary report about each watercolor's general condition; the museum categorized the paintings according to the degree of recommended treatment; and Paisley then systematically conserved the works. Thanks to Paisley's diligent assessment, the museum applied for and received conservation support from the National Endowment for the Arts. Paisley's study also determined that some of the works under consideration for the exhibition should not be included. Her examination revealed that Arthur Dove's *Frosty Moon,* for instance, acquired as a watercolor by Edward Root and made part of the museum's collection with the 1957 Root bequest, is in fact an oil sketch on paper. Other works were eliminated because they have received either too much or very little light exposure. Mark Tobey's *Structures,* 1946, has been exhibited so often that its brown paper and media are excessively faded, but Jimmy Ernst's *Improvisation,* 1949, was removed from the checklist because it has rarely been shown at all; as such, it can be preserved in a pristine state for future generations' appreciation while another Ernst work, *Several Shadows* (cat. no. 44), will circulate with the exhibition. Such is the luxury of having more than one work by an artist in the collection.

The process of reviewing material for *American Twentieth-Century Watercolors at the Munson-Williams-Proctor Arts Institute* has highlighted the museum's acquisition practices and the patterns of what has been, and has not been, acquired and when. Jacob Lawrence, a preeminent practitioner of gouache and one of the brightest young talents to emerge in the 1940s, is not represented in the collection. During the 1940s Edward Root began collecting non-representational paintings and drawings, including works by another African-American artist, Norman Lewis. Is it because Lawrence's work was narrative that Root did not acquire his gouaches at that time? The last work in the exhibition, *Stagedoom* by Bob Thompson, is dated 1962 but was not acquired until 1996, with the resurgence of interest in Thompson's work. Since the 1960s the museum has focused its contemporary works-on-paper acquisitions on printmaking, so there are fewer contemporary watercolors in the collection.

As we enter a burgeoning cyber culture that steers artists toward computer-generated imagery, watercolor — as the oldest painting medium — continues to entrance. Contemporary artists have used the medium creatively and variously; as in the past, artists who work in watercolor manipulate it to suit their needs. Janet Fish, Patricia Tobacco Forester, or Neil Welliver employ traditional wash techniques and subject matter such as landscape and still life. Francesco Clemente's watercolors are among the richest produced since those of German Expressionist Emil Nolde.[60] In counterpoint to Clemente's lush and expressive treatment, Chuck Close has controlled the medium with conceptual rigor.[61] The adaptability of this medium to a diverse range of contemporary artistic styles and practices suggests that there will be a place for watercolor painting even as artists in the twenty-first century have at their disposal an ever-increasing array of media.

ENDNOTES

1 The American Watercolor Movement, which flourished between 1870 and 1885 "as an interval of sustained popularity of the medium," set the precedent for this later appellation. See Linda S. Ferber, "'A Taste Awakened': The American Watercolor Movement in Brooklyn," in *Masters of Color and Light: Homer, Sargent, and the American Watercolor Movement* (Brooklyn, N.Y.: Brooklyn Museum of Art, in association with Smithsonian Institution Press, 1998), 1. Barbara Dayer Gallati, "Language, Watercolor, and the American Way," in *Masters of Color and Light*, 144 n. 4, has observed that the term "the American Medium" "came into casual use."

2 Helen Appleton Read, "Watercolors are Waving a Gay Banner," *Art Digest* (Nov. 15, 1934): 6.

3 Jacob Getlar Smith, "The Watercolors of Winslow Homer," *American Artist* 19 (February 1955): 19.

4 Alan Burroughs, *A History of American Watercolor Painting* (New York: Whitney Museum of American Art, 1942), 14.

5 Narrowly defined, watercolor is a medium of transparent, layered washes that work in concert with the white of its paper to create a particularly sparkling effect. However, this exhibition argues that watercolor in the twentieth century cannot be narrowly defined. During the past one hundred years, niceties of practice and traditional methods have met unusual challenges. Here, the term "watercolor" is widely interpreted to embrace transparent and opaque water-based media on paper, as well as mixed media works that add pastel, ink, and/or crayon to water-soluble pigments. I concur with Jeffrey Wechsler, *Watercolors from the Abstract Expressionist Era* (Katonah, N.Y.: Katonah Museum of Art, 1990), unpaginated, who preferred the term "water-based media" to define "mediums that offer, through differing proportions and properties of pigments suspended in water, a wide range of transparency, viscosity, and visual effects."

6 See Ralph Fabri, *History of the American Watercolor Society: The First Hundred Years* (New York: American Watercolor Society, 1969).

7 Cited in Sherman E. Lee, "A Critical Survey of American Watercolor Painting" (Ph.D. diss., Western Reserve University, 1941), 127.

8 Unattributed newspaper clipping, microfilm 95, frame 132, George Luks Papers, AAA-SI.

9 *New York Tribune*, Jan. 23, 1921.

10 Judith Kaye Reed, "Competence Not Enough at Aquarelle Annual," *Art Digest* 20 (Feb. 15, 1946): 9.

11 Unsigned review, *Art News* 45 (March 1946): 56; see also, for example, *Art News* 48 (March 1949): 52, for a comparison review of the AWS's eighty-second annual exhibition: "The style is overwhelmingly conservative realist, and it was surprising to find that with such a praiseworthy level of competence there are so few brave experiments."

12 A[lbert] E[ugene] Gallatin, *American Water-Colourists* (New York: E.P. Dutton & Co.,1922), vii.

13 Edward Hopper, "Charles Burchfield: American," *Arts* 12 (July 1929): 9.

14 Frederick A. Sweet, "Foreword," *Twenty-first International Exhibition of Water Colors* (Chicago: Art Institute of Chicago, 1942), unpaginated.

15 The Art Institute of Chicago held watercolor exhibitions from 1888 to 1950; the Pennsylvania Academy of the Fine Arts staged watercolor annual or biennial exhibitions from 1904 to 1969; the Brooklyn Museum hosted biennial watercolor exhibitions between 1921 and 1963; the Whitney Museum of American Art alternated annual painting exhibitions with sculpture and works-on-paper shows until 1973, when the museum combined the two in a biennial event. Watercolors were last listed in the Whitney's works-on-paper and sculpture shows in 1958. The Corcoran Gallery of Art never had a

separate watercolor or works-on-paper annual, nor did the Carnegie International feature watercolors. See the Sound View Press series, edited by Peter Hastings Falk, of annual exhibition records for these institutions. See also Thomas B. Parker, "Chronology of the American Watercolor Movement," in *Masters of Color and Light*, 209-16.

16 Thomas Hess, "The Whitney Draws Slowly to the Left," *Art News* 45 (March 1946): 29, 62.

17 For example, the 1914 exhibition review praised the efforts of Luks, Sargent, and Frieseke, and in his review of the 1946 Whitney exhibition Hess recognized the merits of Edward Hopper's work. The Maurice Prendergast watercolor in this exhibition (cat. no. 2) was first exhibited in the 1912 American Water Color Society exhibition.

18 E[dgar] P. Richardson, "Watercolor: The American Medium?" *Art News* 44 (Apr. 15-30, 1945), 21.

19 See Marilyn S. Kushner, *The Modernist Tradition in American Watercolors, 1911-1939* (Evanston, Ill.: Northwestern University, 1991) and Carol Troyen, "A War Waged on Paper: Watercolor and Modern Art in American," in *Awash in Color: Homer, Sargent, and the Great American Watercolor* (Boston, Mass.: Museum of Fine Arts, Boston, in association with Bulfinch Press, Little, Brown, Inc., 1993), xxxiv-lxxiv, esp. xxxvi.

20 Gallatin, *American Water-Colourists*, 3.

21 Ibid., ix.

22 Guy Pène du Bois, *Watercolors by Gifford Beal, Maurice Prendergast, William Zorach, Reynolds Beal, and George Luks* (New York: C. W. Kraushaar Galleries, 1923); the exhibition was held from Oct. 15 to Nov. 3, 1923.

23 Cahill (1887-1960) was a curator and critic in the 1920s and 1930s before becoming the national director of the Federal Art Project of the Works Progress Administration, a position he held for the duration of the agency's existence, 1935-43. See microfilms NDA 15, 1105-1110, 3482, and 5285-5299, Holger Cahill Papers, AAA-SI.

24 The artists were Frank Benson, Charles Burchfield, Arthur B. Davies, Charles Demuth, Preston Dickinson, Winslow Homer, Edward Hopper, John La Farge, Dodge MacKnight, John Marin, Maurice Prendergast, and John Singer Sargent.

25 Lee, "A Critical Survey," 11.

26 See, for example, Adolf Dehn's approach to landscape painting, described in cat. no. 31.

27 Charles Burchfield, interview with John Morse, Aug. 19, 1959, 14 (transcribed), AAA-SI.

28 Lee, "A Critical Survey."

29 Burroughs, *History of American Watercolor Painting*, 14. The twentieth-century artists in the exhibition (and number of works included) were Childe Hassam (4); Maurice Prendergast (8); Arthur B. Davies (4); George Luks (3); George "Pop" Hart (6); Alfred Maurer (1, on loan from the Phillips Collection); John Marin (10, all on loan from Alfred Stieglitz's An American Place gallery); Max Weber (6); George Bellows (1, from the Museum of Modern Art); Edward Hopper (7); Charles Demuth (10); Charles Burchfield (7); George Grosz (6); Adolf Dehn (6); and Reginald Marsh (4).

30 Sweet, "Foreword," *Twenty-first International Exhibition of Water Colors*, unpaginated.

31 Lloyd Goodrich, *American Watercolor and Winslow Homer* (Minneapolis, Minn.: Walker Art Center, 1945), 7.

32 Richardson, "Watercolor: The American Medium?" 21.

33 Prendergast, Marin, Demuth, Burchfield, Hopper, Dehn, and Marsh.

34 Maude Riley, "Whitney Annual of Sculpture, Watercolors and Drawings," *Art Digest* 19 (Jan. 15, 1945): 5, 31.

35 Dorothy Drummond, "Watercolor Annual at the Pennsylvania Academy," *Art Digest* 23 (Nov. 15, 1948): 26.

36 "Whitney Draws Slowly to the Left," 29, 62.

37 Henry McBride, "As the Whitney Sees It," *Art News* 49 (May 1950): 22. McBride singled out Yves Tanguy, William Thon, William Kienbusch, Loren MacIver, Eugene Berman, and Philip Guston as exhibiting the most successful modernist pieces. He further recognized works of representational subject matter by Paul Cadmus, Beauford Delaney, Rico Lebrun, John Marin, Ogden Pleissner, Charles Sheeler, and George Tooker.

38 According to the *Art Index*, the ninetieth American Watercolor Society annual exhibition received reviews in *Art News, Arts*, and the *Studio*. There are no *Art Index* American Watercolor Society citations until 1966, when *American Artist* reviewed the annual in its June and December issues that year. In 1969, *American Artist* reviewed the Society's 100th anniversary exhibition.

39 Valerie Peterson, "Masters of American Watercolor," *Art News* 61 (March 1962): 49.

40 Gallati, "American Watercolor Canon," in *Masters of Color and Light*, 183.

41 Gallati, "Language, Watercolor, and the American Way," in *Masters of Color and Light*, 144.

42 "The American Action Painters," *Art News* 51 (December 1952): 22.

43 Peterson, "Masters of American Watercolor," 49.

44 Ann Eden Gibson, *Abstract Expressionism: Other Politics* (New Haven, Conn., and London: Yale University Press, 1997), xxiii.

45 The closing decades of the century have seen an exciting number of scholarly and museological projects that are resurrecting the careers of once-successful artists who, often because of their race, gender, sexual orientation, or simply being "unfashionable," have been omitted from prevailing histories. See, for example, the recent exhibition catalogs for Sonja Sekula and Bob Thompson in cat. nos. 43 and 50. These efforts are complemented by others, such as the research by Ann Gibson, which looks afresh at those histories to offer alternative readings on the heretofore "official" script of twentieth-century American art. See, for example, Michael Leja, *Reframing Abstract Expressionism: Subjectivity and Painting in the 1940s* (New Haven, Conn., and London: Yale University Press, 1993).

46 Wechsler, *Watercolors from the Abstract Expressionist Era*, unpaginated.

47 Lisa Mintz Messinger, *Abstract Expressionism: Works on Paper, Selections from the Metropolitan Museum of Art* (New York: Metropolitan Museum of Art, 1992), ix-xi.

48 See Ruth E. Fine, *Gemini G.E.L.: Art and Collaboration* (Washington, D.C.: National Gallery of Art, 1984), 48-49.

49 See Trudy V. Hansen et al., *Printmaking in America: Collaborative Prints and Presses, 1960-1990* (New York: Harry N. Abrams, Inc., in association with Mary and Leigh Block Gallery, Northwestern University, 1995).

50 See Paul D. Schweizer and John R. Sawyer, "A History of the Collection," in *Masterworks of American Art from the Munson-Williams-Proctor Institute* (New York: Harry N. Abrams, Inc., 1989), 7-13, and Anna T. D'Ambrosio, "With Style and Propriety," in *Masterpieces of American Furniture from the Munson-Williams-Proctor Institute* (Utica, N.Y.: MWPI, 1999), 10-24, for histories of the Institute's collections.

51 The "Eight" were Arthur B. Davies, William Glackens, Robert Henri, Ernest Lawson, George Luks, Maurice Prendergast, Everett Shinn, and John Sloan. They represented a progressive approach in American painting at the turn of the century; they painted with a perceived lack

of finish and used urban subjects that were deemed inappropriate or coarse by the jurors of the Academy's annual exhibition.

52 Luks had given the watercolors *Dyckman Street Church* (cat. no. 6) and *Screecher, Lake Rossignol, Nova Scotia* (cat. no. 11) to Root in the 1910s.

53 The three paintings are *Young Couple Drinking, Child Blowing a Balloon*, and *Young Girl with a Yellow Kerchief* (all MWP Arts Institute).

54 Root donated twenty-two of these during his lifetime or as part of his large 1957 bequest; three works, George Luks' *Dyckman Street Church* and *Screecher, Lake Rossignol* and Morris Graves's *Resting Duck*, were among twenty-six works the Institute purchased from Mrs. Root between 1957 and 1959.

For more on Root as a collector, see Aline B. Saarinen, *The Proud Possessors* (New York: Random House, 1958), 250-68; *Edward Wales Root (1884-1956): An American Collector* (Utica, N.Y.: MWPI, 1957); *Edward W. Root: Collector and Teacher* (Clinton, N.Y.: Fred L. Emerson Gallery, 1982); and Mary E. Murray, "Theodoros Stamos and Edward Wales Root: A Friendship in Art and Nature," in *Theodoros Stamos, 1922-1997: A Retrospective* (Athens, Greece: National Gallery and Alexander Soutzos Museum, 1997), 53-57.

55 Theodore E. Stebbins Jr., *American Master Drawings and Watercolors* (New York: Harper & Row, 1976).

56 Marjorie B. Cohn, *Wash and Gouache: A Study of the Development of the Materials of Watercolor* (Cambridge, Mass.: Harvard University, 1977).

57 Notable catalogs include *American Drawings and Watercolors in the Museum of Art, Carnegie Institute* (1985); *American Drawings and Watercolors from Amherst College* (1985); *American Traditions in Watercolor: The Worcester Museum Collection* (1987); *American Drawings from the Wadsworth Atheneum* (1987); *American Watercolors from the Metropolitan Museum of Art* (1991); *American Drawings and Watercolors from the Kansas City Region* at the Nelson-Atkins Museum of Art (1992); *Awash in Color: Homer, Sargent, and the Great American Watercolor*, Museum of Fine Arts, Boston (1993); and *Masters of Color and Light: Homer, Sargent, and the American Watercolor Movement*, Brooklyn Museum of Art (1998). See also Parker, "Chronology of The American Watercolor Movement," 216. This is not to say that there was no scholarly, popular, or museological attention toward watercolor before the 1970s; see the bibliography in Stebbins, *American Master Drawings and Watercolors*, 440-41.

58 Ruth Fine, *John Marin* (Washington, D.C.: National Gallery of Art, 1990); *Winslow Homer* (Washington, D.C., and New Haven, Conn.: National Gallery of Art in association with Yale University Press, 1995); Nancy Weekly, ed., *Life Cycles: The Charles E. Burchfield Collection* (Buffalo, N.Y.: Burchfield-Penney Art Center, 1996); *The Paintings of Charles Burchfield: North by Midwest* (New York: Harry N. Abrams, Inc., in association with the Columbus Museum of Art, 1997); and Virginia Mecklenburg, *Edward Hopper: The Watercolors* (New York: W.W. Norton & Co., 1999).

59 Wechsler, *Watercolors from the Abstract Expressionist Era*; Kushner, *The Modernist Tradition in American Watercolors*; and Messinger, *Abstract Expressionism: Works on Paper*. See also Barbara Dayer Gallati, "American Watercolor Canon," in *Masters of Color and Light*, 171-207.

60 See, for example, reproductions of thirty Clemente watercolors from 1985 in *Clemente* (New York: Guggenheim Museum, distributed by Harry N. Abrams, Inc., 1999), fig. 119.

61 See Close's *Linda/Eye Series I-V, 1977* (Art Institute of Chicago), reproduced in Robert Storr, *Chuck Close* (New York: Museum of Modern Art, distributed by Harry N. Abrams, Inc., 1998), 134-35.

American Twentieth-Century
Watercolors
Munson-Williams-Proctor Arts Institute

Each entry contains standard catalog information — artist's name and dates; the watercolor's title and date; materials; measurements; inscriptions; watermark, if applicable; provenance of the watercolor; exhibition and publication histories; and an essay written by Mary E. Murray or a guest scholar who is identified.

Notes to each entry follow as endnotes. Short form references are used in the endnotes for publications listed in the Exhibitions and Publications sections of each watercolor.

Measurements for the watercolors are given with height preceding width.

Provenance, exhibition and publications histories are as complete as possible. In some instances, however, ownership of the watercolor could not be traced beyond the donor or gallery from which it was acquired.

The Exhibitions and Publications sections are in chronological order and follow the essays.

In the Exhibitions section, exhibitions for which a checklist or catalog was published are so noted, and, in the interest of saving space, exhibition publications are not repeated under the Publications section. For exhibition publications that assigned catalog numbers for each work of art, the catalog numbers only are noted. For exhibition publications that are paginated but that did not assign catalog numbers, "catalog" is noted, followed by the page number on which the watercolor is listed. For exhibition publications that are not paginated and for which catalog numbers were not assigned for each work of art, "catalog" is simply noted. Exhibition publications that illustrate the watercolors are indicated by "illus." with the page number or figure number of the reproduction, if applicable.

In the Exhibitions section, in the interest of saving space, for multivenue traveling shows, the first or organizing venue and the dates of its exhibition are listed only.

The Publications section lists books and articles in which the work appears.

In 2000 the Institute changed its name from Munson-Williams-Proctor Institute (short form MWPI) to Munson-Williams-Proctor Arts Institute (MWP Arts Institute). Publications, exhibitions and acquisitions dating before 2000 retain the original name.

The Archives of American Art, Smithsonian Institution, Washington, D.C., is abbreviated as AAA-SI.

For conservation purposes, catalog numbers 1, 14, 45, and 49 will be shown in Utica only.

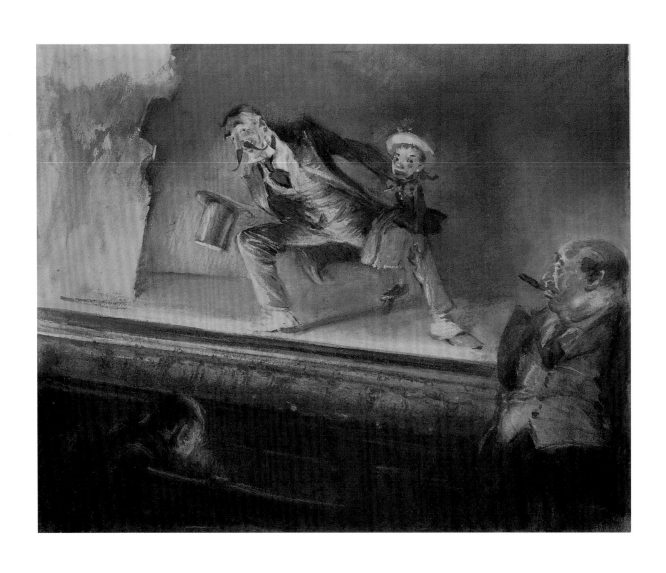

Everett Shinn (1873-1953)

Paris Music Hall, 1902

Opaque and transparent watercolor and pastel on wove paper

8 x 9 15/16 in.

Everett Shinn toured Europe in the summer of 1900, and from this trip he derived years' worth of subject matter to paint. His primary interest lay in Parisian cafés and cabarets (which easily translated to New York venues upon his return to the United States), and critics applauded his interpretations of continental nightlife, dubbing Shinn the American Degas, Forain, or Raffaëlli.[1] In *Paris Music Hall* he used pastel and watercolor to depict a ventriloquist as seen from the first rows of a theatre. The combination of materials creates a velvety surface, rich color, and a spontaneous feel, appropriate to the quick-observation reportorial style for which Shinn was renowned. He drew the stage at a dynamic upward angle, which is reinforced by the performer's pose. The composition's cropping and point of view are not as extreme, however, as in other works of this kind; Shinn centered attention on the entertainer, who smiles from behind his oversized stage mustache and brows. He hams it up with his girl puppet. She sports red stockings and gloves, a big blue bow tie, and a flower-garnished hat. While her limbs hang lifelessly, the puppet's face is animated. Both she and her master look to their left at the cigar-chomping fat cat, presumably the establishment's proprietor, at the far right of the composition. One can only imagine what "she" is saying about him. For all the entertainer's exaggerated antics, though, it appears that he performs for an unresponsive crowd, if the sleeping, anonymous patron in the front row is any measure of the rest of the audience.

In spring 1943 the Whitney Museum of American Art, in New York, staged the exhibition "New York Realists, 1900-1914," and the Brooklyn Museum opened "The Eight" in November of that year.[2] Shinn was the youngest member of the Eight; in the 1940s he and John Sloan were the surviving members of the once-rebellious group. Shinn benefitted from this revival of interest in early twentieth-century American painting. The Feragil Galleries, in New York, held two one-artist shows of his work in 1943, and the American British Art Center, also in New York, similarly organized Shinn exhibitions for 1945 and 1946.[3]

Edward Root attended both Art Center shows and purchased works on paper from each, the pastel *Paris Cabaret, 1917* (MWP Arts Institute) and *Paris Music Hall*. In the early years of the twentieth century, Root was a novice collector who supported artists of the United States; among his initial acquisitions were works by selected members of the Eight. Root's first purchase was an Ernest Lawson painting; he also had a long and fruitful friendship with George Luks, from whom Root acquired dozens of paintings and drawings through gift and purchase. In addition, Root acquired Arthur B. Davies' *Refluent Season* from the 1911 Society of Independent Artists exhibition and Maurice Prendergast's *Landscape with Figures* from the Armory Show in 1913.[4] As the decades progressed, Root remained current in his collection-building. In the 1940s, for example, he frequented galleries such as the Betty Parsons and Willard and bought works by Jackson Pollock, Richard Pousette-Dart, Mark Tobey, Sonja Sekula, and Morris Graves, among others. Root's purchase of the two Shinn works on paper that dated from several decades earlier was highly unusual because he rarely bought retrospectively.

INSCRIPTIONS

recto, lower left (black paint): EVERETT SHINN; verso of illustration board from which drawing was removed for conservation purposes, upper right (commercial label): The American British / Art Center, Inc. / 44 West 56th Street / New York, N.Y. / Title Paris Music Hall [in brown ink] / Artist Everett Shinn [in brown ink] / Date of work [not dated] / Purchaser EW Root [in brown ink] / Date of Purchase [not dated] / Price $ [in brown ink] [price crossed out with graphite]; right center (graphite): 10 x 8; center (graphite): No - 17 / The Ventriloquist / 12-1/2 x 19-1/4; center (white chalk): 10 – 1; left center, adhesive label (blue ink): W 50 / PAR C; lower left center (red crayon): 18 (circled)

PROVENANCE

American British Art Center, New York; to Edward W. Root, Clinton, N.Y. [W-50]; to the Museum of Art, Munson-Williams-Proctor Institute, Edward W. Root Bequest, 57.235

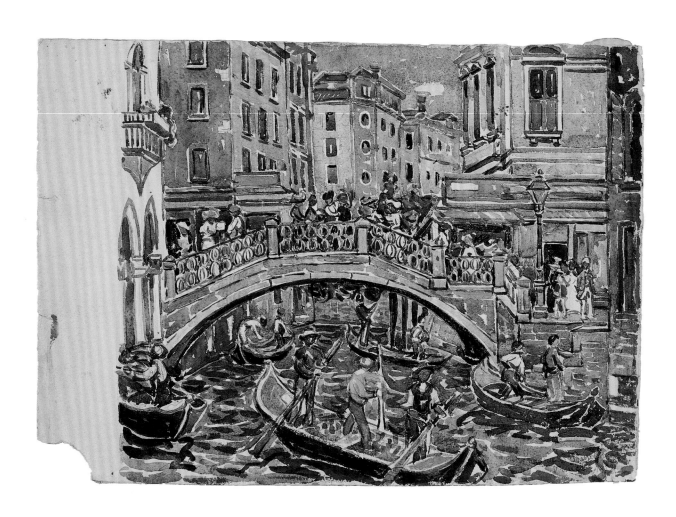

Maurice B. Prendergast (1858-1924)

Canal, 1912

(verso: unfinished watercolor sketch, *Rialto Bridge*)

Transparent watercolor over graphite on heavyweight textured wove paper

15 1/2 x 22 1/16 in. (irregular)

Maurice Prendergast arrived in Europe in August 1911 to meet his brother Charles, who remained with him on the continent until October. Maurice settled in Venice; it was his second extended stay in the city, for he had previously lived in Italy in 1898-99. *Canal* was painted in late summer/early fall 1911 but may not have been completed until January 1912, because Prendergast spent a difficult autumn in the Cosmopolitan Hospital, Venice, suffering from prostate problems.[1] In a series of letters written in November and December 1911 to Charles in Boston, however, Maurice described his improving health. As his strength returned after weeks in the hospital, Maurice wrote of the city's inspiration for him: "I am keen about getting a hold of my watercolors again for I would like to finish some of them while I am here … in spite of everything Italy is the place for Ideas."[2] "I am commencing to like Venice immensely," he wrote to Charles several weeks later. "The winter is so different and the color seems to get richer and deeper."[3]

Upon his return to the United States, Prendergast exhibited *Canal* in the American Water Color Society Exhibition of April-May 1912. According to Edward Root, George Luks saw the work and encouraged Root to buy it, which he did. Root related this history in a letter to Herman More of the Whitney Museum of American Art when More requested its loan for the museum's 1934 Prendergast Memorial show.[4] Root closed his letter to More with an enthusiastic endorsement of *Canal:* "As a piece of color I have always thought it extraordinarily beautiful and subtle."[5]

Prendergast composed *Canal* with a gestural graphite sketch. In some instances, such as with the figure at the lower left, he drew in the forms extensively, but for the most part, his drawing is a flow of rapid notations over

which he subsequently painted.[6] Prendergast first used shades of blue paint to delineate architectural features, such as the planes of buildings and the bridge.[7] Once the artist had demarcated these forms, he inpainted with quick strokes of color to capture the vibrant parade of activity. In some instances, Prendergast built up transparent layers of paint, but for the most part the work is sparkling mosaic of individual marks playing against the white paper of unpainted passages. Venice and its architecture, according to Prendergast scholar Nancy Mowll Mathews, served him "as decorative aspects for the parade of human life seen throughout the tourist's Italy."[8]

Prendergast's images of Venice from 1911-12 differ from those of his 1898-99 trip. His watercolor *Venice,* ca. 1898-99, depicts the same scene as that of *Canal.*[9] When Prendergast painted the earlier work, he was beginning to internalize the latest Post-Impressionist painting styles, but not until his 1907 trip to France did he truly begin to paint more abstractly, with less three-dimensional illusionistic perspective, a more expressive palette, and the less unified brushstroke that is found in *Canal.* Ironically enough, however, as Mathews observed, after the 1911-12 sojourn and because of his long convalescence "what seems to have had a more lasting impact on his future direction was his discovery, through books, of early Italian paintings and art history in general."[10]

When Edward Root acquired *Canal,* Prendergast wrote, "I hope you will always like the watercolor and never put it in a dark corner."[11] This painting has indeed been exhibited frequently in its history, and, as a consequence, certain blue-violet pigments have faded. The bright palette of Prendergast's unfinished watercolor of the Rialto Bridge on the verso of *Canal* indicates the degree of light damage.

INSCRIPTIONS

recto, lower right (ink): "Maurice B. Prendergast / Venice 1912"

PROVENANCE

Purchased from the artist by Edward W. Root, Clinton, N.Y. [W-46], May 1912; to the Museum of Art, Munson-Williams-Proctor Institute, Edward W. Root Bequest, 57.213

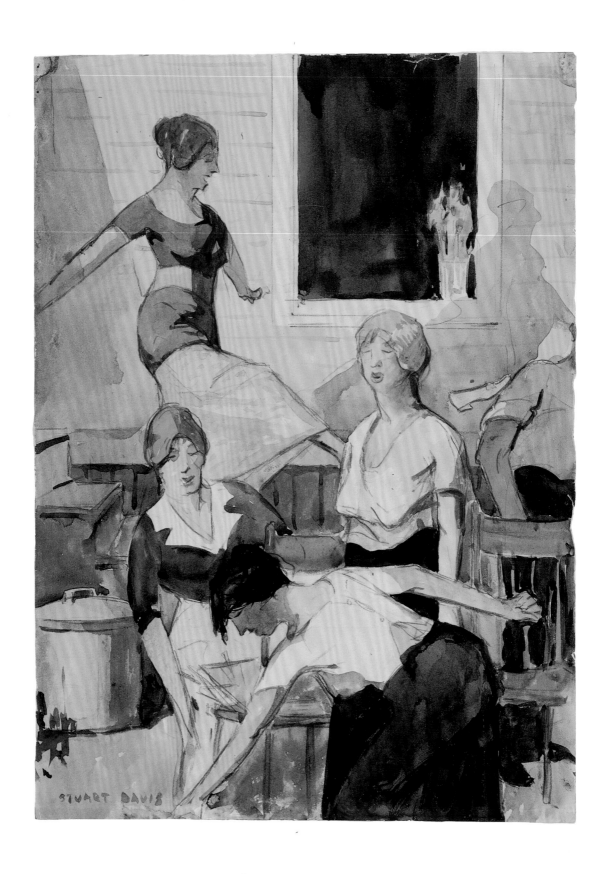

Stuart Davis (1894-1964)

Servant Girls, 1913

Transparent watercolor and graphite on moderately thick, slightly textured, machine-made wove paper

15 x 10 15/16 in.

A student of the American painter Robert Henri (1865-1929), who pioneered the use of urban subject matter and bravura brushwork, Stuart Davis was encouraged by his mentor "to draw from your own experience, to look at not only art, but at the people around you, at the situations around you and draw them."[1] A precocious talent, Davis already was an accomplished artist in 1913 when he exhibited five watercolors, including *Servant Girls,* at the Armory Show. Fifty years later he could still describe these paintings with reserved pride: "[They were] all right … I even sold one there, so — you know, they were decent looking things, and they still look all right."[2]

In *Servant Girls* Davis's watercolor technique is characterized by graphite underdrawing and loosely handled transparent washes. In some passages, he applied color as if the underdrawing were an outline to be filled, but in other areas he painted quite freely. In the composition's periphery, such as the background shadows cast against the building, Davis painted with a wet brush on wet paper and allowed the paint to pool. In passages with expanses of color, such as with the skirts of the three women in the foreground, he used a wet, broad brushstroke. In these areas, Davis only occasionally hinted at the illusion of volume. For elements central to the image, Davis rendered the graphite underdrawing more completely, and onto the graphite he layered washes, from light to darker tonalities. After he defined figures and forms generally, Davis added details, and it is here that he is most fastidious (though, arguably, never excessively so). To give personality and color to the central blond woman, for example, he applied a light yellow ground for skin tone, added pinks and a very selective amount of darker red-violet around her nostrils, lips, neckline, the hollow of the neck, and her left arm. A darker violet also shadows the nape and face of the woman in the foreground.

If *Servant Girls* was derived from an observation Davis made, the scene seems plucked from a specific narrative. The setting suggests a summer's day, and the women appear to be setting up chairs for an outdoor event. Recent literature has taken the title to include all four women as servants, but it is possible that Davis depicted women of two classes.[3] In costume and behavior, the three women in the foreground certainly seem like they are in service. They look wilted in their nondescript, sagging shirtwaists. The blond woman in the center of the composition moreover resembles Davis's "Mag," of "Gee, Mag, Think of Us Bein' on a Magazine Cover" fame, from the June 1913 issue of *The Masses.*[4] By contrast, the woman in the background standing on the steps looks more fashionably dressed than the other three. She sports a patterned skirt and short-sleeved, belted tunic and playfully kicks her shoe at the fellow in rolled-up shirt sleeves who ducks out of the picture to the right. Her attitude is markedly carefree in comparison to the appearance of the three other seemingly hot and busy women.

As it was for so many other American artists, the Armory Show was an epiphany for the young Davis.[5] In its immediate aftermath, the quotidian scenes from which he had drawn subject matter for works such as *Servant Girls* gradually ceased to inspire him. Davis first painted in emulation of Post-Impressionists van Gogh and Gauguin before arriving at his mature style which owed more to Cubists Picasso and Léger.

INSCRIPTIONS

recto, lower left (brown paint): STUART DAVIS; verso, upper center (graphite): Servant Girls #813

PROVENANCE

Downtown Gallery, New York; to the Museum of Art, Munson-Williams-Proctor Institute, Purchase, 63.91

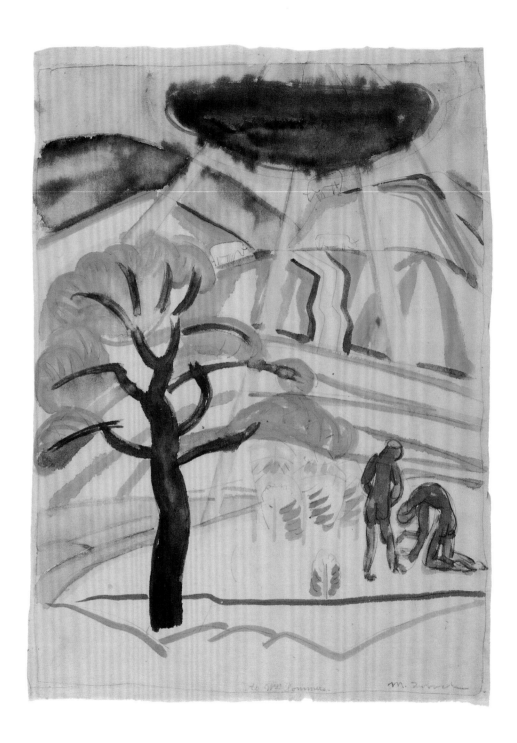

INSCRIPTIONS

recto, lower center (graphite): to W<u>m</u> Sommers;¹ lower right (graphite): M. Zorach

PROVENANCE

Gift of the artist to William Sommer, Cleveland, Ohio; to the estate of William Sommer; to a private collection, Cleveland; to the Spanierman Gallery, New York; to the Museum of Art, Munson-Williams-Proctor Institute, Purchase with donated funds, 92.31

Marguerite Zorach (1887-1968)

Autumn in the Country, 1914

Transparent watercolor and graphite on Japanese mulberry paper

13 11/16 x 10 1/8 in.

By 1914, when Marguerite Zorach painted *Autumn in the Country,* she had gained sufficient versatility and assurance in vanguard aesthetics to execute watercolors with saturated hues and very few, swift strokes. Zorach deliberately replaced traditional spatial illusion and tonal modulations with transparent veils of vibrant color, disjunctive, soft-edged planes, and simplified forms.

Between 1908 and 1912, Marguerite Thompson circumnavigated the world from west to east. Thereafter, non-Western art was an integral part of her eclectic visual vocabulary. In Paris in 1910 and 1911, she studied with John Duncan Fergusson and Jacques-Emile Blanche at La Palette, where she met William Zorach, her future husband; Anne Estelle Rice, an American expressionist painter; Emily Carr, a Canadian vanguard painter; and Jessie Dismorr, later a vorticist in London.[2] Thompson and Dismorr also shared a studio in Paris and summers in Provence. Thompson practiced Parisian modernist approaches to art, visited Gertrude Stein's soirées, and exhibited her inventive works at the American Woman's Art Association, the Société des Artistes Indépendants, and the Société du Salon d'Automne. Thompson traveled in North Africa and Asia (1911-12) and returned to her native California in April 1912.

Thompson's two solo shows in 1912 included her vividly colored and innovatively designed paintings from four continents and demonstrated her place among international modernists.[3] She had completed the five newest works in August in California's Sierra Mountains. As she decisively stroked these canvases with loaded brushes, she recalled naturalist John Muir's works: "Climb the mountains and get their good tidings. Nature's peace will flow into you as sunshine flows into trees. The winds will blow their own freshness into you, and the storms their energy, while cares will drop off like autumn leaves."[4] She told a critic that paintings by such Post-Impressionists[5] as Fergusson were alive and strong through techniques that inspired her. When she said that she "earnestly strove to express the inner spirit of things" and that she admired Post-Impressionists because they did not hesitate either to use intense colors or "to go boldly into whatever fields open before them," she demonstrated her comprehension of Wassily Kandinsky's seminal treatise *On the Spiritual in Art* (1911).[6]

Thompson married William Zorach on December 24, 1912 in New York City. Zorach's oil portrait *Study* (unlocated), on view in the Armory Show, attracted critical notice. "In the 'study,' by Marguerite Zorach, you see at once that the lady is feeling very, very bad," Aloysius Levy wrote in the *New York American.* "She is portraying her emotions after a day's shopping. The pale yellow eyes and the purple lips of her subject indicate that the digestive organs are not functioning properly."[7] The Armory Show *Study* is one of many reductive Fauve portraits she created in 1913.

During 1913 and 1914 the Zorachs summered in rural Chappaqua, on the Hudson River in New York. There she painted *Bathers* (oil on canvas, 1913-14) and *Autumn in the Country,* which depicted redheaded, serpentine figures in harmony with their pastoral surroundings. In *Autumn* and *The Garden* (signed and dated "M.ZORACH-1914-"), her most spectacular Chappaqua canvas, humble folk cultivate the primordial earth. In *The Garden,* also known as *The Magnificent Squash,* she celebrates the exuberance of a giant yellow squash plant with her signature flat-patterned design. The absence of machines and her choice of squash and corn suggest her intentional references to pre-Columbian American civilizations.

Zorach executed *Autumn in the Country* with a rare authority and energy. Very few painters in American in 1914 were so modern, and even fewer were female.[8] Her exploitation of full sunlight and the whiteness of the Japanese paper support increased the luminosity of the transparent colors. She favored hot-orange amorphous shapes intensified by simultaneous contrast to such Prussian-blue interlaced forms as the oversized tree in the foreground of her ambiguous spatial structure. She was frugal and quick in her selection of elements of the landscape she wanted to share with viewers.

The Bather, The Garden, and *Autumn in the Country* were in "William and Marguerite Zorach," an exhibition in their Greenwich Village studio in November 1914. From 1915 to 1918, the Daniel Gallery represented them, first in their second two-artist exhibition in November and December 1915 in which she exhibited *Autumn.* Of the seventeen artists in "The Forum Exhibition of Modern American Painters" in New York in 1916, Zorach was the only woman and the only artist who was not given space for her credo. Ironically, because of its similarity to statements in her 1912 interview and her poem, "The Moon Rose," I am convinced she wrote the essay signed by William Zorach in the Forum Exhibition catalog: "It is the inner spirit of things that I seek to express, the essential relation of forms and colors to universal things. Each form and color has a spiritual significance to me, and I try to combine those forms and colors within my space to express that inner feeling which something in nature or life has given me."[9]

For the rest of her life Marguerite Zorach created abstracted images reliant upon natural inspiration, international folk forms, a sense of universal spirituality, and Expressionist color.

ROBERTA K. TARBELL

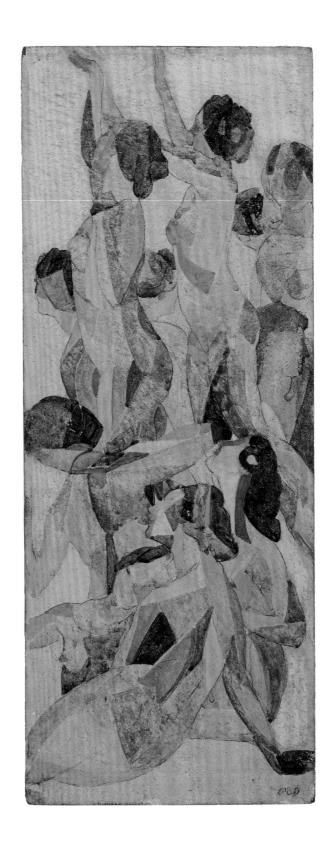

Arthur B. Davies (1862-1928)
Figures, ca. 1914-16
Water-based media on gessoed panel[1]
20-1/16 x 8 in.

In January 1958 the writer, painter, and champion of modernism, Walter Pach (1883-1958), sent a letter to Munson-Williams-Proctor Institute Museum of Art director Richard B. K. McLanathan, in response to a request for biographical information about the Utica-born artist Arthur B. Davies. In this letter Pach discussed when he and Davies worked together organizing the 1913 International Exhibition of Modern Art, known as the Armory Show (for the Sixty-ninth Infantry Regiment Armory in New York City, where the exhibition was first shown).[2] He praised Davies' intelligence, his keen intuition, and the breadth of his knowledge of modern art. "Modern art in America owes more to him," Pach concluded, "than anyone else."[3]

The paradox of Davies' career is that the converse of Pach's statement is not true. Although he was radical in philosophy, outlook, and lifestyle, Davies' conservative artistic vision was governed by a lyrical, subjective point of view that found expression in poetic landscapes and idealized figure compositions embellished with symbolist or classicist titles. Only being one of the principal organizers of the Armory Show could prompt Davies to experiment, for a few years thereafter, with several avant-garde styles, most notably Cubism.

One of the works Davies made during his Cubist phase is the MWP Arts Institute picture now titled *Figures.*[4] It is not dated but traditionally has been assigned to 1916, when Davies' interest in Cubism began to wane.[5] By this time several events that informed the picture had taken place in his life. In addition to working on the Armory Show, Davies began making figure compositions—which he called "continuous composition"—in which several closely related poses of a model were repeated several times in a design.[6] He also organized an exhibition of Cubism which traveled to several cities in the United States. A young woman named Wreath McIntyre started posing for him, and he executed an ensemble of monumental, Cubist-style wall decorations in the Manhattan music room of his close friend and patron, Lillie P. Bliss (MWP Arts Institute).[7]

For *Figures,* Davies sketched in graphite the outlines of ten female nudes within the confines of a narrow, vertical composition.[8] The head of an eleventh figure, that of a young man facing right, appears halfway down the right edge of the design. The compression of these figures in a shallow space close to the picture plane recalls the pictorial conventions of sixteenth-century Italian Mannerist painting. Like the figures that populate the Bliss murals, some of the nudes in *Figures* appear on different ground planes.[9] Conversely, while the figures in the Bliss murals inhabit a space interwoven with decorative patterns, suggestions of landscape and even a still life, the relationship between the figures and background in *Figures* is not as clearly defined.

Whatever meaning — if any — Davies intended this work to have may possibly be linked to his decision to depict the male head looking, Janus-like, in the direction opposite that of the female nudes. They, in turn, direct their attention, and in some cases raise their arms, in a gesture of hope or aspiration towards some object or incident outside the upper left edge of the design. In this respect the MWP Arts Institute work differs from the Armory Show's most famous painting, Marcel Duchamp's *Nude Descending a Staircase, No. 2,* 1912 (Philadelphia Museum of Art). Whereas Duchamp's painting depicts the sequential movement of *one descending* nude, Davies' picture shows the movement of *several ascendant* nudes arranged as a "continuous composition." He also used a more lively palette than Duchamp, and, instead of painting an illusionistic background like the one in *Nude Descending a Staircase,* Davies rendered his figures against a randomly highlighted, putty-colored ground that has a coarse texture like a wall surface.

In discussions of the Cubist phase of Davies' career scholars have frequently noted that he never painted orthodox Cubist *facture*. Despite his knowledge of the styles of many of the European Cubists, he produced works that can be described as "cubizing" rather than Cubism. In *Figures,* his personal interpretation of the conventions of European Cubism enabled Davies to preserve the anatomical integrity of each nude's profile — he was a classicist at heart. Similarly, the prismatic spectrum of warm and cool hues that optically advance and recede on the surface of this "continuous composition" of Wreath McIntrye bear no relationship to the topography of the nudes. These segments and polygons of Fauve-like color create a decorative effect that is provocatively similar to the "simultaneous" clothing designs Sonia Delaunay-Terk (1885-1979) made in France around 1914.[10]

PAUL D. SCHWEIZER

INSCRIPTION

recto, lower right (graphite): ABD [superimposed over a second inscription in pale yellow pigment: A.B. Davies]; verso: graphite inscription obscured by paper label

PROVENANCE

Museum of Art, Munson-Williams-Proctor Institute, Purchase, 57.66

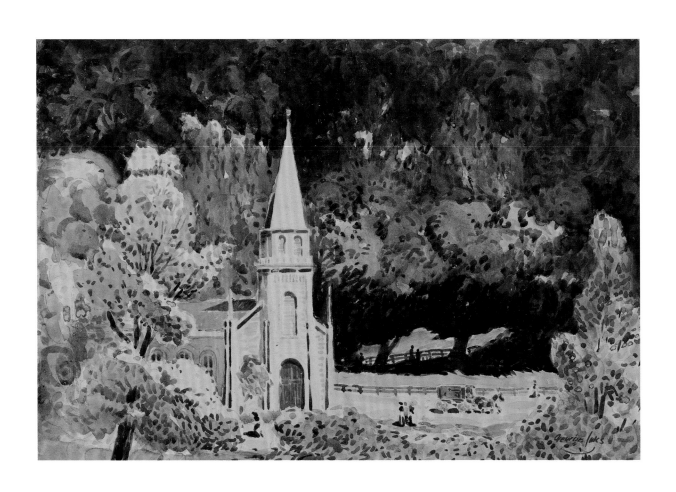

George Luks (1867-1933)

Dyckman Street Church, ca. 1915

Transparent watercolor over graphite on wove watercolor paper

15 1/8 x 22 5/16 in.

Edward Wales Root, scion of a patrician family, and George Luks, self-proclaimed "art's bad boy," enjoyed an unlikely friendship for three decades. They met in 1909, when Luks painted a portrait of Root's father, Elihu Root, secretary of state and senator. At virtually the same time, Root had begun to frequent New York City galleries as a fledgling collector of new American painting. Eager to develop his own drawing and painting skills, Root studied with Luks. The two men roamed all around New York sketching. "Yesterday with Luks on Spyten Dyvil [sic] creek," Root wrote in his diary in January 1910. "We made our way slowly up the side of this wooded promontory."[1] Under Luks' influence, Root's diaries, which he kept from his youth, became filled with Luks-esque drawings, and in at least one instance Luks drew directly in one of Root's books.[2]

In the summer of 1912 Luks moved from Fifty-sixth Street to an upper Manhattan house with a studio; it was located at the corner of Jumel Place and Edgecomb Road, adjacent to Highbridge Park and near 170th Street.[3] In this comparatively bucolic milieu, Luks discovered a new suburban subject matter, and his palette lightened accordingly. One can see correspondences between the work he produced in this period to that of Maurice Prendergast, whom Luks had known since the "Eight" exhibition at the MacBeth Galleries in 1908.[4] Dyckman Street Church, for

example, depicts a brilliant summer's day on which a few people are strolling and a horse-drawn wagon proceeds down the street.[5] The figures are dwarfed, and the sun-washed eponymous church is engulfed by rich foliage. Luks framed these central elements of his composition with great washes of light-green paint that provide the basis for the abundant, cultivated verdancy. In the foreground he added leafy texture by punctuating the light-green ground with dabs of darker green; in the background he applied darker blue pigment to increase the impression of volume and receding space.

Edward Root's inventory book dates Dyckman Street Church to about 1915 and notes that the painting was a wedding gift from the artist to Root and his wife, Grace.[6] Root unsentimentally tried to sell this watercolor later (and during Luks lifetime). In an undated letter to the Rehn Galleries, Luks' New York dealer, Root wrote that he had shipped Dyckman Street Church with another unnamed Luks watercolor to Rehn. His plan seems to have been to "trade up:" "I think you will like them. ... If you can undertake to sell the two of them ... it would just about reimburse me for the watercolor I am buying."[7] The painting presumably did not sell, for after Edward's 1957 bequest to the Munson-Williams-Proctor Institute, Dyckman Street Church was among twenty-six works of art that the Institute bought from Grace Root in 1958.[8]

INSCRIPTIONS

recto, lower right (red paint): George Luks

PROVENANCE

Gift of the artist to Edward W. and Grace C. Root, Clinton, N.Y.; to Grace Root; to the Museum of Art, Munson-Williams-Proctor Institute, Purchase, 58.293

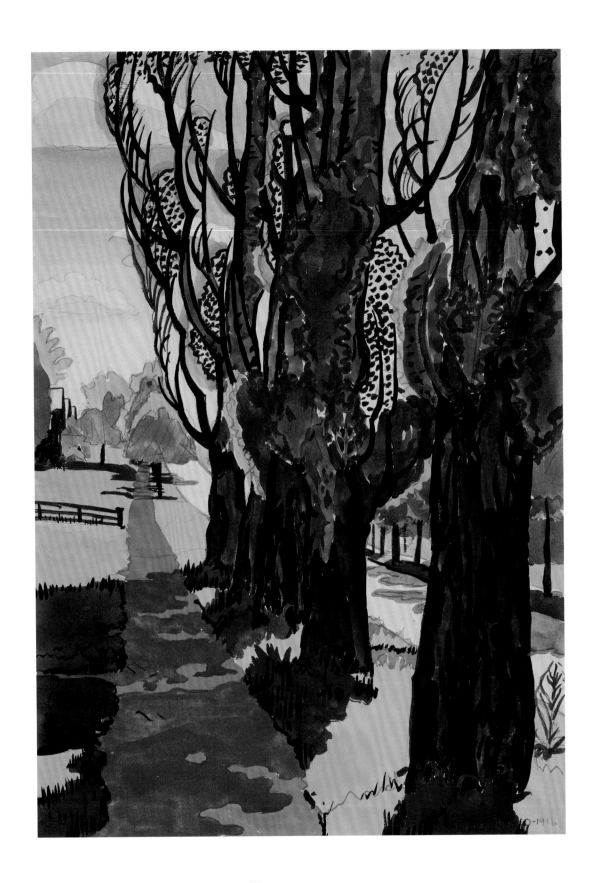

Charles Burchfield (1893-1967)

Poplar Walk, 1916

Transparent and opaque watercolor over graphite on medium-weight wove paper

19 15/16 x 13 15/16 in.

Munson-Williams-Proctor Arts Institute benefactor Edward W. Root was an early enthusiast of Charles Burchfield's work. The two men met in the artist's studio on the weekend of February 2 and 3, 1929. Edward's wife, Grace Cogswell Root, in a January 11, 1929, note to the couple's Buffalo-based friend Harry Yates, wrote to confirm the arrangements for the trip from their home in Clinton, N.Y. "I find Edward is anxious to go to see a painter, Birchfield [*sic*] by name, in Gardenerville [*sic*],"[1] she wrote, and added that her husband hoped to discuss "complimentary [*sic*] colors and perspectives" with the artist.[2]

This auspicious meeting launched a decades-long friendship between artist and patron.[3] Burchfield, with little in the studio to show the couple, opened old portfolios of youthful, 1910s watercolors that elicited a keen response from Root. He immediately arranged another meeting the following week in Clinton with the artist and dealer Frank Rehn, who represented Burchfield for the remainder of his career. These early Burchfield watercolors, among which *Poplar Walk* can be counted, would soon become widely known in the contemporary art world.[4] Burchfield modestly told the Roots after their initial studio visit that he enjoyed sharing his work with "an understanding and appreciative audience. I am still surprised that you re-acted to them as you did, as I thought they would not mean much to anyone but myself."[5]

In spring 1916, the year the artist painted *Poplar Walk,* Burchfield was completing a four-year program at the Cleveland School of Art. Although during the first half of the year he was despondent, he subsequently referred to 1916 and 1917 as the most productive period in his career.[6] The summer months of the 1916 found him at home in Salem, Ohio, where the familiar environment gave him a renewed enthusiasm for life and art. He instructed himself in painting and composition and recorded both practical information and exhortations to himself to capture the spirit, not the detail, of nature.[7] An August 12 entry, for example, used the shorthand code for color notes Burchfield employed in his watercolors at the time, including *Poplar Walk.*[8] In *Poplar Walk* and other very early works, Burchfield sketched the lines of his composition in graphite and annotated it with color initials such as YG, RV, or OY.[9] At this stage of his career, Burchfield painted with both transparent and opaque watercolor over his graphite drawing and, in keeping with traditional watercolor technique, left expanses of unpainted paper for highlights (though in *Poplar Walk* he did use opaque white in the upper left).

Burchfield incorporated the poplar tree into numerous compositions in 1916-17.[10] The striking silhouette and decorative foliage of the tree lent itself to the artist's Asian-inspired style at the time. *Poplar Walk* also exhibits expressive color, used for emotional effect that characterized the artist's exquisite sensitivity to the natural world. The brilliant swathe of the orange-red sidewalk and the vibrant yellow of burned summer grass shimmer with the heat of the season at its peak.

INSCRIPTIONS

recto, lower right (graphite): -C.E. BURCHFIELD-1916; verso, lower left (graphite, upside-down): June 27, 1916

PROVENANCE

Frank K. M. Rehn Galleries, New York; to Edward W. Root, Clinton, N.Y. [W-10], February 27, 1929; to the Museum of Art, Munson-Williams-Proctor Institute, Edward W. Root Bequest, 57.103

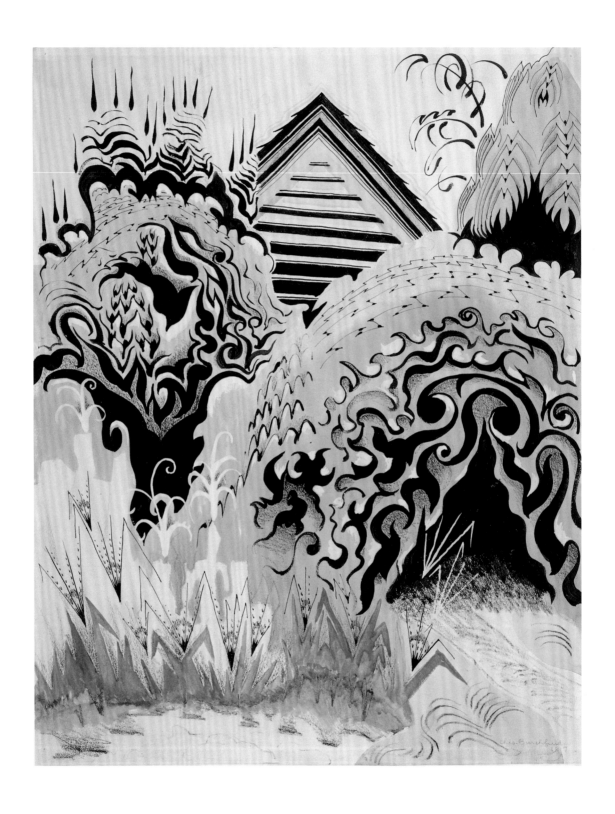

Charles Burchfield (1893-1967)

The Insect Chorus, 1917

Opaque and transparent watercolor with ink and crayon on wove paper

20 x 15 7/8 in.

During Charles Burchfield's prolific "golden year" of 1917 he painted expressive compositions, including *The Insect Chorus,* in which he sought to capture sensations about natural phenomena and nostalgic feelings from childhood about such phenomena. After this body of youthful work became widely known years later, Burchfield wrote to collectors Edward and Grace Root, "In 1917 I made a collection of such 'memories' (childhood moods I called them) filling a note-book with them. They formed the starting point of many of the sketches of that period. ... It is refreshing to me to find another man remembering and cherishing such childish impressions, and considering them valuable. Most adults spurn the things of their childhood and consider the yearning for such things in a grown man as a weakness."[1] Several years after he wrote these comments, Burchfield's dealer, Frank Rehn, organized a show of the artist's paintings from 1917-18. The checklist included a statement by Burchfield about his ambitions as a young artist. His goals included "pure decoration" and "pure painting" as well as the more metaphysical aims of recreating and recording "certain moods and impressions of my childhood, which occupied my mind chiefly thru 1917 and early 1918. In addition I made experiments in what was then a 'forbidden' field; the joining of sight and hearing."[2]

In August and September 1917 Burchfield painted several compositions that are, like *The Insect Chorus,* visualizations of his late-summer wanderings through Salem, Ohio.[3] *The Insect Chorus* is a mysterious backyard world in which the overgrown shrubbery overwhelms the architecture. The bushes open somewhat menacingly with a looming dark entrance that could at once delight and frighten a small boy. In this painting Burchfield incorporated several abstract motifs to convey nostalgic moods of childhood.[4] Here he developed variations on an angled line that simultaneously stand for hopping bugs, tree leaves, and tall grasses; it is difficult in some areas of the composition, in fact, to discern flora from fauna. Similarly, Burchfield used another system of lines to describe both the pitched roof in the center background as well as the lush plant forms (although with the latter the lines become freely arabesque). In *The Insect Chorus* the forms are all of one piece in a total compositional and emotional structure, just as his journal notations weave together a complete multi-sensory experience: "noon — z–ing of katydids, high shrill pin-point cricket chorus; darting of yellow & white butterflies — dark blue grey north sky, whitish sepulchral sunlight over things, dry leaves rattle in wind, a cicada; dying sun-flowers; afternoon sunlight turns whiter, color like moonlight, the katydids subside, leaving the pinpoint cricket song; searing grass; sad sunlight on windows —."[5] *The Insect Chorus* conjures an elegiac late summer afternoon during which harmonious insects create an aural and visual vibration of vitality that resonates with the shimmering heat — the "joining of sight and hearing," as the artist described it — but that also signals the imminent autumn.

In painting *The Insect Chorus* Burchfield combined several media. He drew extensive portions of the composition in crayon and ink and blocked out the principal components of the image with graphite. He washed over the graphite with passages of gray, light green, and yellow transparent watercolor (which have faded from extensive exposure in the past seventy years). Burchfield then painted with opaque black to define major forms and highlighted these with opaque white paint and black crayon. He also used a fine line of ink to render jumping grasshoppers and finally drew abstract forms with red crayon in the lower left to add a bit of complementary spice to that section. This painting is a remarkable leap forward in its use of materials from *Poplar Walk* (cat. no. 7) of a year earlier and demonstrates Burchfield's free and unconventional techniques which defied expectations for watercolor.

INSCRIPTIONS

recto, lower right (graphite): Chas- Burchfield/1917; verso, upper left (graphite): 1 [encircled]; upper center (graphite): M.M. Photo; upper right (graphite): Root; center (red pencil, in artist's hand): The Insect Chorus/Sept 5, 1917; lower right-center (graphite, in artist's hand): "The Insect Chorus"/It is late ^Sunday afternoon in August,/the child stands alone in the garden/listening to the metallic sounds of/insects; they are all his world,/so to his mind all things become/saturated with their presence–crickets/lurk in depth of the grass, the shadows/of the trees conceal fantastic creatures,/and the boy looks with fear at the/black interior of the arbor, not knowing/what terrible thing might be there.; lower left (graphite): B-274; lower right (graphite): Black

PROVENANCE

Frank K. M. Rehn Galleries, New York; to Edward W. Root, Clinton, N.Y. [W-13], February 6, 1930; to the Museum of Art, Munson-Williams-Proctor Institute, Edward W. Root Bequest, 57.99

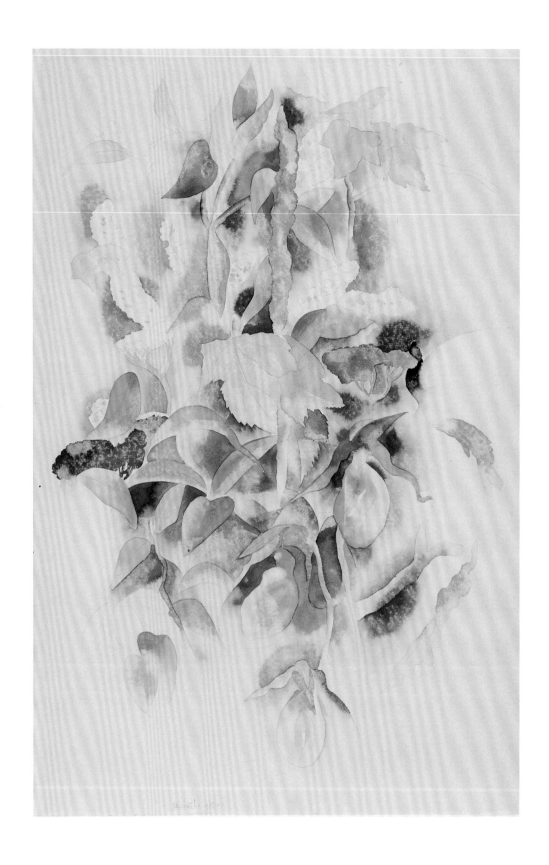

Charles Demuth (1883-1935)
Lady Slippers, 1918
Transparent watercolor over graphite on wove paper
18 x 11 7/8 in.

Charles Demuth painted floral still life watercolors in different stages of his career, between figurative illustration projects, poster portraits, and precisionist homages to industrial Lancaster, Pennsylvania, his hometown.[1] Gardening and flowers were dear to the artist's family. In his early sketchbooks Demuth made numerous flower studies in which he usually isolated a branch for study.[2] As an adult, he wrote to his mother from Paris: "I'm glad the flowers did so well. They are all doing very well still here. The gardens look fine and gay — although it never seems to rain."[3] The family gardens or floral arrangements were also important as readily accessible subject matter for Demuth who was often ill and whose movements were sometimes circumscribed.[4] The Demuth family home, however, has been described as "effectively set apart from the world, creating 'a secure retreat.' … Most of the windows in the house opened onto a walled garden, as in a cloister."[5] This enclosed atmosphere has come to symbolize the exquisite hothouse quality of Demuth's flowers, which are typically characterized as *fleurs du mal.* They are also interpreted as images of coded sexuality for the homosexual artist; Demuth's lifelong friend, poet William Carlos Williams, once stated: "In my paintings of Orchids which Charlie did — the one called *Pink Lady Slippers* (1918) — he was interested in the similarity between the forms of the flowers and the phallic symbol, the male genitalia."[6] The lady slipper — ironically, given Williams' observation — is an orchid of the *cyripedium* (cypri = Venus; pedium = foot or slipper) variety whose name derives from medieval gardens in which plants had religious meaning; "lady" has been shortened from "Our Lady," or Mary, the mother of Jesus in the Christian tradition. Various types of lady slippers grow across the Northeast and Midwest of North America in boggy environs, although Demuth's source for the MWP Arts Institute watercolor is probably the pink lady slipper, the *cypripedium acaule,* which grows in Pennsylvania from May through July in variable habitats, but primarily in pine woods or near streams.

While there are similarities within Demuth's floral still life paintings, he introduced a great deal of compositional inventiveness within the genre.[7] In some instances it is quite clear that the artist was painting cut flowers in a vase. But for this *Lady Slippers,* Demuth used a vignette format that has decontextualized the plant so that it appears to be living organism, as in Asian still life painting, rather than an element in a *nature morte.* At the center of the composition Demuth placed a woody stem around which leaves of different species cascade. They are painted in a range of pigments from light yellow-green to deep gray-inflected olive. Demuth complemented these tonalities with the muted plum of the blossoms. Opposite the deepest red flower, at the lower center of the image, Demuth also added one small touch of golden yellow. On the periphery and at the heart of the still life Demuth painted spots of dark gray, brown, and black to frame and give depth to the composition that continually shifts, as if sun-dappled, in a Cézannesque play of negative and positive space.[8]

INSCRIPTIONS

recto, lower center (graphite): -Demuth-1918-

PROVENANCE

Mrs. Meredith Hare; to Maynard Walker;[9] to the Museum of Art, Munson-Williams-Proctor Institute, Purchase, 50.10

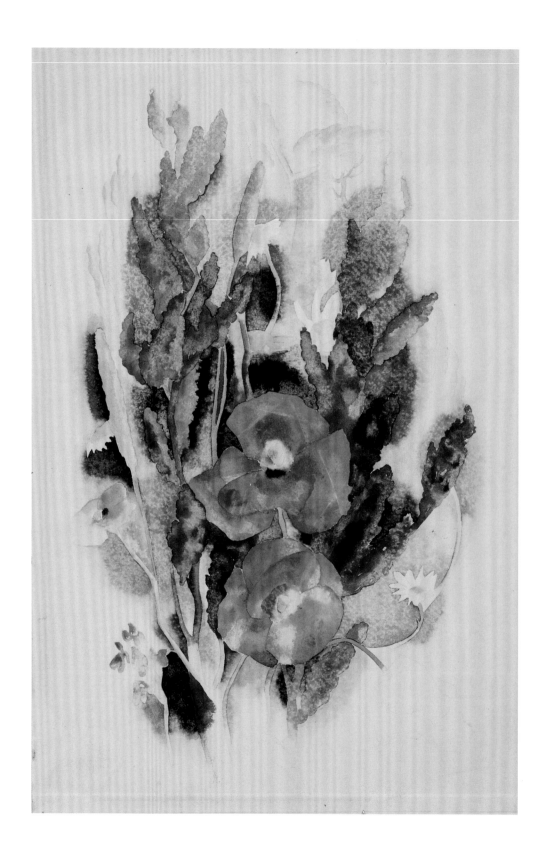

Charles Demuth (1883-1935)

Poppies, 1918

Transparent watercolor over graphite on moderately heavy watercolor paper

17 7/8 x 11 7/8

Poppies demonstrates the supreme control of Charles Demuth's watercolor painting method. The image has a vertical orientation and vignette format, with forms and pigment concentrated at the center. The graphite underdrawing gives compositional armature onto which the artist painted with a wet brush on wet paper. He allowed only limited bleeding, however, and used blotting extensively to layer numerous washes of brown, orange, and poppy-red pigment; for the two central flowers, Demuth's technique was especially successful in achieving intense, variegated color and the illusion of sensuous petals. The poppies are framed by stems of other flowers, including small daisies that are left largely unpainted save for their soft yellow centers. Demuth used velvety blacks extensively as a background to set the bouquet in relief.

In a letter dated February 17, 1938, Edith Halpert of the Downtown Gallery congratulated Edward Root on the purchase of *Poppies,* which had been owned by Mrs. Oliver Chaffee. Oliver Newberry Chaffee was an artist of indepen-

dent means who, with his second wife, artist Ada Gilmore, divided his time between Ormond Beach, Florida and Provincetown, Massachusetts. "Frankly, I am very much pleased that this really outstanding Demuth has found an ideal home," wrote Halpert, who served as intermediary for the sale. "Paintings of such subtlety are frequently overlooked by the less sensitive gallery visitor. According to Mrs. Chaffee, Demuth considered this his favorite watercolor and repeated this statement whenever he visited the Chaffees."[1] Root had purchased another Demuth watercolor in 1923 at the behest of the artist's then-dealer, Charles Daniel. On May 8, 1923, Daniel wrote to Root stating that Demuth was seriously ill with diabetes and that the new serum (insulin) treatment was "quite expensive." Daniel encouraged Root to buy one of Demuth's paintings to help the artist pay for his medical treatment. By May 14 Daniel acknowledged Root's check towards *Cyclamen* (MWP Arts Institute), and on June 16 Daniel wrote again to report that Demuth's condition was greatly improved.[2]

INSCRIPTIONS

recto, lower left center (graphite): C Demuth 1918

PROVENANCE

Mrs. Oliver [Ada Gilmore] Chaffee,[3] Ormond Beach, Fla, through the Downtown Gallery, New York; to Edward W. Root, Clinton, N.Y. [W-31], February 1938; to the Museum of Art, Munson-Williams-Proctor Institute, Edward W. Root Bequest, 57.130

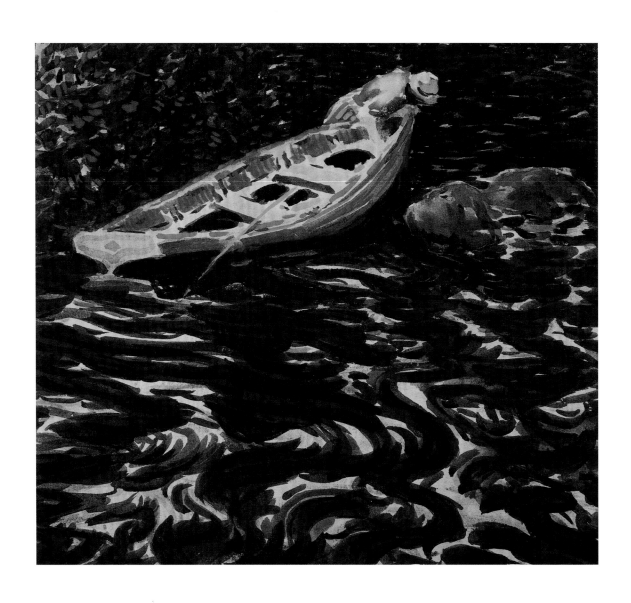

George Luks (1867-1933)
The Screecher, Lake Rossignol, Nova Scotia, 1919[1]
Transparent and opaque watercolor on wove paper
8 3/8 x 9 1/8 in. (irregular)

George Luks spent the summer of 1919 fishing and painting at a remote campsite on Lake Rossignol, the largest interior body of water in Nova Scotia. In an undated letter from Caledonia, Queens County, Nova Scotia, Luks recounted the arduous trek that included boating and a wagon ride "over a road that [makes] the rocky road to Dublin look like glass."[2] Luks was richly rewarded nevertheless. In the same letter he wrote, "There is a nor'wester blowing and I wish you could see me painting the lake — purple with huge white caps breaking on the shore. Perfectly gorgeous." From this inspiring and rugged terrain Luks produced a body of vibrant paintings and watercolors, including *The Screecher, Lake Rossingol, Nova Scotia.* He initially exhibited this material at the C.W. Kraushaar Gallery, New York, in January 1920. "Luks, in his Nova Scotia canvases, makes us pause and listen," one reviewer noted. "The colour scheme is original, almost bizarre; and the staccato style, although the bold, free stroke succeeds in evolving some new rhythm, emphasizes the fact that Luks paints … straight from the shoulder."[3]

The Screecher depicts a canoeist negotiating through dangerous rocks. In Luks' bold composition the boat cuts across the top of the image while the figure is diminished in his efforts against nature. The painting is dominated by Luks' interpretation of the eddying water. His swirling brushstrokes are built up from layers of light blue and red to darker green and blue paint, through which reflective glints from the white of the paper shine. The vibrant brushstrokes of *The Screecher, Lake Rossingol, Nova Scotia* demonstrate that Luks' watercolor technique matched the same bravura and immediacy of his oil painting method. One would not expect that he would tolerate traditional watercolor's painstaking and unforgiving methods, yet Luks created works of both great delicacy and force for two decades. He painted watercolors from the early 1910s and continued to do so for the remainder of his life.[4] The portability of the medium was of practical consideration, for he often used it while traveling, not only to remote Canada but also to Pennsylvania coal towns in the 1920s and to a summer retreat in Old Chatham, New York.[5] Luks had a real facility for the medium and his ability was recognized in his lifetime. In a 1925 review the *New York Times* noted: "As usual the water colors are freer and more delicate and more powerful than the oil colors. The lighter medium invites franker color and a livelier touch."[6] In spite of this early praise, though, this aspect of Luks oeuvre became obscured, to the point that a 1987 reviewer could comment, "The most perplexing thing about Luks is his reputation, or lack of it, as a watercolorist."[7] Since that time, however, recent scholarship has begun to revive appreciation for Luks' sparkling and versatile achievements in the medium.[8]

INSCRIPTIONS

recto, lower left (red paint): George Luks

PROVENANCE

Gift of the artist to Edward W. Root, Clinton, N.Y.; to Grace Root; to the Museum of Art, Munson-Williams-Proctor Institute, Purchase, 58.159

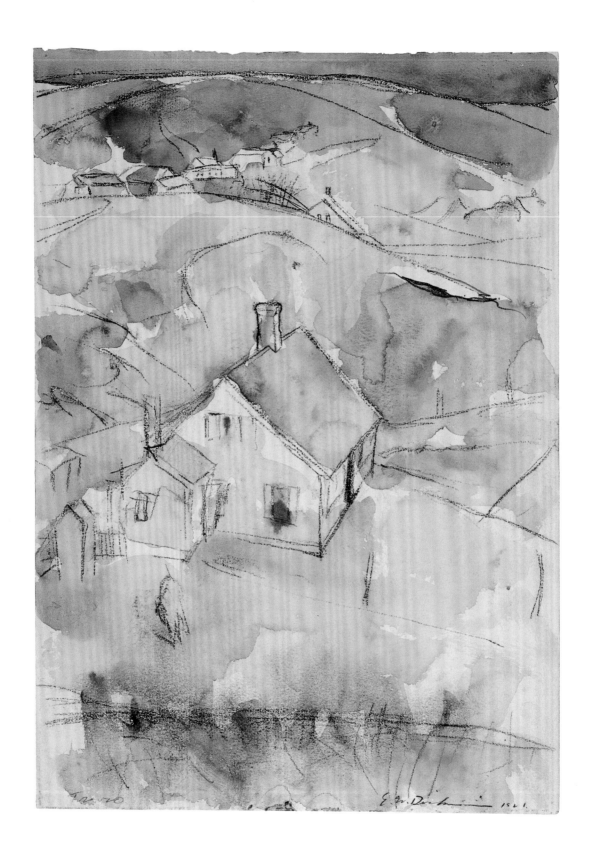

Edwin Dickinson (1891-1978)
Pamet River Valley, Truro, 1921
Transparent watercolor and graphite on wove paper
13 5/8 x 9 3/4 in.

An avowed oil painter, Edwin Dickinson created very few watercolors in his career. The artist's daughter, Helen Dickinson Baldwin, notes "it seems to be a medium he 'tried out,' as he did etching, pastel and monotype." She can account for twenty-three watercolor titles in Dickinson's oeuvre, with thirteen known works extant.[1]

Dickinson moved to Cape Cod in fall 1913 after spending the previous four summers in Provincetown studying with his mentor, Charles W. Hawthorne. He found life on the cape salubrious and beneficial to his work.[2] Elaine de Kooning, in a 1951 profile of Dickinson, observed connections between the artist's work and his environment: "The cold-green gorse and scrub pine, lavender flowers and bleached stretches of sand and sky peculiar to the cape seaside supply a key to his palette, and the highly variable atmosphere that simultaneously sharpens some contours and blurs others could have affected his concept of drawing."[3] Artists' recollections of Provincetown and the cape during the 1920s and 1930s create a picture of a simple life in a fishing village where walking was a regular means of transportation. "Dick was a great walker. He used to walk even to Wellfleet and back, on the back shore, in summer or winter. … It was particularly beautiful and offered an opportunity to get very close to nature."[4]

While he was known for working several years on a few large canvases, Dickinson believed in the *premier coup,* or first strike, approach to landscape painting.[5]

Pamet River Valley, Truro is a spontaneous portrayal of a hilly panorama with houses punctuating the rolling countryside and a figure standing in the foreground. Dickinson rendered the image with heavy, quickly applied graphite and then painted in watercolor over the hills, the foreground buildings, and the background. The tonality is created with a golden under-painting over which Dickinson layered red and blue. In some passages these pigments stand alone so that the general effect is one of an autumnal red-violet.[6] The bird's-eye view of the landscape was consistent with Dickinson's lifelong preoccupation with perspective. "You can get tired of always seeing things from the same height," he once noted. "It's diverting to look at nature physically from viewpoints that are not the usual ones." By altering his point of view Dickinson ensured that he would truly paint from observation instead of from a "memory of a previous experience" or "expectation," which he considered "meaningless."[7]

Artist Jacob Getlar Smith received *Pamet River Valley, Truro* by purchase or as a wedding gift from Dickinson about 1922. Smith described his friendship with Dickinson in a warm portrait of the artist and Provincetown life in the early 1920s for *American Artist* Magazine.[8] When the artists first became acquainted, Smith was not predisposed to watercolors, but in Dickinson's work he found a fresh and original style that inspired his own efforts.

INSCRIPTIONS

recto, lower left (graphite): Truro; lower right (graphite): Edw. Dickinson 1921; verso, upper center (graphite): North Truro

PROVENANCE

From the artist to Adele and Jacob Getlar Smith, Provincetown, Mass.; by descent to Jean and David Loeffler Smith, New Bedford, Mass.; to the Museum of Art, Munson-Williams-Proctor Institute, Gift of Jean and David Loeffler Smith in memory of Adele and Jacob Getlar Smith, 98.15.27

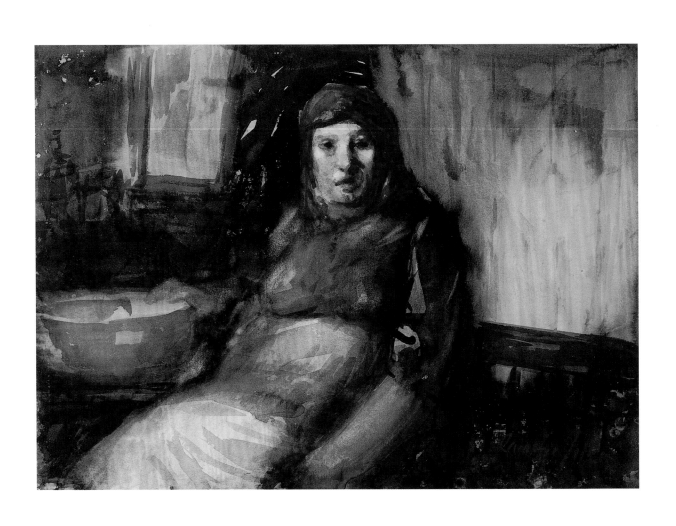

George Luks (1867-1933)
A Daughter of the Mines, 1923
Transparent watercolor on medium-thick, moderately textured wove paper
14 1/8 x 20 1/16 in.

Pennsylvania native George Luks spent his summers during the 1920s in the mining communities near his boyhood home, where he painted both the landscape and the towns' denizens. The Munson-Williams-Proctor Arts Institute owns two strong watercolors from this period, *A Daughter of the Mines* and *Miners' Shacks, Pottsville* (cat. no. 18). Luks painted the former in the summer of 1923.[1] As a portraitist and student of human character, Luks brought to this sitter decades of experience. He depicted a large woman who stares frankly, and perhaps dully, at the viewer. Luks rendered the figure with a monumentality of form and an air of tired resignation.

From his earlier illustration and artist-reporter careers, Luks developed a shorthand character study style that, at its best, uncannily captured the essence of a personality with startling economy. At its worst, though, it smacked of caricature and ethnic stereotype. Luks stated, "I'm not a reformer. I'm just a man who studies nature as I find it."[2] Critics consistently have concurred and have praised him for his unsentimental and unpatronizing view of the poor.[3] His mining imagery was well regarded when it was first exhibited, but critics specifically preferred the portraits to landscapes: "Handsome [the landscapes] are," the *New York Times* noted in 1923, "but far less splendid than the dim living shapes and volumes of the figure subjects."[4] Two years later the same newspaper said of Luks' work, "His paintings of human types are finer, however, than the portraits of the city and the individuals are finer than the groups."[5] Recent scholarship presents Luks in a comparable light. "For Luks at this time, the miners and their families provided the

same inspiration the beggar women and street vendors had almost two decades earlier in the streets of New York," art historian Judith O'Toole has written. "Again he approached his subjects without pity or sentimentality and came away with powerful, down-to-earth images."[6]

Luks painted *A Daughter of the Mines* on a moderately textured watercolor paper. He sketched the barest outline of charcoal or graphite to indicate compositional forms, then added washes of light blue paint and touches of violet and lavender to model the figure and the bowl she touches. The figure's left arm, in fact, is a study of Luks' ability to layer washes; blue paint is laid over a lighter pinkish wash, while the underside of the arm glows with warmer pigments. Luks also introduced selected strokes of yellow-green vertical lines to define the woman's arm and applied highlights of this same color to the woman's face, notably to her eyes and mouth. The light strikes the woman's face from her right, casting the left side in shadow. Luks framed her face and set it in relief by painting the walls behind her in contrasting dark and light tones. He finished the scene in a typically cursory manner; in painting furniture, for example, he used dark tones of blue and violet that are painted in broad, hurried strokes. In fact, the broader strokes of layered washes that Luks painted throughout *A Daughter of the Mines* are markedly different from the watercolor painting technique of multiple broken lines that he employed for *Dyckman Street Church* (cat. no. 6), *The Screecher, Lake Rossignol, Nova Scotia* (cat. no. 11), or *Miner's Shacks* (cat. no. 18). The effect is a calming one that lends dignity to the portrait.

INSCRIPTION

recto, lower right (red paint): George Luks; verso, center (black crayon): No 4 / a daughter of the mines

PROVENANCE

Frank K. M. Rehn Galleries, New York; to Edward W. Root, Clinton, N. Y. [W-40], October 27, 1931; to the Museum of Art, Munson-Williams-Proctor Institute, Edward W. Root Bequest, 57.176

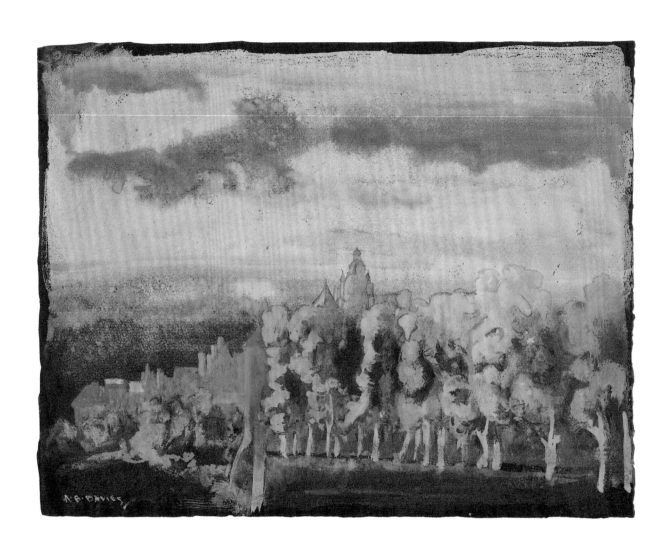

Arthur B. Davies (1862-1928)
Park at Blois (?), 1924

Gouache and graphite on dark-blue moderately textured, moderately thick laid paper
with deckle edge along left, bottom, right edges, with top edge cut
9 1/2 x 12 3/8 in.

Arthur B. Davies enjoyed considerable notoriety in 1924 when the pioneering collector Duncan Phillips published a collection of essays about him by Royal Cortissoz, Frank Jewett Mather Jr., Edward W. Root, and others. Phillips noted in his foreword that this was the first book devoted exclusively to the artist, whom he regarded "as one of the few men of original and authentic genius among the painters of our contemporary world." "Our book may seem premature," Phillips added, "since Mr. Davies is, we hope, very far from the end of his brilliant career."[1]

There is more truth in this statement about the longevity of Davies' career than Phillips probably intended. His lavishly illustrated book featured forty full-page illustrations of Davies' paintings, including one of the principal wall of Lillie P. Bliss's music room (MWP Arts Institute)—the only Cubist work by Davies that Phillips admired.[2] However, the book is less than a comprehensive survey of Davies' art because it lacks any discussion or illustrations of the landscape watercolors he started painting in Europe the summer before it was published.

Davies' heart problems, which began in the early 1920s, appear to have played a role in encouraging him to travel overseas. Moreover, the double life he was leading during these years with his mistress Edna Potter and their daughter Ronnie, with its constant threat of discovery, made the prospect of spending several months overseas an attractive alternative to life in New York City.[3] The hundreds of outdoor studies Davies painted in France, Italy, and Spain during six summers between 1923 and his death in 1928 were well received by critics and the public.[4] These works do not reinforce the general view of Davies as a modern-day visionary, nor do they reflect any of the avant-garde tendencies he experimented with ten years earlier. They are nevertheless some of his most accomplished, visually appealing works.

The MWP Arts Institute watercolor is not dated, but its title suggests that Davies painted it when he was overseas during the summer of 1924, the same months Phillips's book was published. Davies left for Europe in June and settled in Paris with Edna and Ronnie. Before returning to New York early that November he visited several of the Renaissance châteaux on the River Loire southeast of Paris. Traveling down the south side of the river, he made watercolors at Chambord, Chaumont, Chenonceaux, Loches, and Azay-le-Rideau.[5] North of the river he visited the royal château of Blois, the site traditionally identified as being depicted in the MWP Arts Institute watercolor.[6]

Davies painted the work on a piece of high-quality, dark blue paper cut down from a larger sheet. By using dark paper Davies created a set of aesthetic problems different than those he would have faced if he had used a lighter-toned sheet. It is unclear if, knowing that it would require an opaque medium, he chose the dark paper first, or if he first decided to work in gouache and then chose a paper that could not readily be used with watercolors.[7]

Working from the background forward, Davies used white pigment to block out the sky. He applied this to the top half of the sheet, using the rough texture of the paper to create an irregular surface effect. Before the white gouache dried he added passages of blue pigment which bled into the white.[8] If Davies had used a white- or cream-colored sheet, the white gouache would not have been necessary; he could simply have moistened the paper to create a similar blue effect in the sky. After this layer dried Davies traced the outline of the château's roof and the crowns of the trees, which he subsequently rendered in muted greens and grays. The work's dramatic harmonies reveal Davies' exquisite sense of color. Moreover, the paper, as the darkest tone in the composition, was used for the sake of contrast rather than in its more traditional role for highlights and middle tones.

In the winter following his return to the United States Davies exhibited about one hundred of his recently executed watercolors at Feragil Galleries in New York. They sold well, at prices ranging from $275 to $500. A newspaper review described the exhibition as "one of the most shining episodes" of Davies' career and compared the quality of the watercolors to Winslow Homer's fishing studies and John Singer Sargent's Venetian views. It was either at this exhibition or on some other occasion before her death in 1931 that Davies' close friend and patron, Lillie P. Bliss, purchased the MWP Arts Institute watercolor.[9]

PAUL D. SCHWEIZER

INSCRIPTIONS

recto, lower left (white gouache): A. B. Davies/; verso, upper center (crayon, upside down): Miss B/

PROVENANCE

Lillie P. Bliss, New York, to her brother and executor, Cornelius N. Bliss Jr., New York (through William Macbeth, Inc., New York); to the Museum of Art, Munson-Williams-Proctor Institute, Gift of Cornelius N. Bliss Jr., 41.4

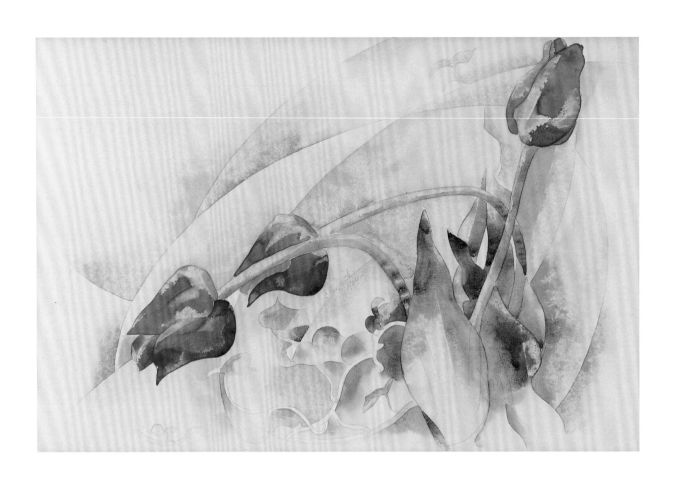

Charles Demuth (1883-1935)

Red Tulips, 1924

Transparent watercolor over graphite on medium-weight wove paper

12 1/16 x 18 1/8 in.

In *Red Tulips* Charles Demuth created an asymmetrical, horizontal study of formal tensions held in balance. He employed his characteristic painting method for his floral still lifes by rendering a graphite drawing over which he painted and blotted layers of watercolor. The brilliant red blooms nicely complement their green leaves. Within this chromatic harmony Demuth situated the organic flowers in a geometric framework. The sweeping lines of a misty gray, prismatic halo crown the blossoms and these lines are echoed in the two stems that droop leftward. A third tulip stretches away from these two, and from the center of the composition, towards the top of the page. The geometry of execution in the upper portion of the image is countered in the lower half, under the bowing stems, by small meandering lines that depict leaves. Spatially, throughout the image, painted and unpainted passages weave together so that the unpainted might represent forms while the painted can denote "space," and vice versa.

Red Tulips dates from the second period of Demuth's floral paintings and points to the more complex still life compositions he would soon produce. Between 1916 and 1922 Demuth had developed his precisionist style and had been painting industrial landscapes in oil. The artist suffered from diabetes, however, and returned to watercolor, which caused him less strain than working in oil. By 1923-24, after he began a regimen of the newly discovered insulin treatment, Demuth's watercolor paintings grew more ambitious and varied to that point that, shortly after he painted *Red Tulips,* Demuth abandoned flowers for his large-scaled and majestic fruit and vegetable still life paintings.[1]

Red Tulips was donated to the MWP Arts Institute by Mary Rhoads Lowery (1905-98), a native of the Pittsburgh area; her parents were Melus Edwards Rhoads and James D. Rhoads, an industrialist and pre-Hollywood movie producer. Mary attended Smith College but did not complete her degree because she left school for an around-the-world tour. An aspiring artist, Mary studied in Paris and Florence, where her fellow students included future museum curator Réné d'Harnoncourt, and artists Peggy Bacon and Miquel Covarrubias, among others; in time she came to feel that "they had talent and I had none," according to her son, James Lowery. Thus her life as an art collector began; her initial acquisitions were the work of these contemporaries.

The Rhoads family had a summer home in Alder Creek, New York, in the foothills of the Adirondacks just north of Utica. Here Mary Rhoads met James Lowery (1890-1954), whom she married in 1931. The couple settled at 1211 Kemble Street in Utica, where Mrs. Lowery lived until she moved to a retirement home in the 1980s. James Lowery's family owned Lowery Brothers, Inc., which in the nineteenth century had been cotton knitting mills and in the twentieth a cotton waste collector and redistributor. Lowery Brothers later became a holding company until the early 1980s, when it closed for good. James Lowery's father, also named James, and mother, Emily Gayle Marklove Lowery, lived in Utica on Genesee Street next to Fountain Elms, the residence of Rachel Williams Proctor (1850-1915) and her husband, Frederick Proctor (1856-1929). In the next house lived Rachel's sister, Maria (1852-1935), with her husband, Thomas R. Proctor (1844-1920), Frederick's half-brother. In the early years of the century the Proctors were leading civic-minded society figures who left their fortune to endow an arts institute for the benefit of central New York citizens.[2] As a patron of the arts and supporter of the Munson-Williams-Proctor Arts Institute, Mary Rhoads Lowery wanted to contribute to that legacy. For many years she donated to the museum's collection decorative arts, works on paper, paintings, and two twentieth-century watercolors, Henry Schnakenberg's *Manchester, Vt.* (cat. no. 20) and this Demuth watercolor, which she probably acquired in the 1930s.[3] She gave a third watercolor in her possession, John Marin's *Landscape,* to her children, who in turn donated it to the MWP Arts Institute.[4]

INSCRIPTIONS

recto, center (graphite): C Demuth- / 1924-

PROVENANCE

Montross Gallery, New York; to Mrs. Montgomery Sears, Boston, Mass; to Mrs. James L. Lowery, Utica, N.Y.; to the Museum of Art, Munson-Williams-Proctor Institute, Gift of Mrs. James L. Lowery in memory of Lucy Carlile Watson, 79.39

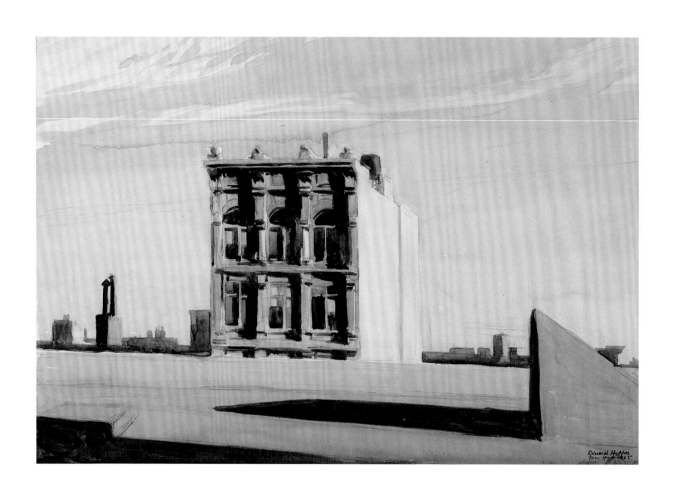

48

Edward Hopper (1882-1967)

Skyline near Washington Square, 1925

Transparent watercolor over graphite on wove paper

15 1/16 x 21 9/16 in.

Edward Hopper painted *Skyline near Washington Square* in 1925, just two years after his debut in watercolor in a group show held at the Brooklyn Museum.[1] Although he had experimented with watercolor as a boy, he had ceased using the medium for fine art during the years he had been forced to earn his living by producing commercial illustrations. Having had little financial or critical success with his work on canvas, Hopper was quite encouraged by the positive critical reception to his watercolors and by the museum's purchase of *The Mansard Roof,* 1923.[2] As a result, he continued to paint watercolors and began to show and sell his work in the demanding medium.

Skyline near Washington Square portrays an austere Manhattan rooftop behind which rises a single gaunt narrow building that dominates the sky. When first shown, this work bore the title, *Self-Portrait,* an ironical and self-referential joke in the form of a visual pun on Hopper's own great height, which had long been an object of caricature and comment by himself and his friends. The original title, which also appears in the artist's record books, must have puzzled any viewer unfamiliar with Hopper's lanky figure. For this watercolor Hopper's wife Jo noted in the record books she kept of his work as it left the studio, "*Self Portrait.* Roof & top of higher house sticking up behind. Skyline near Wash. Sq." By the time he sold the work in 1927 he had renamed it, concealing the self-reference with the purely descriptive title.

Skyline near Washington Square is the immediate precursor to two of the artist's other rooftop views in watercolor, *Roofs of Washington Square* (Carnegie Museum of Art, Pittsburgh)[3] and *Skylights* (private collection),[4] both of 1926. Hopper clearly loved the forms of New York's characteristic chimney pots and skylights, for he also made them the subject of a canvas, *City Roofs* (private collection), in 1932.[5] All of these views were visible from the roof of the building at 3 Washington Square North (in New York's Greenwich Village), in which Hopper lived from 1913 until his death in 1967.[6] (Today the building houses offices for New York University's School of Social Work.) Hopper's love of painting rooftop views reasserted itself as late as 1943, when he painted *Saltillo Rooftops* (Carnegie Museum of Art) on a visit to Mexico.[7]

Hopper's technique in watercolor involved making a quick preparatory sketch in pencil, the lines of which are still visible in the finished work. He then adjusted his composition as he applied the pigment to the surface. Rejecting the use of Chinese white, he preferred instead to leave parts of the surface bare to create the streaks of white that appear across the sky. An artist who preferred control over accident, he painted the sky with greater freedom than other parts of the composition, working on a wet surface and allowing the pigment to bleed slightly.

For Hopper, light was always the animating factor. In this example, he utilized the dramatic presence of the sunlight to highlight the building's surface and made much of the shadows cast. There are no people visible here, yet man's work has totally replaced nature. Through the emptiness, emphasized by the setting in the crowded city, Hopper powerfully communicated a feeling of solitude and stillness.

GAIL LEVIN

INSCRIPTION

recto, lower right (black ink): Edward Hopper/New York 1925

PROVENANCE

Frank K. M. Rehn Galleries, New York; to Edward W. Root, Clinton, N. Y. [W-35], April 1927; to the Museum of Art, Munson-Williams-Proctor Institute, Edward W. Root Bequest, 57.161

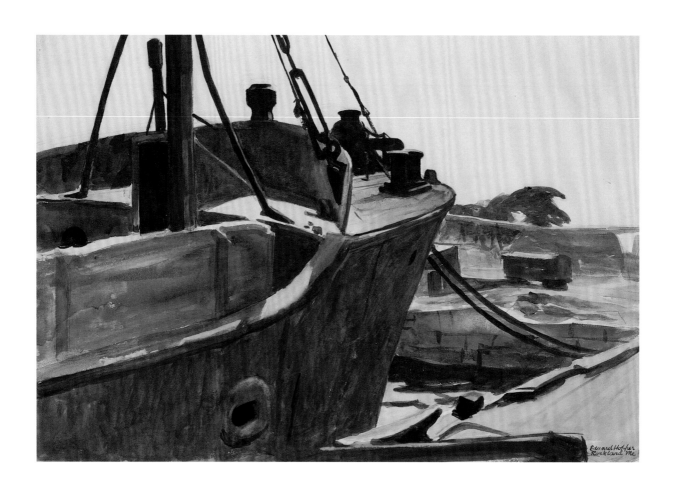

Edward Hopper (1882-1967)
Beam Trawler Teal, 1926
Transparent and opaque watercolor over graphite on wove paper
13 7/8 x 19 15/16 in.

Beam Trawler Teal is one of a series of watercolors of fishing boats that Hopper painted in Rockland, Maine, during the summer of 1926. Some years later, an interviewer who queried the artist about a related work reported that Hopper had "come upon a fleet of lumpy fishing boats equipped with gigantic nets for ground fishing. These had originally been built for the French Government during the War, but with the Armistice they were sold to a large fishing company."[1] A beam trawler is equipped with a bar that spreads the mouth of a trawl net, which it tows while searching for bottom-dwelling fish.

Hopper's other works in this series include the *Bow of the Beam Trawler* Widgeon (Montgomery Museum of Fine Arts), *Beam Trawler* Widgeon (private collection), *Beam Trawler* Osprey (private collection), *Bow of the Beam Trawler* Osprey (Saint Louis Art Museum), *Trawler and Telegraph Pole* (Art Museum, Princeton University).[2]

The vessel in Hopper's painting, like the others in the group, took its name from a bird associated with the water. The teal is a small duck; its several species include the blue-winged, the green-winged, and the cinnamon. The name widgeon also refers to a duck, while the osprey is a large, water-loving, eagle-like raptor.[3]

Observing birds and other animals interested both Hopper and his wife Jo, who in 1926 were spending their annual summer vacation in Rockland. They traveled by train from their home in New York City to Bangor and then took a boat to Rockland. Hopper described Rockland in a letter to his dealer as "a very fine old place with lots of good looking houses but not much shipping."[4] Tentative at first — "I don't know how long we will stay here," he wrote — he and Jo ended up spending seven weeks in the New England port. There Hopper painted about twenty watercolors in what was an unusually prolific period for him.[5]

While in Rockland that summer, Hopper not only painted trawlers but also views of the harbor, the shore, the shipyard, a fishing schooner, the railroad, a quarry, some of the local Victorian houses, and even the site where Union soldiers camped during the Civil War. His focus on the ships and the harbor recalls his boyhood passion for boats in Nyack, New York, the port along the Hudson River where he grew up and, for a time, dreamed of becoming a naval architect.

Trawlers first captured Hopper's attention during his first season working in watercolor — the summer of 1923 in Gloucester, Massachusetts. There these bulky ships became the subject for two watercolors: *Beam Trawler, the* Seal and *Deck of Beam Trawler.* Although Hopper's love for the structure of boats is evident in his choice of the subject for so many watercolors and his repeated use of the specific name, beam trawler, *Beam Trawler* Teal is an especially forceful work. Recording the effect of sunlight to emphasize the forms he observed, he created an audacious composition that seems nearly abstract. The monumental form of the trawler dramatizes the whole scene as he observed it. Jo noted in the record book only that her husband had painted a "Bold profile, low." As is often the case in Hopper's watercolors, the empty boat suggests solitude.

GAIL LEVIN

INSCRIPTIONS

recto, lower right (blue paint): Edward Hopper / Rockland Me

PROVENANCE

Frank K. M. Rehn, New York; Fred L. Palmer, joint gift to Hamilton College, Clinton, N.Y., and Munson-Williams-Proctor Institute; to the Museum of Art, Munson-Williams-Proctor Institute, which purchased the Hamilton College share, 61.83

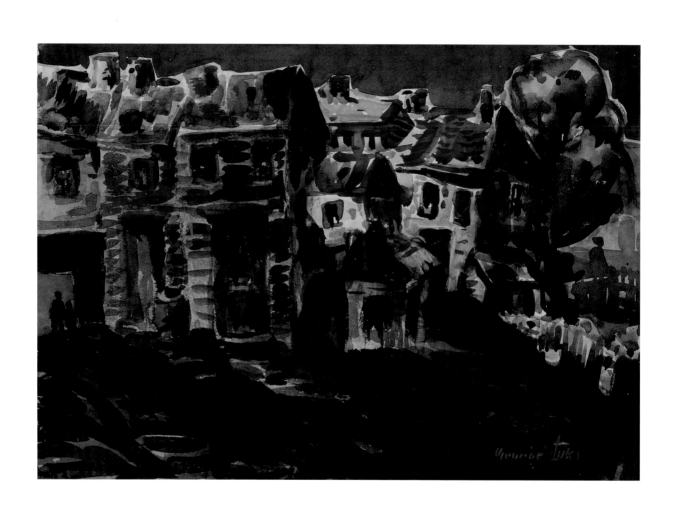

George Luks (1867-1933)
Miners' Shacks, Pottsville, 1927
Transparent and opaque watercolor on medium-weight watercolor paper
14 1/8 x 20 in.

In November 1925 the Frank K. M. Rehn Galleries presented a George Luks exhibition entitled "Recent Paintings, Water-Colors and Drawings Done in the Anthracite Coal Regions of Pennsylvania." Luks had already spent a few years painting this subject and was gratified by the reception it received. He wrote to Edward Root on November 9, 1925: "It seems as tho my summer's painting was not in vain. The show opened Saturday and evidently the high-brows have placed the stamp of approval on its entirety."[1] For Luks the subject remained compelling for several more years; he produced *Miners' Shacks, Pottsville* in 1927.

Miners' Shacks, Pottsville creates an interesting counterpoint to *A Daughter of the Mines* (cat. no. 13). Luks exchanged his formidable portrait skills for those of the landscapist and achieved similarly remarkable results. What is especially notable about *Miners' Shacks* is that Luks painted both a personal testament to the miners' living conditions as well as an abstract modernist landscape. Luks used little or no graphite underdrawing but instead sketched the composition using a thin brush of light blue paint. He built up layers of transparent washes to give form to the houses and to the tree to the right and to suggest at the far right, with a vague atmosphere of blue and pink, the illusion of an expanding distance. Luks then applied bold strokes of a dark, opaque paint to define the foreground hills and a small section of the houses at the center of the image. He generally took great liberties with form and color in this image. With the exception of the atmospheric appearance of distance at right, Luks painted the scene without clearly demarcating illusionistic space; foreground and background are virtually indistinguishable.

The red-shingled buildings at the center of the composition, for example, might be understood to be in the middle ground, but Luks painted them in a brighter key (as if the sun were shining on them), which projects the forms into the foreground. Conversely, the structures at left presumably stand in the foreground but are painted in muted tones and, therefore, recede visually.

Luks' formal handling of *Miners' Shacks,* such as placing the red roofs against a complementary green sky, betrays a preference for heightened emotional resonance over realism, a desire to enhance through expressive means the viewer's feel for the subject. With its vivacious brushstrokes and color, the painting exhibits residual qualities of Luks' earlier, Prendergast-esque images of leisure (and recall Burchfield's early "haunted houses"[2] as well as his later paintings of the same subjects, such as *End of the Day,* 1936-38, Pennsylvania Academy of the Fine Arts), but Luks mediates a lighter mood with his selected use of somber tones, which cast a grave tenor appropriate to his interpretation of the subject matter. Ultimately the general impression of *Miners' Shacks* is one of agitation attributable in large measure to Luks' jittery brushwork, which functions metaphorically for the instability of the miners' existence. The houses are cobbled together, leaning toward and away from each other, and they rest unsteadily on a hill composed of disequilibrating marks of paint. Amidst this swirling environment Luks included the image of two figures, silhouettes only, dwarfed and anonymous within the context of the precarious housing. For Luks the antidote to this anonymity is his *A Daughter of the Mines,* the individual who stands for the corpus.

INSCRIPTIONS

recto, lower right (red paint): George Luks

PROVENANCE

Frank K. M. Rehn Galleries, New York; to Edward W. Root, Clinton, N.Y. [W-39], December 20, 1927; to the Museum of Art, Munson-Williams-Proctor Institute, Edward W. Root Bequest, 57.184

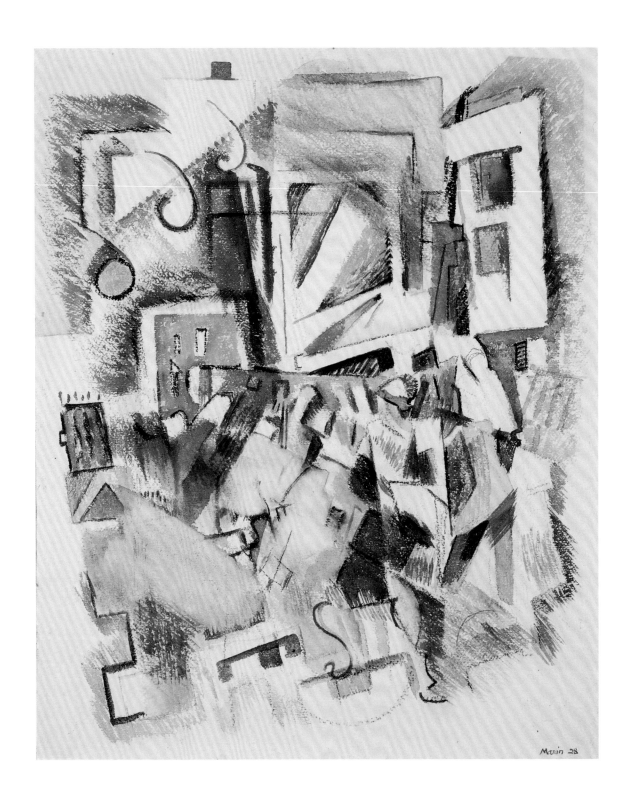

John Marin (1870-1953)

Middle Manhattan Movement (Abstraction, Lower Manhattan), 1928[1]

Transparent watercolor with graphite and charcoal on textured watercolor paper

26 1/4 x 21 1/2 in.

John Marin was the dean of American painting for at least the first half of the twentieth century, and, while he painted extensively in oils, he built his reputation as a watercolorist. His singular painting style has been celebrated as embodying the dynamic and optimistic spirit of American modernism.[2]

Energetic in execution, *Middle Manhattan Movement* gives the impression that Marin applied media very swiftly while creating this work. He composed it with charcoal, graphite, and gray paint over which he dragged a relatively dry brush of watercolor. Around the periphery Marin used a thin brush to paint parallel strokes of various colors; these function as framing elements to the image. The upper half of the composition is predominantly geometric, and Marin played large painted and unpainted portions of paper against each other to evoke looming office buildings. These are relieved by three swirling lines (street lamps?) at the upper left. The lower portion of the composition, street level, is a collision of figures and forms in motion. Here Marin covered most of the paper's surface, and two passages at lower left center are in fact heavily abraded with erasures.

Middle Manhattan Movement is a Whitmanesque celebration of New York City's vibrancy, a subject in which

John Marin exulted from his dancing Woolworth Buildings, 1912-13, to the panoramic *Lower Manhattan, 1922* (Museum of Modern Art), and *Motive, Telephone Building, New York,* 1936 (Metropolitan Museum of Art). Always grounding his imagery in direct experience, Marin painted Manhattan in various modes of realism and abstraction. The artist revealed that his inspiration for cityscapes came from "wanderings thereabouts — These seeings transposed into symbol seeings, not losing the core of my seeings — Rhythm throughout was looked for — ballance [*sic*] and construction — playing part with part — movements of juxtaposition objects — certain objects framed as it were to bear attention to themselves — each object taking its place — the whole — I repeat — to be a ballanced construction."[3] *Middle Manhattan Movement* is not a picture, then, of New York but a painting of Marin's experience of its streets. He stated emphatically, "Ordinarily one is not aware of — what does one see — one gets glimpses — and that I would say is a multiple that we critters call seeing — which has — I will say — nothing to do with Mr. Camera."[4] While it approaches the nonobjective in its formal harmonies, *Middle Manhattan Movement* nevertheless remains based on Marin's sensations, "the core of my seeings."[5]

INSCRIPTIONS

recto, lower right (black paint over graphite): Marin 28[6]

PROVENANCE

Downtown Gallery, New York; to the Museum of Art, Munson-Williams-Proctor Institute, Purchase, 54.5

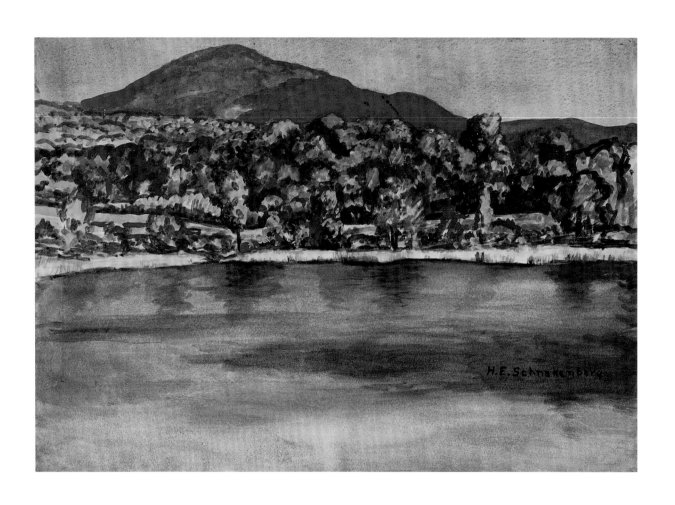

Henry E. Schnakenberg (1892-1970)

Manchester, Vt., 1930

Transparent and opaque watercolor over graphite on wove paper

14 x 20 in.

During the second quarter of the century Henry Schnakenberg enjoyed the reputation of an urbane, well-traveled player in the New York art world. He had personal wealth, which allowed him to collect art works from many cultures and periods (including that of his contemporaries), and held positions of prominence, such as president of the Art Students League in the 1930s.[1] As an artist, Schnakenberg practiced an emotionally detached realism that had a conservative bent but was nevertheless well received critically.[2] Early in Schnakenberg's career, Forbes Watson described the artist as young but not precocious and admired his continued development.[3] Margaret Breuning praised Schnakenberg's palette of "cool, clear tones [with] no violence of oppositions, no theatrical coups, no splashes of vivid colors to set up emotional thrills,"[4] while in 1931 Lloyd Goodrich noted Schnakenberg's "ascetic strain" and characterized him as a methodical painter rather than a "brilliant improviser."[5] In a review of a 1935 Kraushaar Galleries show, Henry McBride called Schnakenberg a "straight painter" whose work was free of the "isms of modern thinking" as well as from psychology, satire, and propaganda; McBride further wrote that while Schnakenberg's paintings were well crafted they were not "sensationally exciting."[6] Reviewing the same Kraushaar show, the more conservative Royal Cortissoz praised Schnakenberg for "doing the best work of his life."[7]

Landscapes, according to the critics, were invariably Schnakenberg's forte. Goodrich, for example, wrote that his "landscapes reveal a genuine unaffected love of the country,"[8] while Cortissoz consistently preferred Schnakenberg's work in this genre. In a 1933 review Cortissoz recommended that the artist exhibit them exclusively.[9] "It is in landscape that he seems most successfully himself," the critic wrote in 1940, "more at ease and in command of his subject and his instruments."[10] Only Edward Alden Jewell, who admired some aspects of

Schnakenberg's work, found that his larger watercolor landscapes were "striving, opaquely and heavy-handedly, for effects that can best be achieved in the oil medium."[11]

Schnakenberg traveled extensively his entire life and used watercolors to capture the sense of place he experienced in each locale. "For me the materials of the painter's craft are the ideal companions on a trip to places near or far," he wrote about 1950. "Seeing something wonderful … is exciting; photographs can be adequate for the recalling of memories; but the most satisfying is, by means of creative recording in paint or pencil or pen, to make a place or person a lasting part of oneself."[12] The source for such inspiration could be familiar or novel. In the case of *Manchester, Vt.,* the subject was the environs of Schnakenberg's second home. As an adult he had his primary residence in New York City (until the late 1940s, when he moved to Newtown, Connecticut), but from the early 1920s he spent summers in Vermont. *Manchester, Vt.* captures the beauty of New England's brilliant late summer-early autumn color. Schnakenberg depicted a wooded lake encircled by a swathe of sandy beach and tall grasses.[13] He painted the forest's foliage as a mosaic; layers of various shades of green pigment are judiciously interspersed with strokes of orange that give evidence to the changing seasons. Schnakenberg then applied a rich, complementary blue to create shadows and the illusion of depth in the receding hill. The sky and water were created with thinly applied paint that was subsequently blotted; Schnakenberg also overlaid brown tones on the water's surface to suggest rippling, shadowy effects.

Schnakenberg exhibited his watercolors widely. In addition to his regularly scheduled shows at the Kraushaar Galleries, he typically entered both the national painting and the works-on-paper annuals, such as those held by the Art Institute of Chicago and the Whitney Museum of American Art.

INSCRIPTIONS

recto, right center (black paint): H.E. Schnakenberg; verso, center (brown paint): MANCHESTER, VT. / SEPT. 1930

PROVENANCE

Gift of Mrs. James L. Lowery, Utica, N.Y.; to the Museum of Art, Munson-Williams-Proctor Institute, 82.46

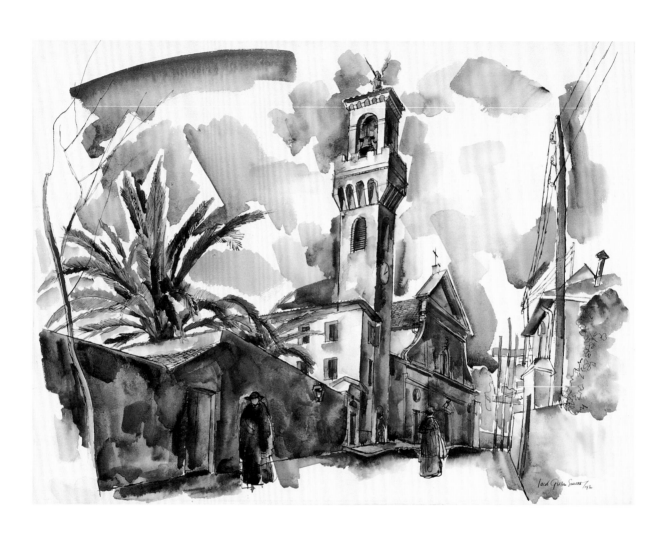

Jacob Getlar Smith (1898-1958)
St. Barthelemy, St. Sylvestre, Nice, 1930
Transparent watercolor with brown ink on thick, moderately textured Fabriano watercolor paper
14 15/16 in. x 19 15/16

Jacob Getlar Smith began painting in watercolor in the early 1920s, when he first went to Cape Cod. Prior to that time, he had found the seemingly infinite and universally bad imitators of John Singer Sargent's watercolor style exceedingly off-putting. "Wherever one looked he was certain to find frauds cashing in on the talents of a pioneer," he once wrote. "Their unabashed plagiarisms had been so offensive I could see little virtue in the medium save that of sport; never could it be considered a serious competitor to oil painting."[1] Smith attributed his change of heart to the influence of Edwin Dickinson, a longtime friend whom Smith met in 1922 in Provincetown. In Dickinson's watercolors, Smith found an original, lively handling of the medium (see cat. no. 12).[2] Smith's commitment was further galvanized when he made his first trip abroad in 1926 and encountered watercolors by Cézanne and Rodin. In 1930 Smith made a second European voyage, courtesy of a Guggenheim Fellowship. He and his family concentrated this stay to Paris and San Silvestre, a hill town near Nice.[3] In the inspiring atmosphere of southern France Smith created a series of watercolors, including this sparkling example.[4]

Smith distinguished between an artist "completing" and "finishing" a painting. In the latter, one risked over-refining a work and destroying its "cardinal virtues: arresting brevity, structural vitality and incisive style."[5] *St. Barthelemy, St. Sylvestre, Nice,* with its loosely handled but contained watercolor, demonstrates the principles to which he aspired. Smith composed the image of the village street in pen and ink and added watercolor to create an airy impression of a bright, warm climate with deep blue skies and earth-toned architecture. He applied rich overlays of washes to suggest shadows on the church's façade and on the cloister wall to the left of the street while his very selective dabs of color around the ink drawing in other areas suggest, by contrast, full sunlight. Elsewhere, such as with the foliage and the wall opposite the church, Smith allowed colors to pool and bleed into one another. In his interpretation of the sky, Smith created a Cézannesque patchwork of brushstroke and white paper; moreover, with a rich blue, he painted closely around the left side of the bell tower, which nicely set the form in relief. In its total effect the composition is a fine balance of controlled line and fluid color.

Upon his return from France Smith exhibited widely and to critical acclaim. In a December 1931 notice for the show "An American Group," for example, William Schrack of *Creative Art* singled out Smith's "robust composition and glowing color."[6] In 1933 Smith was invited to join the New York Water Color Club because, as the secretary wrote, "The club really needs new active members who will be interested in improving our exhibitions, and your election will aid the Board in its search for 'new blood.'"[7] Jacob Getlar Smith would distinguish himself during the next three decades as a landscape painter in oil and watercolor, but he deserves additional recognition because he also promoted watercolors as a writer. Smith authored the book *Watercolor Painting for the Beginner*[8] and, in numerous articles for *American Artist* Magazine, he celebrated watercolor's history and its notable practitioners in the United States.[9]

WATERMARK

(right edge): L FABRIANO

INSCRIPTIONS

recto, lower right (black ink): Jacob Getlar Smith/1930; verso, lower center (graphite): Jacob Getlar Smith; lower right (blue ink): "St Barthelemy" St. Sylvestre, Nice; lower right (graphite): 1930

PROVENANCE

From the artist by descent to Jean and David Loeffler Smith, New Bedford, Mass.; to the Museum of Art, Munson-Williams-Proctor Institute, Gift of Jean and David Loeffler Smith in memory of Adele and Jacob Getlar Smith, 98.15.5

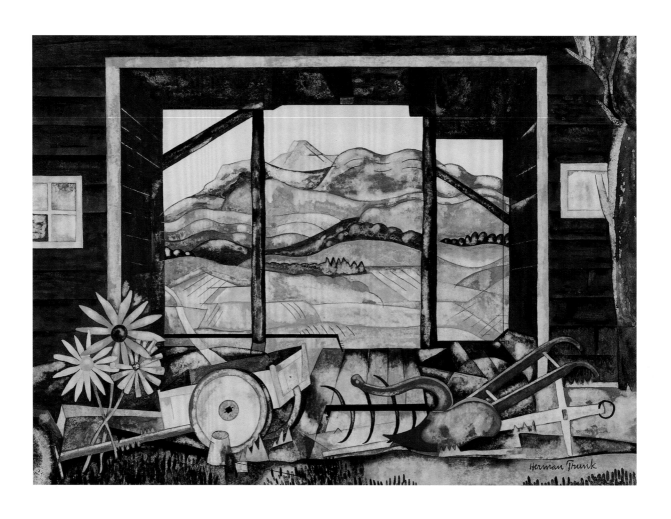

Herman Trunk, Jr. (1894-1963)
Haying (Summer Fantasy), 1930
Transparent watercolor and black ink over graphite on watercolor paper
16 x 22 in.

Between the 1920s and the 1940s Herman Trunk actively exhibited his paintings and enjoyed critical acclaim, all while maintaining a full-time job as a linotypist. After studying at Pratt Institute, Brooklyn, and serving in World War I, he began an affiliation with the Art Students League in 1921, showed with the Society of Independent Artists throughout the 1920s, and was invited to join the Dudensing Gallery in 1925. In 1932 the gallery staged a ten-year retrospective of his work.[1] The Whitney Museum of American Art, New York, selected Trunk's work for its first annual exhibition of contemporary painting (from which the museum bought his *Mount Vernon*) that same year and for its first exhibition of sculpture, watercolors, and prints in 1933. Trunk's work was included in the Whitney's 1935 *Abstract Painting in America* exhibition, and he showed regularly at the Brooklyn Museum's watercolor exhibitions in the 1930s and 1940s.[2]

Although he painted in oils, Trunk distinguished himself as a watercolorist. Critic Forbes Watson, who purchased one of his watercolors in 1926, praised the artist for his "clear personal note … and [his] light fastidious touch."[3] Henry McBride, by contrast, found the work generally too close to Demuth in style, but he did single out Trunk's landscapes as the artist's "best work."[4] William McCormick concurred with McBride. While Trunk's work was "extraordinary in its loveliness," the critic wrote, it exhibited residual "effects of the recent Modernistic craze."[5] Nevertheless, the following year Helen Appleton Read proclaimed that Trunk was "rapidly taking his place among the foremost exponents of watercolor."[6]

Trunk lived in Brooklyn, but his family owned a house in Neponsit, N.Y., and he also visited Sweet Clover Farm in Woodstock, N.Y. After 1938, he spent time on a farm in Milford, N.J. While Trunk painted numerous still life subjects,[7] the seaside views of Jamaica Bay and the Atlantic as well as the rural upstate setting inspired some of the artist's best landscapes, including *Haying (Summer Fantasy)*.

Haying is a fanciful interpretation of farmland in summer. Here Trunk framed a bright and rolling landscape of fields and mountains with the dark, manmade, architectural "window" of a barn.[8] In the foreground, stylized farm implements rest in a seemingly discarded fashion beside equally stylized and charming, if unnaturally large, varieties of daisy. Critics writing in the early 1930s commented that there was a strain of the "primitive" or "naïve" painter in Trunk, but *Haying* is also the composition of a knowledgeable, sophisticated artist who delighted in playing with spatial conceits. The barn's perspectival lines, for example, are purposely askew, according to Trunk's decorative brand of Cubism. Throughout the composition, Trunk conflated space by uniting foreground to background. The barn floorboards seen at the right, for example, transform into an amorphous passage of green, brown, and ochre that stretches into and becomes one with the planted fields, presumably in the distance. Similarly, where or if the upright pole on the left meets the ground cannot be discerned. At left, Trunk also projects a ribbon of road from the field into the foreground to meet the wheelbarrow. Trunk played with color to unite space as well: the framing of the barn door is painted in the same soft, mossy green that defines the distant hills, while the cool slate-lavender color of the highest mountain peak is the same that Trunk used for the wheelbarrow.

Trunk composed the image with a sketch and carefully followed this guide throughout. His watercolor technique here consisted largely of blotting. In all areas of the work Trunk painted local color to model form. In selected passages he layered the blotted pigments for additional depth. This technique, used to define the fields and hills, for example, creates a mottled effect and a lively surface. After this step, Trunk used a paintbrush to add emphasis to the architecture (which is quite heavily painted) and other forms, such as the plough in the foreground. Finally the artist penned in a few lines in ink as an accent to suggest rows of cut hay.

INSCRIPTIONS

recto, lower right (black ink): Herman Trunk; verso, lower left (ink stamp of circular logo with square inset): Dudensing Galleries •5 E 57 N.Y.C.• (graphite): 639/(ink stamp): MODERN/AMERICAN/PAINTERS

PROVENANCE

Dudensing Gallery, New York; to Edward W. Root, Clinton, N.Y. [W-54], February 1932; to the Museum of Art, Munson-Williams-Proctor Institute, Edward W. Root Bequest, 57.271

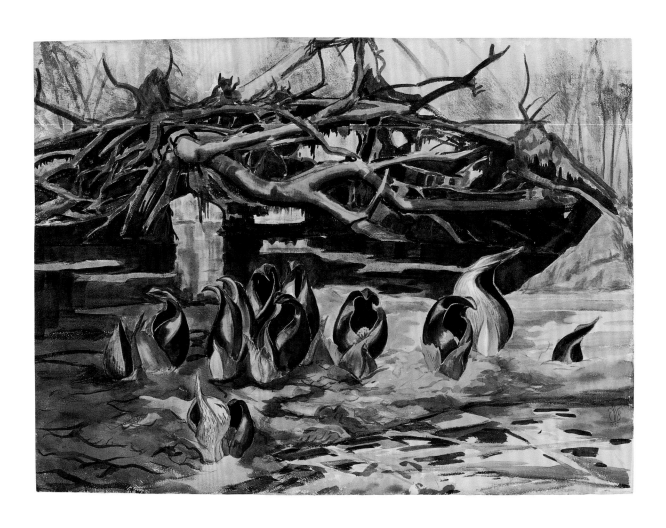

Charles Burchfield (1893-1967)

Skunk Cabbage, 1931

Transparent and opaque watercolor on heavy-weight watercolor paper

21 7/8 x 29 13/16 in.

Skunk Cabbage depicts a scene not far from Charles Burchfield's home in Gardenville, New York.[1] With its unglamorous subject matter and lowly point of view — here is no majestic forest interior or vast landscape vista — one might describe the painting as humble if Burchfield had not invested the image with such lush intimacy. He clustered the voluptuous plants in the foreground and framed them within a primeval setting, complete with a tangle of intertwined branches in the background. Moreover, while the initial impression is of a muted, monochromatic palette, Burchfield in fact used a rich and subtle variety of colors. The predominant hues for the skunk cabbages are deep reds inflected with blue. Burchfield complemented these with strokes of light green and, in the near foreground at the lower right, selectively used a light peach tone to describe the sandy marsh floor. Burchfield painted the background with equal care and deliberation, although he limited his palette to shades of gray, brown, and green.

At this stage of his career Burchfield was an accomplished, if unconventional, watercolor artist.[2] He layered pigments, as an oil painter would, to create a rich, glowing surface. In *Skunk Cabbage,* each brushstroke is sensitively conceived and rendered; he incorporated a number of painting techniques into this work, each appropriate to the section depicted. By dragging his brush over a relatively dry paper, especially in the upper portion of the painting, Burchfield created a flickering surface with white inflections that shine through the dark pigment. At the center of the composition, however, in rendering the shifting, watery marsh surface, he used a damp paper over which he painted with a damp brush. To describe the plant forms Burchfield applied transparent washes in several stages and then, over selected passages, applied opaque color with controlled, delicate dry strokes to add the precise touch for modeling forms.

In 1932, the year after he painted *Skunk Cabbage,* Burchfield described the rewards and difficulty of working on the same marshy subject *en plein air* during April: "the cold wind & the bright sunlight made the process a physical stimulation."[3] Similarly, he wrote to Edward and Grace Root what, from anyone else, would have been an unseemly compliment: "I hope you won't be insulted when I tell you that seeing my first skunk-cabbage of the year gave me the thought that I must write you … when you consider the place skunk-cabbages hold in my esteem you won't feel so bad. I made a special pilgrimage one afternoon to see them."[4]

For Burchfield the skunk cabbage heralded spring after western New York's brutal winters. The fetid marsh plant symbolized for the artist the ferocious and mercurial late winter-early spring season that he loved so well.[5] For all the naturalist's care that Burchfield took in representing marsh flora in *Skunk Cabbage,* the painting is also a spiritual one. It celebrates nature's resurrection following the trial of winter's dormancy. Burchfield wrote in April 1932, "[The] skunk-cabbage well up — the atmosphere of the swamp fills me with vague yearning and sadness and pleasure."[6] In spite of the looming tangle of roots and branches Burchfield, in the near foreground at the lower right, reveals in the reflection of puddled water the clear, light blue sky of early spring.

INSCRIPTIONS

recto, lower right (black ink): CEB [monogram] / 1931

PROVENANCE

Frank K. M. Rehn Galleries, New York; to Edward W. Root, Clinton, N.Y. [W-19], November 12, 1931; to the Museum of Art, Munson-Williams-Proctor Institute, Edward W. Root Bequest, 57.105

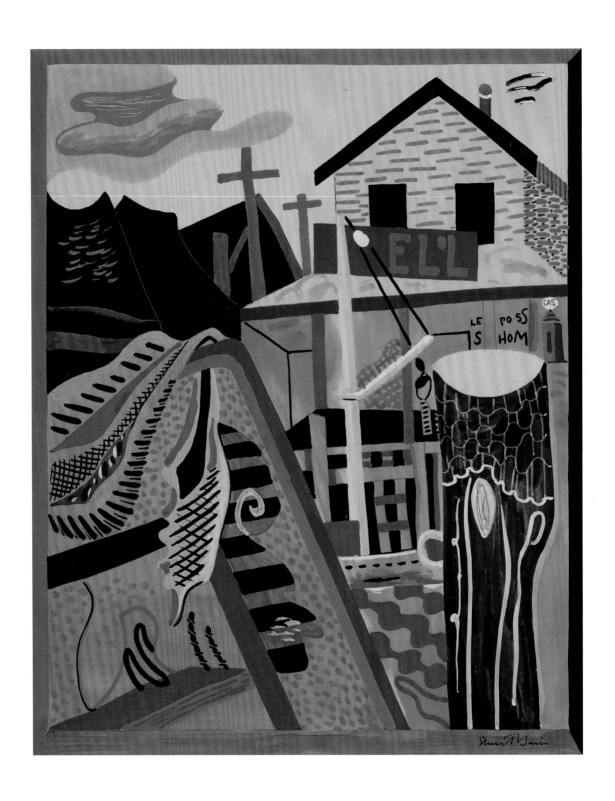

Stuart Davis (1894-1964)

Black Roofs, 1931

Opaque watercolor and blue pencil on machine-made wove paper
24 x 17 15/16 in.

Stuart Davis's harborscape, *Black Roofs,* was inspired by his sojourns in Massachusetts, where he had spent many seaside summers from as early as 1913, the year he first went to Provincetown. As a child growing up in East Orange, New Jersey, his family frequented the Jersey shore, "so the water, sun, sand, and all that were part of my experience," Davis stated in a 1962 interview. "I just accepted that as the normal thing to do, so Provincetown was a continuation of that."[1] In 1915 Davis went with artists John Sloan and Charles Winter to Gloucester for the first time. While the light in Provincetown captivated him (he described it as "noticeably more brilliant"),[2] Davis nevertheless preferred the larger and livelier Gloucester. He noted, "It had everything [Provincetown] had, but there was more of it, a greater variety, more visual interest, more topographical interest with rocks, surf and all that, and Gloucester was a city, a sizeable city of twenty-five thousand underpaid people."[3] It should not be surprising that Davis preferred Gloucester's energy to Provincetown's extraordinary brilliance. One could argue that, in Davis's mature style, the quality of natural light affected his painting less than it did the work of another kind of landscape painter, such as Edward Hopper, and that expressing his experience of a locale's "vibes" would take precedence.

What Davis did appreciate about both Provincetown and Gloucester was that neither at the time was merely a summer resort. Both had long maritime traditions, the vestiges of which Davis enjoyed exploring. About Provincetown he said, "It was a working place with fishing boats and even a tradition of whaling — a little bit. It was an adventure to go through the piers, the houses on the piers and look at the whaling gear."[4] *Black Roofs* captures in Davis's stylized and witty interpretation the fishing milieu of these towns. He drew the outlines of the composition with graphite and then painted with opaque color the composition's forms and textures. He generally used saturated pigments. Davis, however, left the top of the paper, the sky, largely open, although at left he painted an undulating cloud in blue and white with scratched lines and, to the right, sketched in the outline of flying birds. In the near foreground is a knotty net-draped piling, behind which stands a brilliant yellow (perhaps sun-washed) boat house; brushstrokes in orange, red and blue suggest it is a stone structure. Below the "ELL" sign the building is open with a dock, ladder, crane, and fuel pump.[5] Three "black roofs" of the title are to the left of the yellow building (which also has a black roof), separated by blue telephone poles.[6] The first of the trio at the far left has brushstrokes that suggest shingles, while the center building has a grid that hints at a regularized pattern of tiles. To the center building's right is a red chimney. In the left foreground Davis painted an unusual, abstracted still life that alludes to fishing accoutrements such as nets, ropes, and seashells.

For Davis, *Black Roofs* did not reproduce a scene he saw but an independent creation inspired by what he experienced.[7] He later wrote, "[An artist] reacts to [a scene] in relation to the mood he brings to it, his general state of mind and interest of the time. … By taking the immediate reactions to a subject matter as a field of action, and integrating them with the pre-existing emotional urges, a synthesis is created which is the realization of emotion within the limits of the defined space."[8] That is, in *Black Roofs* Davis translated the harbor, its history of fishing, the seaside sensations of light, salt air, and breaking surf to "analogous dynamics of spaces and color," and his subjective sensations are "given objective permanence."[9] Davis believed this translation elevated an ephemeral and personal response from a sentimental memory into a "a living factor in present experience."[10]

INSCRIPTIONS

recto, lower left (graphite): Black Roofs; lower right (black ink): Stuart Davis; far right (graphite): 1/3; lower right (graphite): 3-1/4; lower right (graphite): Hard mat hinged; verso, upper left (stamped in black ink): OCT 24 1932; upper left-center (graphite): HA; upper left-center (graphite): Black Roofs

PROVENANCE

Downtown Gallery, New York; to Edward W. Root, Clinton, N.Y. [W-25]; to the Museum of Art, Munson-Williams-Proctor Institute, Gift of Edward W. Root, 53.406

John Marin (1870-1953)

Speed, Lake Champlain, 1931

Transparent watercolor and graphite on thick, roughened, white watercolor paper

16 x 21 in.

John Marin, in a letter from the 1940s, wrote with unbridled enthusiasm about the thrill and inspiration he derived from nature, "Just look out of this door — Holy Moses — look out of that door — holy holy Moses — hundreds of canvases … doomed to paint. … I'll <u>joy to look</u> and if I get a bit of joy in my paintings down — I'll joy at that bit of joy."[1] While he is best known for his Maine seascapes, Marin also spent some time in 1931 in Vermont on Lake Champlain, which inspired this painting.[2] Lake Champlain, "the sixth great lake," is a large body of water above Lake George (where Marin's friend and patron, Alfred Stieglitz, had a home) that separates New York and Vermont. In Marin's interpretation, the energy of the turbulent water crackles into the sky above and effectively captures the spirit that he would later describe so effusively.

Speed, Lake Champlain not only is a painting of admiration for the sublime qualities of nature but is also a modernist study in surface and Cubist space. Marin used a minimum of graphite underdrawing to set basic compositional outlines for the work, painted over these with lines in gray, and then built up forms with color. For the sky he applied broad strokes of lighter to darker blue-gray wash around geometric lines. To complement the structure of these forms Marin added a sweeping, whimsical rounded line that emphasizes the painting's surface as it evokes a commanding breeze over the water. The lake itself was painted with a wet, if controlled, brush. Light blue, green and gray comprise the underpainting over which Marin applied darker values of the same hues; in some instances he allowed these passages to bleed into each other. He blotted paint in the center of the composition with a rag, which lends additional texture to the stormy surface, and he left extensive portions of the paper unpainted to create the impression of whitecaps. Around the areas of white Marin selectively painted with short dashes and, finally, using black paint and a drier brush, he added the fine geometric lines in the sky and the lower left of the painting. Marin actively worked the surface, especially in the lower right-center, where he scrubbed the heavy watercolor paper to remove paint and lighten the tone of that section.

Recent conservation of *Speed, Lake Champlain* revealed remnants of silver leaf embedded in glue residue within a pencil line around the border of the painting, which suggests that a silver leaf fillet was once glued to the painting's outer edges. This physical evidence corresponds to the artist's inscription on the verso of the paper, indicating his preference for matting and framing: "silver strip/white mat" and "strip of grey, then white."[3] Marin's explanation for using a gold or silver mat was characteristically colorful and curmudgeonly: "Why? Because it fights and that within it has got to put up such a fight that neither one gets the best of it."[4]

INSCRIPTIONS

recto, lower right (black paint over graphite): Marin 31; verso, upper left (blue pencil): Frame/yellow or olive/ + black greene [*sic*]; center (charcoal): silver strip/white mat; lower left (graphite): strip of grey then/white

PROVENANCE

Peridot Gallery, New York; Downtown Gallery, New York, to the Museum of Art, Munson-Williams-Proctor Institute, Purchase 54.6

Reginald Marsh (American, born France, 1898-1954)
Untitled (*Lower Manhattan*), 1931
Transparent watercolor over graphite on medium-weight watercolor paper
14 x 19 7/8 in.

As an artist, Reginald Marsh was above all a draftsman. He began his career in the 1920s working in black and white as a graphic artist and cartoonist. When he sought to paint with color by the end of the decade, he adopted media — watercolor, then egg tempera, but not oil — that enabled his drawing skills to shine. Marsh stated, "Watercolor I took up and took to it well, with no introduction."[1] He had spent 1925-26 in Europe studying old masters and upon his return marveled that "New York City was in a period of rapid growth, its skyscrapers thrilling by growing higher and higher. There was a wonderful waterfront with tugs and ships of all kinds."[2] Marsh was in a hurry to capture New York's energized spirit, and the quick-drying egg tempera and watercolor served his aims because "reaching a quick climax … seemed to suit me rather than oils. I like transparence."[3] With photography and his omnipresent sketchbooks, watercolor was a medium that Marsh depended on particularly for working outdoors as he rode tugboats and documented the Manhattan skyline.

Untitled (*Lower Manhattan*) is a majestic view of the working city that Marsh so admired. From his high, Brooklyn-based vantage point, he first sketched a very few lines in graphite to outline clouds and the general shapes of buildings and docks. Painting with free and calligraphic strokes, Marsh modeled the skyline by layering transparent washes, from light blue-gray to ever-darker shades of blue and violet. To depict the river he painted horizontal strokes with a relatively dry brush and dabbed touches of green paint around the piers for emphasis. The boats were developed from similar cursory brushstrokes. It is probable, however, that Untitled (*Lower Manhattan*) is a work that Marsh abandoned because it exhibits a lack of finish, as if Marsh never applied the final layers of wash to define details. Moreover, the paper was scuffed in five different areas of the composition. It is possible that Marsh had rubbed the sheet excessively in these areas to erase passages to be corrected or, more likely because of the regularity of the abrasions, that broken glass caused the damage.

The Munson-Williams-Proctor Arts Institute received Untitled (*Lower Manhattan*) as a bequest from Marsh's widow, Felicia Marsh, and the watercolor was cataloged and known for twenty years as *Hudson River Skyline,* a curious title for an image of the East River.[4] While the image is not signed, it is dated "9/16/31." A survey of Marsh's sketchbooks from the early 1930s reveals numerous random water-level studies of tugboats, ferries and their passengers, water birds, and the Manhattan skyline.[5] Marsh was using what is now called sketchbook number 167 during September 1931.[6] On September 10, he created a two-page drawing inscribed "from 11 St. bier, Brklyn."[7] The book also has several figure studies, including one dated September 16 of women in shirtsleeves (as if the weather were warm) on some unspecified mode of public transportation, the subway or perhaps a ferry.

In 1939 Marsh grew tired of egg tempera after a decade's triumph with the medium. He turned to painting watercolors on a more ambitious scale because, he stated, "Watercolors give clarity, and allow for better drawing."[8]

INSCRIPTIONS

recto, lower right (graphite): "9/16/31"; stamped in red ink: F. MARSH COLLECTION; (graphite): WC 31-2; verso, lower right (graphite): Rehn / WC 31-2

PROVENANCE

Felicia Meyer Marsh, New York; to the Museum of Art, Munson-Williams-Proctor Institute, Bequest, 79.18

Edward Hopper (1882-1967)

Hill and Cow, 1934

Transparent and opaque watercolor over graphite on textured watercolor paper
14 1/8 x 20 1/16 in.

Hopper painted *Hill and Cow* during the early autumn of 1934, just after he and his wife Jo moved into the new house that they had built in Truro, Massachusetts, on Cape Cod. Jo's description of this watercolor in the record books that she kept is largely descriptive:

> *Hill and Cow.* Black & white cow. Grey cloud in back of hill with touch of blue above. Foreground bright yellow, then strip of pale green. Hill in shadow (blue green). Then light on top brighter green. Bare spots of sand at base of hill at left in shadow with reddish glaze — look deep. In front of these bare spots. Green bushes tipped with pale green. Foliage of hill (trees) look very dense — Deer would like it there.

The motifs of this watercolor, with a cow grazing in the foreground and farm buildings in the middle distance, suggest the Cape Cod setting of the Hoppers' rental cottage of the previous four summers, Burly Cobb's farm in South Truro. This locale was the subject of several watercolors and oils from Hopper's first summers on the Cape, including *Roofs of the Cobb Barn,* 1931.[1] We can assign *Hill and Cow* to the autumn because of the golden color of the grass in the foreground and the fact that the Hoppers, preoccupied with the construction of their new home and their move into it, were unable to settle down and paint before September.[2]

Cows had appeared earlier in Hopper's work. An etching he called *Cow and Rocks,* 1918, places front and center the posterior of a rather rocky cow in a rocky Maine landscape.[3] The scene makes an ironical departure from the soft pastoral of traditional landscape. Hopper borrowed the cow from earlier art, a painting by Jacob Jordaens, the seventeenth-century Flemish artist. He was not the first artist to appreciate Jordaens' cows: van Gogh copied Jordaens' entire composition of cows in 1890.[4]

Another of Hopper's etchings, *American Landscape,*

1920, even more emphatically than *Cows and Rocks,* undercuts the traditions of pastoral landscape: cows meander home across a railroad track that horizontally bisects the entire plane; in the background a lonely farmhouse reaches starkly above the horizon. The tracks encroach on the countryside and connect it to urban life. Hopper continued to develop these ironies in a series of prints, which include the drypoint, *Railroad Crossing,* 1923, where a man leading a cow is blocked by a lowered barrier from crossing tracks.

The cow motif continued into Hopper's oil paintings of the early twenties with a work called *The Red Cow,* which appears to have been destroyed.[5] By 1928, when he painted the canvas *Cape Ann Granite* (private collection), Hopper omitted the cow from the rocky pasture he depicted. But in a related watercolor, *Cape Ann Pasture* (Yale University Art Gallery) of the same year, he depicted several cows grazing amid the rocks.[6]

Ironically, Hopper played a small part in the urban assault on the country through the drawings he reluctantly produced as commercial illustrations for farm journals to advertise modern conveniences and lighten work.[7] His vision of the country, then, is anything but sentimental. In the irony of his outlook he resembles Robert Frost, whom he admired, and whose bitter New England pastoral sequence, *North of Boston,* had appeared in 1914.[8]

In *Hill and Cow* Hopper's interest in Jordaens and in Dutch seventeen-century paintings of cows (such as those by Jan Both, Aelbert Cuyp, Adam Pijnacker, and Paulus Potter) seems to have intersected with the rural environment he had chosen for his home in Truro, as well as with his intellectual interest in questioning urban development. Hopper, who spent much of the year living in New York City, was clearly sympathetic with the critic Lewis Mumford, his friend, who attacked the increased standardization of American life and published articles in this period with such titles as "Botched Cities."[9]

GAIL LEVIN

INSCRIPTIONS

recto, lower right (brown ink): Edward HOPPER

PROVENANCE

A joint gift by Fred L. Palmer to Hamilton College, Clinton, N.Y., and Munson-Williams-Proctor Institute, Utica; to the Museum of Art, Munson-Williams-Proctor Institute, which purchased the Hamilton College share, 61.84

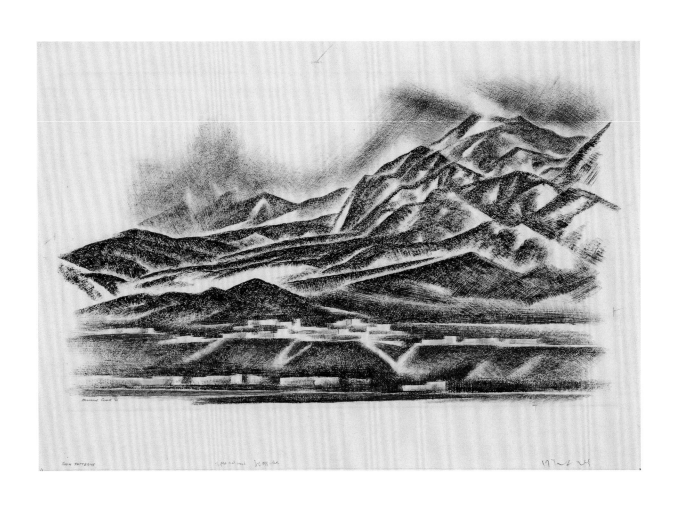

Howard N. Cook (1901-80)
Snow Patterns, 1935

Drybrush watercolor on handmade watercolor paper
13 15/16 x 20 in.

Howard Cook first visited New Mexico in the autumn of 1926 while on an illustration assignment for *Forum* Magazine. He remained in the Santa Fe and Taos region for eighteen months and described this initial encounter as "the happiest time of my life."[1] While he and his wife, Barbara Latham, led a peripatetic existence after this time, Ranchos de Taos and environs became their true home.[2] Cook never seems to have tired of the New Mexican landscape's striking beauty. In 1943 he could still exult: "[Our valley] is especially gorgeous in fall, with the golden notes of cottonwoods and alders against the black mountains. … The winter mountain sides … are simply gorgeous. It is all too much to paint in a lifetime anyhow."[3] Cook was still a young artist in the late 1920s, and he found that the relative isolation of Taos (the established art community there notwithstanding) assisted the development of his mature style. After he had lived there for a decade, Cook continued to value the freedom to work independently and experiment away from the pressures of art centers; the serenity in his adopted home was conducive to work.[4]

Snow Patterns depicts Taos and the low pueblo dwellings at the base of its mountain range. While his imagery from the southwest often focused on people and Indian ceremonies, landscapes were an important component of his oeuvre. The mountain terrain was perhaps most compelling, if elusive, for him. "I have made several watercolors of landscapes here as I have been particularly impressed by the beauty of the mountains in snow, although these efforts have always been of a fugitive nature,"[5] he wrote in 1935 to his friend and dealer, Carl Zigrosser of the Weyhe Gallery. In one of his most eloquent observations, Cook described Navajo Canyon and Ghost Ranch in this way: "It seems as if the elements had chosen to plow deeply through a magnificently colored area leaving exposed great cliffs of rock definitely stratified in terra cotta reds, green earths, and swinging up like the superstructure of a ship a vivid slab of cadmium yellow."[6]

Snow Patterns was created in dry-brush watercolor, a technique that preoccupied Cook in the late 1920s and early 1930s. Its ascetic characteristic is virtually an abnegation of the medium's lush and baroque potential, but it is also, nevertheless, appropriate for the stern beauty of the mesa in winter. Cook did not use underdrawing to create *Snow Patterns*. With a very dry brush on dry paper, he applied pigments in subtle, rich layers of crosshatched patterns. The lower portion of the terrain is built up with darker tones of brown against which he balanced shades of blue-green. The higher plane of the pueblo was painted first with ochre, over which Cook applied shades of olive green. Above the pueblo, the mountains rise in slate- and green-blue. Cook rendered the buildings and the craggy crevices of the mountains from the paper itself; these sections are unpainted.

In his voluminous correspondence with Carl Zigrosser Cook rarely spoke of personal matters, but an uncharacteristically candid letter dated 1941 could serve as a manifesto for the artist. In it Cook confessed that he envied others' artistic facility because he had to "thrash a thing out" to arrive at the solid but subtly conceived compositions he strove to create.[7] In its reticent dry-brush technique and imposing description of the landscape *Snow Patterns* reveals such solidity. In 1940 Cook departed from his more typical, methodical approach and noted to Zigrosser that this new group of watercolors from Taos were "completely different from my usual work, spontaneous, wet, and a good advance in color landscape."[8]

In an undated, handwritten list of Cook's works in Carl Zigrosser's papers, *Snow Patterns,* along with two other works, is identified as a New Mexico subject.[9] This may be a preliminary checklist for Cook's February 1937 one-artist show at the Weyhe Gallery, one of five solo exhibitions Cook had there. MWP Arts Institute records indicate that Edward Root acquired this and other works by Cook from the Weyhe Gallery that year, although it is not certain whether *Snow Patterns* was included in that exhibition. Most notices about the show comment on imagery from Cook's second Guggenheim Foundation-funded project, during which he traveled through the American Southeast depicting people in North Carolina, Texas, Louisiana, and Appalachia.[10]

INSCRIPTIONS

recto, lower left (graphite): Howard Cook '35; lower left (graphite): SNOW PATTERNS; lower left center (graphite): 1/2 [flat?] nat. wood; lower center (graphite): 3 / 3 ⅝ off white; lower right (graphite): 17-1/2 x 24. In the center of each margin is a framer's mark, in graphite, for proposed mat window opening.

PROVENANCE

Weyhe Gallery, New York; to Edward W. Root, Clinton, N.Y. [D-11]; to the Museum of Art, Munson-Williams-Proctor Institute, Gift of Edward W. Root, 53.404

Federico Castellón (American, born Spain, 1914-71)

Mystery of the Night, 1936

Opaque watercolor and graphite on heavy black paper

10 1/8 x 12 3/16 in.

When he was just twenty-two, Federico Castellón had his second one-artist show at New York City's Weyhe Gallery in November 1936. Edward Root collected numerous works on paper by Castellón during this period, when the emerging artist enjoyed a flurry of attention as a precocious talent.[1] The checklist for the 1936 Weyhe Gallery show includes titles for eight paintings as well as categories of works on paper: "pen and ink drawings/resist-ink process drawings/dry-brush drawings/tempera on black paper drawings/pencil drawings/ink and white on brown paper drawings." While the titles of these works on paper are unlisted, it is probable that *Mystery of the Night* was among the "tempera on black paper drawings"; Edward Root's records indicate that he bought the work in January 1937.[2]

Castellón created *Mystery of the Night* in 1936 upon returning from Europe, where he had studied art and exhibited his work in Spain, Paris, and London on a fellowship from the Spanish Republic. As a child Castellón had immigrated with his family to the United States from Spain, and this fellowship was the first return to his homeland. It proved a powerful stimulus to dormant memories. Castellón described the trip as an "awakening [of] all sort of strange things that came up, like finding I had a soul, because these memories became real all of a sudden where I had seen them, thought of them as dreams."[3] He translated the dreamlike quality of rediscovering a life lost in memory and time into a Surrealist-inflected style.

Labeled a Surrealist early in his career, Castellón admitted to the movement's influence on his youthful efforts, but he came to resist the association. It nevertheless has endured. Sarah Clark-Langager observed that the young Castellón initially emulated the styles of de Chirico and Tanguy, but he soon developed "the hyper-realist style and

tortuous eroticism of Dalí."[4] Castellón explained that he preferred the term "poetic mysticism" to describe his symbolic, figurative visual language.[5] While critics interpreted his representational imagery as irrational (and therefore Surrealist), Castellón believed that it best conveyed the profound emotional states that were central to his meaning. In his estimation, a nonobjective style was ultimately only decorative, and representational imagery with a clear narrative was too restricted in its interpretation.[6] Castellón conceded that his work had a dark cast and that his subject matter always came from his own imagination, without benefit of model or other external source.[7]

To create the haunting, nocturnal dreamscape of *Mystery of the Night* Castellón appropriately chose a ground of heavy black paper.[8] He made a cursory graphite underdrawing and then carefully constructed figures from closely drawn parallel lines of tempera. Exercising great control of the medium, Castellón created texture and volume by varying the weight of each line. To these he added layers of highlights, such as those found on the long, red, billowing scarf (or hair) or the petals of flowers on the Golitha-like head of the reclining figure in the foreground.

As a mature artist Castellón felt that watercolor was not his medium, though he used it when expedient — while he traveled, for instance, or as a reprieve from his commercial, graphic design projects in the 1950s.[9] Edward Root acquired several Castellón paintings on paper but surprisingly he favored the artist's work in black and white. In a letter to Carl Zigrosser Root stated, "I find that Castellón's drawings in pen and ink and pencil are at least tolerable from the point of view of anyone interested in the way in which things are said, but that the colored pictures don't work so well. And of course they are all interesting in their subject matter."[10]

INSCRIPTIONS

recto, lower right (gray paint): FEDERICO - N.Y. / CASTELLON '36

PROVENANCE

Weyhe Gallery, New York; to Edward W. Root, Clinton, N.Y. [D-2]; to the Museum of Art, Munson-Williams-Proctor Institute, Gift of Edward W. Root, 50.25

Charles Howard (1899-1978)

Concretion, 1937

Opaque watercolor and graphite on medium-weight wove paper
10 x 13 15/16 in.

Charles Howard was reared in a San Francisco Bay area family that embraced art, education, and travel.[1] After having established himself as a serious artist on both coasts of the United States, he moved to the United Kingdom with his British wife, Madge Knight, in 1933.[2] The London art world during the 1930s was a stimulating milieu for Howard and Knight. Led by artists such as Paul Nash, Ben Nicholson, and Barbara Hepworth, the avant-garde embraced, wrestled with, and internalized a plethora of theories and practices, including Cubism, the Association Abstraction-Création movement from Paris, and Surrealism.[3] Howard later noted that, upon arriving in Britain, he had initially tried to paint in an idealist, nonobjective style to give order to an increasingly chaotic world, but he soon discovered that painting in the manner of Dutch artist Piet Mondrian did not suit him.[4] He persisted, though, and like many of his contemporaries in the British vanguard Howard transformed prevailing forms and methods for his own ends.[5]

Concretion is one of several gouaches Howard painted in the mid- to late-1930s that displays the artist's growing interest in allusive shapes, created from a union of the natural and geometric and reminiscent of those in works by artists Jean Arp or Joan Miró. Critics and scholars in fact regularly recognized the close affinity of Howard's painting to Surrealism.[6] As early as 1932 New York art dealer Julien Levy had included Howard, one of just three Americans, in his gallery's groundbreaking Surrealism show. Howard was similarly represented in the 1936 *International Surrealist Exhibition* at London's New Burlington Galleries (although not in the Museum of Modern Art's 1936 *Fantastic Art, Dada, Surrealism*). For himself Howard preferred not to be labeled and considered his painting a dialectic between intuition and reason.[7] He was inspired by certain Surrealist ideas, but automatism, the practice of painting in a trance-like state without pre-conceived ideas and a central tenet

of the movement, was not one of them. Howard's friend and champion, Douglas MacAgy, wrote that the artist took "great pains to isolate the images from attachments that might appear to be idiosyncratic ... he is on guard against the sudden felicitous inspiration. ... He distrusts spontaneous responses because he suspects them of being flashes of individual fancy."[8] *Concretion* is anything but spontaneous. Howard drew its shapes in graphite prior to painting, and the precision of some lines, such as that which defines the kidney-shaped form to the left against its black ground, suggests that the artist used tape or some other stop-out device.

In *Concretion* the two biomorphic forms dominating the composition are at once sculptural and flat; they appear to be placed on a surface before a gray ground that emerges at the center of the composition. The form at left is relatively two-dimensional, although Howard's use of color and shape is layered, but he modeled the form on the right with graphite to create the illusion that the central form has some depth. Howard then undermined the illusion by placing a vertical yellow bar, very flat, directly on the surface. The painting's palette is subtle and sensitive. The ground is created with three varying hues of brown to taupe, with a soft, light blue for the background to silhouette his bold central forms. Interestingly, Howard created the two forms from so-called negative space; he left the white of the paper virtually unpainted.

Howard had a solo exhibition at the Julien Levy Gallery in New York in 1932, but he exhibited far more frequently in this country during his 1940-46 wartime interval stateside, when his work was selected for nearly all major exhibitions nationwide.[9] In March 1946 Edward Root acquired Howard's 1944 painting *Wild Park* (which had been included in the Whitney Museum annual of that year) and *Concretion* from the Karl Nierendorf Gallery in New York.[10]

INSCRIPTIONS

recto, right center (white paint): Chh '37

PROVENANCE

Nierendorf Gallery, New York; to Edward W. Root, Clinton, N.Y. [W-37], March 1946; to the Museum of Art, Munson-Williams-Proctor Institute, Edward W. Root Bequest, 57.162

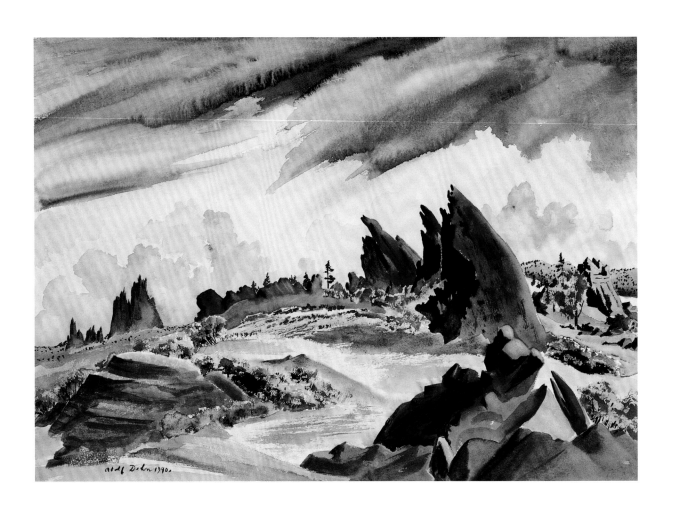

Adolf Dehn (1895-1968)

Garden of the Gods, 1940

Transparent and opaque watercolor over graphite on heavy watercolor paper

20 x 28 in.

In the 1920s, while living in Vienna, Paris, and elsewhere in Europe, Adolf Dehn established a reputation as a satirical cartoonist in the style of George Grosz, whose work Dehn admired. Dehn's illustrations appeared in such publications as *The Liberator, The Dial, The Worker's Monthly,* and *Vanity Fair;* typical imagery portrayed café society or the wealthy and bourgeoisie — fat and overdressed — with ironic captions such as "unemployed." Other Dehn illustrations depicted beggars or the plight of laborers, as in his 1926 *New Masses* illustrations of the South Wales (Rhonda Valley) miners' strike.[1] Throughout his career, this genre of satirical social commentary ran parallel to Dehn's interest in landscape. Widely traveled, he regularly sketched his environment, and from these cursory notes Dehn created lithographs and, by 1937, watercolors.

As a landscape artist Dehn never pretended to be a reporter; he frequently noted that he had foremost in his mind the compositional design components of picture-making.[2] Ironically, then, Dehn the landscape painter readily confessed that he never painted outdoors. Although he enjoyed walking and making quick sketches, painting *en plein air* was another matter entirely. Dehn's inventory of discomforts included glaring sun, wind, rain, cold, snow, sand, dust, and "the wondering stares of the lowly laymen who pass by." He found the most potentially damaging pitfall to watercolor landscapists, however, was the seductive array of information before them. One would be tempted to include everything he or she saw, at the expense of structuring a "moving and exciting" composition.[3] Critics recognized the edited quality of Dehn's work early on and generally praised him for it; in the mid-1920s, one reviewer wrote, "[Dehn's] successful tho exaggerated treatment of landscapes suggest those qualities of selection and of simplification which Chinese painters of the Sung period esteemed so highly. ... Dehn picks out its essential elements and, discarding all else, records these with brevity [and] intensity."[4]

Although he developed a creditable reputation as a watercolorist, Dehn was reluctant to try painting in color for years. By 1937, however, he was determined to overcome his trepidations. His first watercolor exhibition was held at the Weyhe Gallery in spring 1939,[5] and within a

decade he wrote an instructional book entitled *Water Color Painting.* Here Dehn guided the aspiring artist by sharing insights into his own choices of materials, techniques, compositional strategies, and subject matter:[6] "I use any number of brushes, from four to a dozen, both round and flat" he wrote, and recommended that "flat brushes are best for laying big washes, for straight clean edges, and square effects; but the round ones are best for the real calligraphic drawing."

Dehn won a Guggenheim Foundation grant in 1939 and used the funds to travel in the southwestern United States. Having been invited to teach summer classes at the Colorado Springs Fine Arts Center by his mentor, Boardman Robinson, Dehn remained in the West for portions of the next few years. During this period he created a large body of work, in lithography and watercolors, inspired by the majestic terrain of the Rocky Mountains, the New Mexican desert, and similar sublime landscapes. Included in this material are several compositions from the Garden of the Gods, a park of extraordinary rock formations near Colorado Springs.[7] In the MWP Arts Institute watercolor Dehn chose a point of view from within the upthrusting boulders. He made a very sketchy graphite underdrawing and painted over this with a limited palette. The rocks were created from a brownish-red that ranges from a warm orange in the foreground to a burgundy in the background formations. Within these tones Dehn painted several layers; the preliminary light washes allow the white of the paper to show through, and over these passages Dehn built up form with ever-darker shades to create the illusion of striated rock, dark shadows, and great volumes. For the intervening passages, he lightly brushed, with a relatively dry and broad stroke, shades of light brown and gray. Dehn built up trees and brush as he did the rock, by laying in layers of light green that he selectively dappled with darker shades to create illusionistic space and a lively surface pattern. While there are a few areas within this landscape that reveal a wet brush on wet ground, the scene is created with relative control. It is only in the dramatic sky that Dehn exploits the medium's capacity for pooling and bleeding by pulling a wet brush across another wet passage.[8]

INSCRIPTIONS

recto, lower left (brown paint): Adolf Dehn 1940

PROVENANCE

Weyhe Gallery, New York; to Edward W. Root, Clinton, N.Y. [W-30], 1940; to the Museum of Art, Munson-Williams-Proctor Institute, Gift of Edward W. Root, 53.407

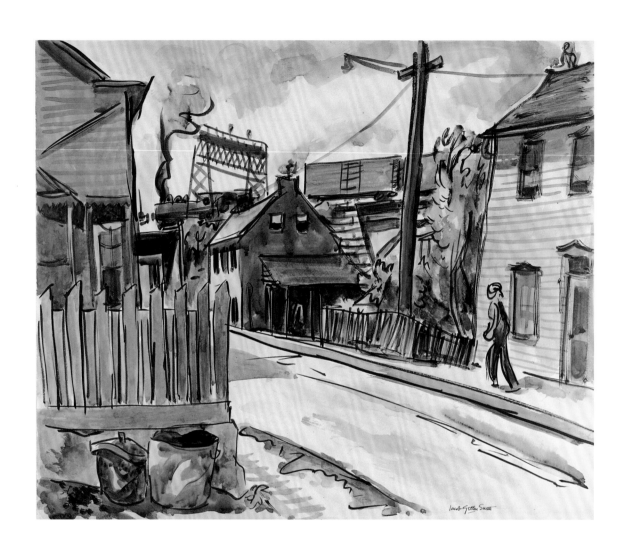

Jacob Getlar Smith (1898-1958)
Approach to a Town, 1940
Transparent watercolor on moderately textured cream-colored Whatman wove paper
20 x 24 inches

Jacob Getlar Smith's *Approach to a Town* makes an interesting comparison to his watercolor of ten years earlier, *St. Barthelemy, St. Sylvestre, Nice* (cat. no. 21). The two paintings are superficially similar; in both Smith depicted a street scene with walking figures, and he also drew a preliminary compositional outline over which he painted with watercolor. In the later work, however, Smith's line and paint handling are markedly looser. The artist's style had evolved during the intervening decade, but Smith also noted that his choice of hot-pressed paper for *Approach* demanded "boldness of technique" because its "smooth surface prohibits the subtleties obtained on cold-pressed paper and discourages overpainting."[1] A true watercolorist, Smith championed the brilliance of white paper and transparent washes, and his quick brushstrokes here weave harmoniously with the painting's unpainted passages.[2]

Smith's seemingly cursory painting method belies the amount of rich detail he introduced into the composition. He in fact observed the scene with great care. The subject matter of *Approach to a Town* evokes an industrial northeast urban milieu in the vein of Charles Burchfield's middle period (although the painting looks nothing like Burchfield, nor is it trying to) rather than the sun-infused Mediterranean climate of Smith's earlier painting. Smith acknowledged that the landscape artist seeking subjects will find that "nature is far from perfect" and that one must exercise keen discernment in selecting a meaningful locale.[3] He championed humble subjects: "When will some artists discover that an object as unpretentious as a lone leaf may unfold more universal text than a big chunk of panoramic bombast like the Grand Canyon?"[4] Smith incorporated this belief into his vision of the American scene by including small and poignant moments of human behavior into a picturesque setting. Critics acknowledged this quality: "[Smith, a] well-known watercolorist, combines a sentimental sense of the loneliness of life and landscape with a feeling for light-dark contrasts."[5] In *Approach to a Town* Smith depicted a short block with three structures built right to the curb; these include a sun-drenched house in the middle ground with laundry hanging to dry on the side porch. There are two trash (or ash) cans beside a clump of grass or weeds, slatted fences, trees of undefined species, and a power line towering above. In the background an elevated train track cuts across the composition at a dynamic angle and carries freight cars. A sole figure walks up the street from these outskirts in the direction of town. The lines of the road are painted at an angle that will eventually converge with those of the train tracks.

Approach to a Town may be a fairly objective interpretation of a scene Smith happened upon, but the key details he includes suggest wider meanings. One can begin to see beyond the seemingly mundane activity to understand the painting as an image of American life as the country found itself in the tense moment between a decade of the Depression and the looming European war. On one hand, the overall impression of this setting is somewhat drab, if not seedy — the "wrong" side of the tracks. Another interpretation, however, might be that the man is in motion, striding up the hill, toward town, perhaps towards work, perhaps towards potential and promise.

INSCRIPTIONS

recto, lower right (black ink): Jacob Getlar Smith; verso, lower center (blue ink): "Approach to a Town" / 1940; lower center (graphite): < 39

PROVENANCE

From the artist by descent to Jean and David Loeffler Smith, New Bedford, Mass.; to the Museum of Art, Munson-Williams-Proctor Institute, Gift of Jean and David Loeffler Smith in memory of Adele and Jacob Getlar Smith, 98.15.6

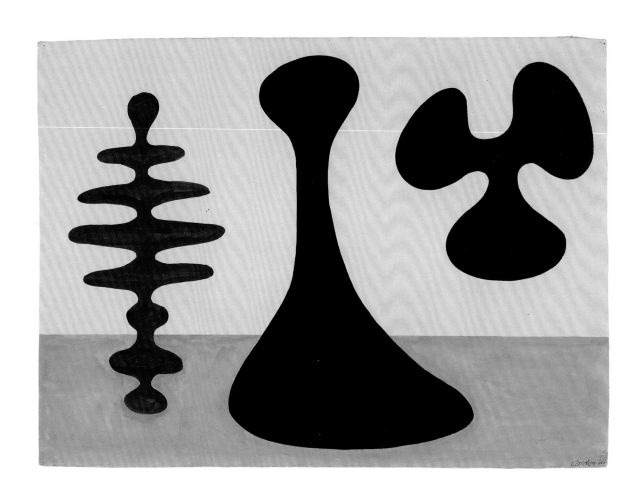

Alexander Calder (1898-1976)
The Propeller, 1944

Opaque watercolor and graphite on heavy watercolor paper
22 1/8 x 30 15/16 in.

While he had previously divided his time between France and the United States, Alexander Calder lived in Connecticut for the duration of World War II. He continued, however, to affiliate with his School of Paris colleagues who similarly found themselves in stateside exile. Wartime rationing made the sheet metal of Calder's mobiles largely unavailable to him, so he adapted by creating sculpture with wood. These changes to Calder's métier, however, did not present hardships. To the contrary, his work and career flourished. In late 1943 the artist had a retrospective at the Museum of Modern Art[1] and, after changing his materials, Calder created his inventive *Constellations* series.

The *Constellations* are open sculptures, in relief and free standing, of shaped wooden forms linked by wires. They have been described as having "infinitely suggestive forms … that call to mind rockets, bones, airplanes, stones, or bowling pins" and reflect Calder's associations with artists Jean Arp and Joan Miró.[2] "The first [abstract] things I made were of stellar bodies, atmospheric conditions, etc., in very simple form,"[3] Calder maintained. "There have been variations from this theme but I always seem to come back to it."[4]

A prolific artist, Calder complemented his prodigious sculptural production by painting daily with gouache on paper. He noted, "I very much like making gouaches. It goes fast and one can surprise oneself."[5] Calder began using the medium in earnest in the mid-forties, about the time he produced *Propeller.* The artist described his preferred method as using wet paper, as demonstrated by an untitled work of 1944 (Art Institute of Chicago); Calder allowed the ink to bleed and then painted over these marks with gouache.[6] By contrast, *Propeller* seems to have been painted on relatively dry paper, but Calder's handling was nevertheless quite free. For each of the three large forms, he drew in gouache an outline which he subsequently in-painted (he did, however, use a light graphite line to draw the horizon which marks the edge of the yellow boundary). The three forms dominate the composition, while the yellow paint creates an interesting play of space, an illusion of a foreground and a field in which two forms, seemingly staggered slightly into the distance, are grounded. The third "propeller" hovers above them, and its movement away from the scene seems imminent.

The painting's title, *Propeller,* could be derived from wartime activity, of planes in flight or ships at sea. Despite the engineering basis of his work, however, Calder was truly influenced by nature at its most elemental. "The basis of everything for me is the universe," he stated. "The simplest forms in the universe are the sphere and the circle. I represent them by disks and then I vary them. … Even my triangles are spheres, but they are spheres of a different shape."[7] The key to a successful composition, in Calder's estimation, was to manipulate these elemental forms with spontaneity and "disparity": "To me the most important thing in a composition is *disparity*. Thus black and white are the strong colors, with a spot of red. … To vary this still further use yellow, then, later, blue. Anything suggestive of symmetry is decidedly undesirable."[8]

INSCRIPTIONS

recto, lower right (black ink): Calder '44; verso, upper right center (black ink, upside-down): 89

PROVENANCE

[Perls Gallery, New York]; to the Museum of Art, Munson-Williams-Proctor Institute, Purchase, 66.19

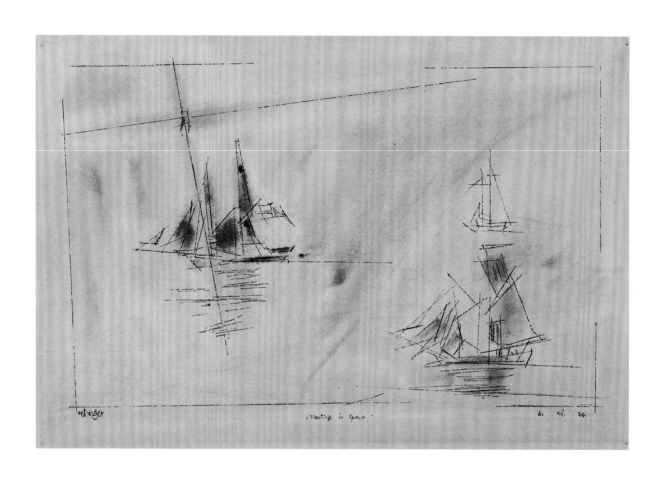

"Floating in Space"

Lyonel Feininger (1871-1956)
Floating in Space, 1944
Transparent watercolor and black ink on laid Ingres paper
12 3/8 x 18 3/16 in.

The play between pictorial space and surface design was a key factor in Lyonel Feininger's work, and this quality is ably demonstrated in his watercolor *Floating in Space.* Here the artist depicted three sailing vessels of differing shapes and on different levels of the picture plane, which at once flattens the space and renders it naively perspectival. With characteristic efficiency Feininger created each ship and its wake with a few quick strokes of the pen. A master printmaker, he employed watercolor as the handmaiden to these primary, graphic motifs of the composition. He enhanced the ink drawing with a subtle shade of soft blue-gray watercolor that he applied in various densities. In broad, open passages Feininger moved the wet pigment with his fingers to cast a thin, pervasive atmosphere across the scene. For the ship at left he concentrated the paint with a wet, bleeding effect, while he diluted and softened the tonality for the craft at right. Feininger added just one other color, a dark yellow, in the form of a large cross — a sun, a star, or a sign — over the left ship. In its totality, *Floating in Space* is a crystalline image of light, water, and sailing ships that hover in an indeterminate realm where sky and sea are indistinguishable.

Feininger exhibited *Floating in Space* in February 1946 at the Bucholz Gallery/Curt Valentin, in New York, his home for a decade upon leaving Germany. The show included thirteen oils and thirty-two watercolors. Critical reception was generally strong, particularly for the watercolors.[1] Edward Root bought *Floating in Space* from this exhibition. Feininger was an atypical artist for Root to collect. Root had distinguished himself as a prescient collector of emerging American talent, and in the mid- to late-1940s his patronage was cast on younger artists such as Jackson Pollock, Theodoros Stamos, and Charles Seliger. Feininger, who was seventy-five in 1946, was the former head of the graphics studio at the legendary German art school, the Bauhaus (while he had been born in the United States, Feininger had lived in Germany from the age of sixteen). Moreover, in 1944, when the Museum of Modern Art exhibited simultaneously the work of Feininger and Marsden Hartley, one reviewer portrayed Feininger as a suave and highly regarded European painter and Hartley as the anguished, as-yet-to-be recognized American.[2] It is a testament to the sparkling, reticent beauty of Feininger's watercolor that Root chose it for his collection.

WATERMARK

lower left: INGRES

INSCRIPTIONS

recto, lower left (black ink): Feininger; lower center (black ink): "Floating in Space"; lower right (black ink): 6. xii. 44.

PROVENANCE

Bucholz Gallery/Curt Valentin, New York; to Edward W. Root, Clinton, N.Y. [W-36], February 1946; to the Museum of Art, Munson-Williams-Proctor Institute, Edward W. Root Bequest, 57.145

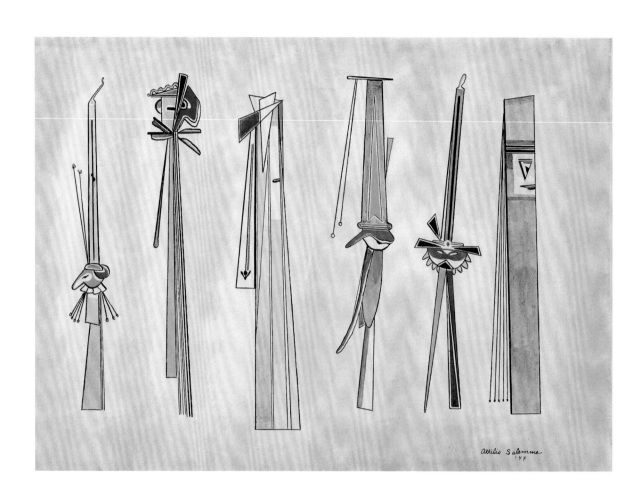

Attilio Salemme (1911-55)

In the Realm of Fancy, 1944

Black ink with opaque and transparent watercolor on medium-weight wove paper
9 7/8 x 13 3/4 in.

Attilio Salemme developed his singular style of totemic figures from personal study of such diverse material as ancient Egyptian art and the influx of avant-garde ideas circulating around the New York City art scene during World War II.[1] In the early 1940s, Salemme was a frame maker for the Museum of Non-Objective Painting (precursor to the Guggenheim Museum), in New York, where he encountered the artwork of both displaced Europeans as well as of Americans. By 1943 Salemme had refined his ink drawing experiments into the "symbolic personages," as he called them, that would populate his compositions (with some variations and temporary departures) for the rest of his short career. While Salemme's figures sometimes floated in an indeterminate field, as they do in *In the Realm of Fancy,* he also introduced fairly early in his development confining, sometimes impossible, architectural spaces for the characters to occupy. This combination of cartoon-like figures in metaphysical environments prompted comparisons to Paul Klee, Giorgio de Chirico, and Yves Tanguy, artists whose work Salemme could have seen at New York galleries and museums. The doll-like character of Salemme's personages also suggests the Hopi Kachinas, donated by Max Ernst, that were displayed at Art of This Century, the vanguard art museum that collector Peggy Guggenheim briefly ran in New York during World War II.[2]

Salemme had his first one-artist exhibition at Howard Putzel's 67 Gallery in New York from December 31, 1944, to January 15, 1945. From this exhibition collector Edward Root acquired three works on paper, including *In the Realm of Fancy.*[3] Salemme later explained, "People are the subject of my painting; what they are doing is usually indicated by the title."[4] The titles of the thirty-four works in the 67 Gallery show suggest varying states of mind, from scathing observations on social discourse (*One against Seven, Narcotic Personalities, The Specious Solemnity of Gossip*), to mythic heritage (*Atavistic Premonitions, High Priests of the Ancients, Return of the Knights*), to collective disassociation (*In Their Own World, Congregation of Painful Souls, The Pathos of Common Affinity*).[5] Among these sober titles, one finds other moods in Salemme's repertoire. He also celebrated in his art "the calm of self-realization, the ports of gratification. The beauty of release, the solace of dreams, the magic of transfigurations of visions that restore the sense of purity … the joys of participation, the poetry of peace, the tenderness of love, the wonderful balm of humor."[6] His symbolic personages express, therefore, a range of emotional qualities, from the bawdy dance of *Madame X,* 1955, to the festive pageantry of *In the Realm of Fancy.*

Salemme created *In the Realm of Fancy* with characteristic precision. The six figures are somewhat unusual, however, in that Salemme departed from the strict geometry that typifies his mid-1940s oeuvre. The image is an ink drawing into which he painted with great control an array of pigments. Salemme balanced rich hues of deep red and hot pink with subtler shades of moss green and soft yellow. The overall effect suggests brightly costumed figures on parade, perhaps medieval courtiers in procession. The figure at far left wears a long-nosed mask, a ruffled collar, and a long "bib" or vest for an effect that combines elements of the Commedia dell'Arte and *Alice in Wonderland.* The other figures are similarly masked and costumed. The second figure from the left has an almost Cubistic face, while the figure third from right could be wearing a tall hat with long ribbons cascading from the crown. Similarly, the figure second from the right resembles either a masked jester or a Japanese actor. Like all of Salemme's compositions, *In the Realm of Fancy* feels highly theatrical, and his symbolic personages seem to enact an obscure narrative. Here, however, the artist did not provide the architectural stage that he often set for his players. Instead they are enveloped in a wash and are suspended, floating, in a fanciful drama.[7]

INSCRIPTIONS

recto, lower right (black ink): Attilio Salemme / '44; verso, upper left (graphite): 21 [circled]

PROVENANCE

67 Gallery, New York; to Edward W. Root, Clinton, N.Y. [W-49]; to the Museum of Art, Munson-Williams-Proctor Institute, Edward W. Root Bequest, 57.220

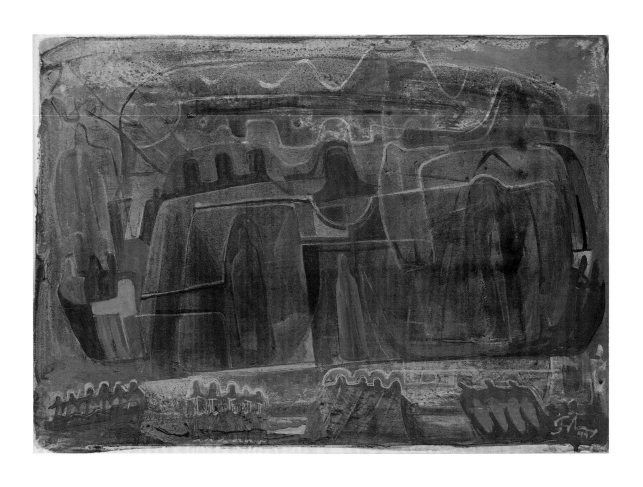

Mark Tobey (1890-1976)
Vita Nova, 1944

Tempera and opaque watercolor on wove paper

11 1/2 x 16 1/4 in.

Late in World War II, when bloody battles raged from Normandy to Okinawa, Seattle-based artist Mark Tobey painted *Vita Nova*.[1] Perhaps this watercolor maps an escapist war-time itinerary, a spiritual path that would deliver misguided mortals from their strife. The lowest register suggests groups of huddled figures moving from right to left and then perhaps mounting to a higher sphere from the left. The earthy-toned forms in the large central section of the picture are unclear, but two shrouded figures seem to be continuing the progression from right to left, a taller russet figure leading a fellow-traveler garbed in ochre. The pair evokes William Blake's cycle of illustrations of Virgil guiding Dante through the circles of hell. In this scene, however, the forms surrounding the central pair are difficult to identify with any specific iconography. Perhaps caravans of more figures trudge on before crenellated embattlements and rows of mountains on the horizon. The upper left corner of the picture is distinguished by light traces of a delicate pink tone that can be found nowhere else in the picture. Are these the lineaments of some final ascension or transcendence?

Vita Nuova is the title of an early book by Florentine poet Dante Alighieri (1265-1321) which begins "Incipit vita nova" — here begins the new life. In this autobiographical and mystical narrative, Dante's "new life" is brought on by the power of his love for Beatrice. Dante's extraordinary passion transports him far beyond the sensual to attain divine and eternal truth. Upon the narrator-protagonist's vision of his blessed love, "the spirit of life, which dwells in the most secret chamber of the heart, began to tremble so strongly that it appeared terrifying in its smallest veins; and trembling it said these words: 'Behold a god more powerful than I, who comes to rule over me.'"[2]

In the late 1940s Tobey's work was increasingly admired for imputed metaphysical content. Frederick Muhs wrote, "A natural abhorrence for a world of materialistic boundaries has gravitated his art even further into a realm of mystical conception."[3] The German American painter Lyonel Feininger, who became an intimate friend of Tobey in the year of the *Vita Nova* painting, shared Tobey's penchant for the metaphysical. Feininger had had an interest in the spiritual since his years in the milieu of Expressionism in

Germany between the wars. Feininger believed that Tobey was "deeply inclined toward religion" and borrowed the words of the great medieval German mystic Meister Eckehart to fathom the intensity he admired in Tobey's painting: "If you seek the kernel, then you must break the shell. And likewise if you would know the reality of Nature, you must destroy the appearance, and the further you go beyond the appearance, the nearer you will be to the essence."[4] Feininger himself titled a painting *Vita Nova* two years after Tobey's work.[5] But in his version, Dante's spirituality was evoked in a luminous yellow vision of a north German townscape dominated by a great Gothic spire.

But Tobey's spiritual program was driven by a compass quite contrary to that of Feininger as well as of Dante, not to mention the mainstream of contemporary religious thinking in North America. The work of the medieval poet was an expression of Christian eschatology; Feininger's interest in spirituality was similarly Christian, though decidedly of a North European cast. Tobey, however, had been an active adherent of the Bahá'í faith ever since his conversion at age twenty-eight in 1918. This religion was founded in Persia in the nineteenth century and is closely related to Islam. Universalism is one of its central tenets. Thus in 1912, Abdu'l-Bahá, the leader of Bahá'í, declared upon his visit to the United States, "The body of the human world is sick. Its remedy and healing will be the oneness of the kingdom of humanity." And in this sermon, which was published in a book Tobey may well have read at about the time he painted his *Vita Nova*, Abdu'l-Bahá explained this metaphysical world unity that shall remedy the world's ills in terms of "new life": "It is my wish and hope that in the bounties and favors of the Blessed Perfection we may find a *new life*, acquire a new power and attain to a wonderful and supreme source of energy so that the Most Great Peace of divine intention shall be established upon the foundations of the world of man with God."[6] In a Bahá'í sermon of his own Tobey preached, "Our minds and hearts must be unlocked [to reveal] the vision of unity." This, Tobey continued, shall bring us to "the threshold of a new day — a new time spiritually."[7] Thus, in one of the most horrible historical moments of the twentieth century, Tobey brought the perspective of a modern Islamic religion to envision a *vita nova*.

Bert Winther-Tamaki

INSCRIPTION

recto, lower right (gouache): Tobey 44

PROVENANCE

Willard Gallery, New York; to Edward W. Root, Clinton, N.Y. [T-11], April 1946; to the Museum of Art, Munson-Williams-Proctor Institute, Edward W. Root Bequest, 57.266

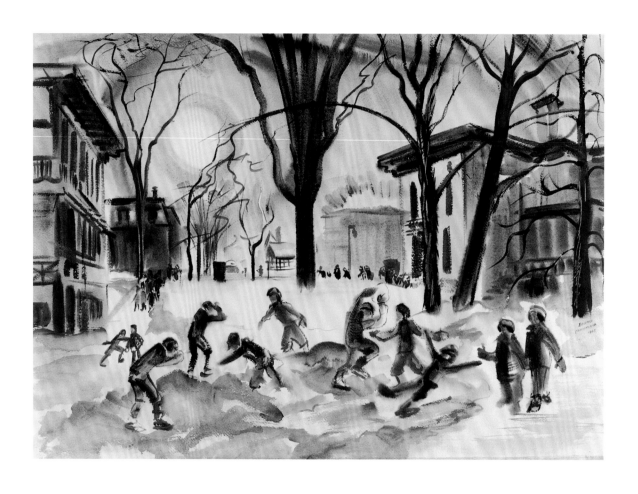

Edward Christiana (1912-92)
Winter Sun and Kids, 1945
Transparent watercolor on medium-weight watercolor paper
22 1/2 x 31 1/4 in.

Born in White Plains, New York, Edward Christiana was reared in the Utica area. After graduating from Pratt Institute in 1933, he returned to central New York and continued his studies at the newly founded Munson-Williams-Proctor Institute. In 1943 Christiana was himself appointed instructor, and he taught at the Institute until 1982. From the beginning of his career, Christiana distinguished himself as a watercolor artist. In spring 1933, for example, while still a Pratt student, he exhibited four works in the juried New York Water Color Society Show. By the early 1940s Christiana's work was regularly included in national exhibitions, including annuals of the American Watercolor Society, to which Christiana was elected in 1949.[1]

Watercolor was for Christiana, as for so many other artists of his generation, a medium that suited his predilection for, as he called it, "on the spot" landscape painting. In a statement from 1946 he described painting as "exciting … to visualize and then to organize some phase of nature into a plastic design through the use of line and color."[2] *Winter Sun and Kids* typifies his early style and subject matter. The playful and raucous scene Christiana captures here is one of scores of images he created from his observations of midcentury life in Utica. The setting is, in fact, on the grounds of the Munson-Williams-Proctor Arts Institute. To the right is the nineteenth-century Italianate mansion Fountain Elms, the home of the Institute's founders. Fountain Elms housed the Institute's Community Arts Program, the Museum of Art's first incarnation. To the left stands the erstwhile Music Building (which was razed in the late 1950s to make way for the 1960 Philip Johnson-designed Museum of Art). As eyewitness to this revelry, Christiana's vantage point would have been from the School of Art buildings, which were formerly the Proctor families' carriage houses.

Christiana rendered *Winter Sun and Kids* with a very loose and fluid hand. In selected wet passages he broadly brushed in the basic forms of structures, some figures, and the expressive sky. In other areas he quickly painted other figures and trees, some of which are calligraphic in their gestural quality. To the wet passages Christiana then dragged a drier brush over the initial impressionistic forms for added weight and dimension. He also scratched into a few selective wet areas, such as the tree trunks, to create texture. The overall effect is quite lively; Christiana's dancing line is in perfect step with the free-spirited activity of his subject.

After his early success with watercolor Christiana abandoned the medium for nearly two decades, during which time he devoted himself to oil painting. He conceded, however, that "those who are familiar with my old paintings will be aware, I am sure, that in fact, they were not so far removed from watercolor. My technique in oils deriving positively from the aqueous medium."[3]

INSCRIPTIONS

recto, right center (black ink): Edward/Christiana/1945

PROVENANCE

From the artist to the Museum of Art, Munson-Williams-Proctor Institute, Purchase, 46.8

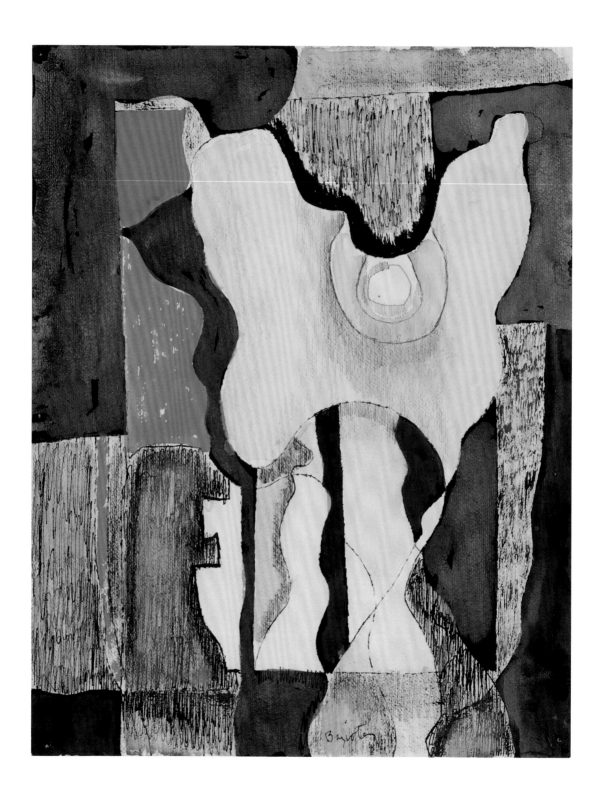

William Baziotes (1912-63)

Glass Form, 1946

Transparent and opaque watercolor, black ink, and graphite on machine-made wove paper

13 7/8 x 11 in.

William Baziotes described his painting process as intuitive; he manipulated forms and colors until the composition revealed itself.[1] He observed, "A few brush strokes start me off on a labyrinthine journey [and] I am led to a more real reality."[2] Critic Harold Rosenberg concurred, noting that Baziotes's quietly evocative imagery suggests an ineffable presence, perhaps "a landscape not by its images but by its quality of feeling only — of other planes and of corridors of depths."[3]

If Baziotes's subjects seem elusive, there are recurring forms in his work. As with *Glass Form,* there are several compositions from this period in which variations on circular shapes abound. While he was reluctant to label it overtly, Baziotes was willing to acknowledge the circle's archetypal associations to eye, target, or female sexuality.[4] *Glass Form* suggests organic, cellular life, but the title also evokes a surface that could be transparent or reflective. In the late 1940s Baziotes painted several works that explored his fascination with the dual nature implied by the mirror and he also wrote, in an essay entitled "The Artist and his Mirror," "To me a mirror is something mysterious, it is evocative of strangeness and otherworldliness."[5]

Baziotes reveled in the sensuousness of oil paint, but he created and exhibited smaller gouaches on paper as early as the mid- to late 1930s.[6] *Glass Form* was initially exhibited in a solo 1946 Kootz Gallery show that included equal numbers of oils and gouaches.[7] In *Glass Form* Baziotes initially sketched with pen and graphite the planar composition of interlocking organic and geometric shapes; he then shaded some passages by scribbling further in ink or graphite. Baziotes complemented these textured areas with open forms, some of which he subsequently painted. For those passages that remain unpainted, the paper's white surface works in concert with other textures. The artist worked the surfaces of his paintings in emulation of rhinoceroses, lizards, crocodiles, and other seemingly prehistoric creatures whose natures elicited both terror and humor, qualities that particularly struck him as appropriate metaphors for human behavior.[8] Onto this skin of graphite and ink Baziotes liberally applied an opaque orange paint, only to cover most of it with another pigment to achieve brown. In the central biomorphic form he layered washes of light green and rose, which now seem quite faded. Indeed, *Glass Form* is probably a shadow of its former self and provides an unfortunate example about the ravages of light exposure to the medium. The edges of the watercolor, long hidden from light under the protective edge of the mat, reveal a bright blue-green color. Today, one can surmise that the fugitive blue pigment has faded, leaving only its yellow partner. The painting, then, was once primarily a juxtaposition of warm orange and brown shades against the cool teal-blue green. The *Artnews* review of the Kootz Gallery show in which *Glass Form* was first exhibited remarked on Baziotes's sensitive palette; describing it as "rich" and with "restrained contrasts" the reviewer praised the artist's lyricism amidst the "pyrotechnical display" of his contemporaries.[9] In his desire for poetic subtlety, Baziotes sought a nuanced palette. "When you look at nature," he once said, "the colors are in between, and when you add psychology, they are even more in between."[10]

At its essence, Baziotes's painting explored life's inexplicable capacity to sustain simultaneously horror and beauty. A devotee of French poetry, Baziotes emulated in his painting the sensuous, decadent *fleurs du mal* of Baudelaire, Verlaine, and Rimbaud: "I love the mysterious, the stillness and silence. I want my pictures to take effect very slowly, to obsess and haunt."[11] Or, as artist David Hare wrote in a memorial tribute, "Baziotes knew … that life is that which dies."[12]

INSCRIPTIONS

recto, lower center (black ink): Baziotes; verso, upper left (black ink): glass form 29 [circled]; verso, upper center (graphite): TOP

PROVENANCE

Samuel M. Kootz Gallery, New York; to Edward W. Root, Clinton, N.Y. [W-1]; to the Museum of Art, Munson-Williams-Proctor Institute, Edward W. Root Bequest, 57.310

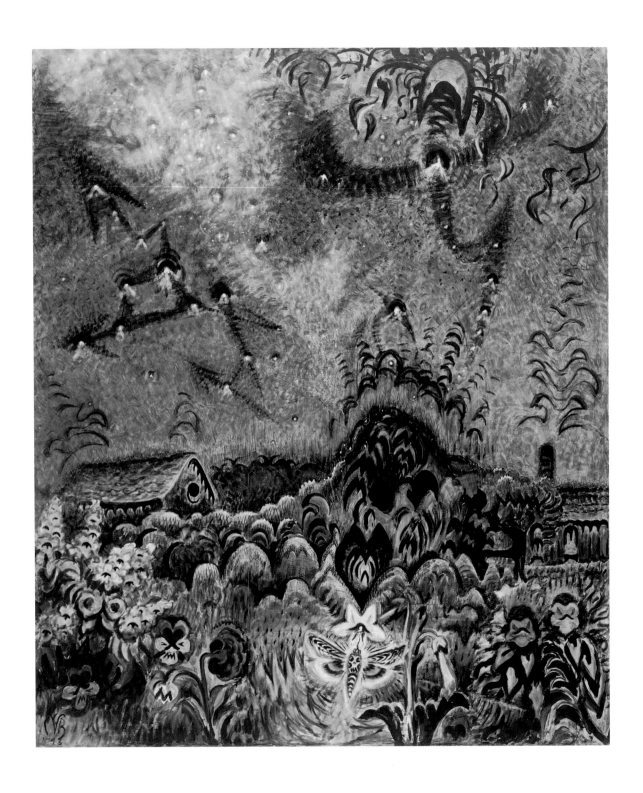

Charles Burchfield (1893-1967)
The Sphinx and the Milky Way, 1946
Opaque and transparent, watercolor, chalk, and crayon on wove watercolor paper
52 5/8 x 44 3/4 in.

Charles Burchfield described 1917 as his "golden year," an inspired period of youthful productivity. For all his brilliant successes, however, the young artist also abandoned numerous paintings in frustration. These unfinished works would later haunt Burchfield; his journal entries from as early as 1931 indicate that he was ruminating on the early compositions, which came to mind through some elusive sensation.[1] Similarly, in 1933 Burchfield wrote to Edward Root, "Much of what I did [in 1917] was chaff, yet the things that clicked I think were the better for it, they have a vividness and spontaneity that the more careful learned things of my recient [sic] years lack."[2] By the mid-1940s Burchfield returned to his unrealized early paintings that he felt had potential.[3] With the emotional and technical maturity he had accrued in the intervening decades, Burchfield created some of his largest and most ambitious paintings by reworking and expanding his youthful efforts. Among these is *The Sphinx and the Milky Way.*[4]

Like *The Insect Chorus* (cat. no. 8), *The Sphinx and the Milky Way* was inspired by Burchfield's nostalgic, multisensory memories of his family's yard in Salem, Ohio; he sought to capture the mystery of a midsummer's night, the fragrance of the lush garden's oversized pansies, dahlias, and hydrangeas, and the hum of buzzing insects. In Burchfield's interpretation the scene is a fantastical evocation of a very large sphinx or hawkmoth partaking of the nectar of a nicotiana flower below a vast star-swept sky. The painting's elaborate astronomical patterns were inspired by an overnight boat ride to Detroit that Burchfield and his son took. In the middle of the night father and son stole up to the deck and were mesmerized by the Milky Way above, "seeming so close we could almost reach up and touch it. It was a magnificent revelation to me. Later on when I was really at work on the picture, I climbed a lonely hill about 60 miles south of here, to make studies."[5]

The surface of *The Sphinx and the Milky Way* is extremely rich. A multisheet composition, Burchfield wedded new paper to old, though he eventually painted out all of the original image. He applied numerous layers of paint, beginning with light-colored transparent washes in light and medium greens for the foliage and yellow and lavender for the flowers. The flowers and moth in the foreground are painted with a relatively wet brush. Over the transparent layers Burchfield selectively painted with opaque color; the red of the flower in the foreground, for example, was built up with several colors and highlights. The opaque paint is largely used in the white stars and for expressive emphasis, as in the dark green and black outlines of the flowers at lower right or the wavy lines in the sky. Burchfield's paint application in the sky differs from that of the flowers in that he used a much dryer brush with visible, wispy strokes. He continued to work the painting's surface after he applied the final layers of paint by drawing extensively in crayon. Small black lines emanate from the white stars to create shimmering effects, and extensive passages of foliage in the middle ground are shaded with vertical strokes of crayon. Burchfield also scratched into the crayon to lighten selected sections, such as the central area of shrubbery.[6]

Burchfield had intended that *The Sphinx and the Milky Way* would be an "Adagio" in a "Symphony of Seasons" quartet of pictures. He wrote: "First movement–Allegro: 'Cherry Blossom Snow' Second Adagio 'Sphynx [sic] and the Milky Way' Third–'Scherzo: Autumnal Fantasy' Fourth: Allegro Vivace–'The Blizzard.' However the Adagio did not get finished [in 1944]."[7] Burchfield's journal from August 1945 reveals his disappointment about his failure to complete this cycle.[8] The following year, Burchfield was nevertheless pleased by his ongoing progress with the painting: "All day on 'Sphinx & Milky Way'–In the morning it went slow, but by afternoon, ideas began to flow, I succeeded in painting in the moth, the nicotiana, & other minor parts. The work went well."[9] At that time he also continued to make studies of the nighttime sky. "A fine sensation," he noted in his journal, "darkness had increased the height and distances in all directions; the Milky Way was clearly revealed."[10] When *The Sphinx and the Milky Way* was finally completed and had begun to circulate on the national annual exhibitions circuit, Burchfield expressed relief when the newly formed Munson-Williams-Proctor Institute acquired the painting for its budding permanent collection. The painting, he confided to his journal, "is one of the most fantastic of the fantasies which I feared might not find purchasers."[11]

INSCRIPTIONS

lower left (black paint): CEB [monogram]/1946

PROVENANCE

Frank K. M. Rehn Galleries, New York, to the Museum of Art, Munson-Williams-Proctor Institute, Purchase, 48.45

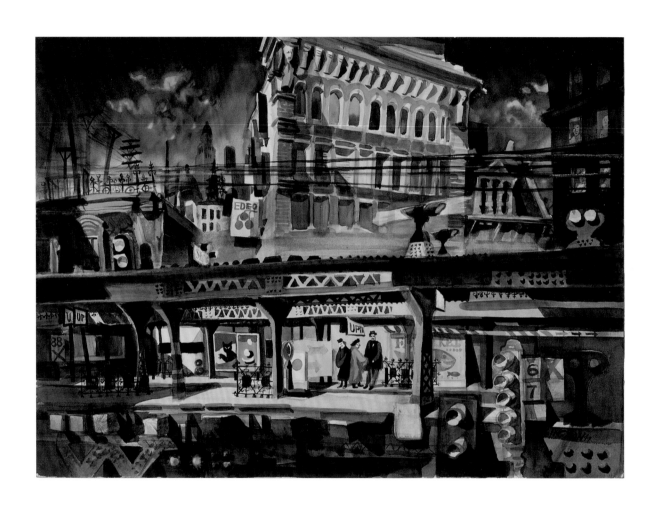

Dong Kingman (born 1911)
Chatham Square, 1947

Transparent and opaque watercolor on wove paper
21 13/16 x 29 3/4 in.

Chatham Square depicts an elevated train stop at a busy intersection on New York's Lower East Side, between the Brooklyn and Manhattan Bridges. Kingman first visited New York after a cross-country journey from his home in San Francisco that was funded by a 1942-43 Guggenheim Fellowship. The city was a revelation to him. A *New Yorker* profile quoted Kingman: "'I am furious with color,' he says. 'New York surprises me. The subway [is] so fast, so terrific. I like things in speed. … Beauty all over. The tall buildings, the people are so interesting.'"[1] Kingman's dealer, Alan Gruskin of the Midtown Galleries, noted that the artist's compositions grew livelier and his palette more varied after being in New York; *Chatham Square* does capture the visual surfeit of the urban landscape.[2] Kingman depicted figures waiting on a platform that is festooned with advertising and rail paraphernalia.[3] Above them looms a building set on a diagonal to the rail line. Although the sky is dark and turbulent, the façade of this structure and the platform are curiously illuminated, as if there were a break in the clouds. Kingman also depicted the architectural details of several other buildings, as well as a more distant lower Manhattan skyline.[4] He bisected the composition with the train structure and overhead power lines, a device he would later renounce: "One lesson I have learned in my years of painting is that it would be distracting to have a direct line, or lines, cut across the top of a picture, or for that matter, across any part of a picture."[5]

With *Chatham Square,* the effect Kingman achieves is one of a vivacious, atmospheric image in which the varied surfaces of the city are spontaneously captured as a unified organism. His witty, sometimes goofy, style belies, however, the calculated planning Kingman's watercolors require. His traditional technique of layering ever-darker layers of wash demand that he understand composition, chiaroscuro, and color patterns very well prior to picking up a paintbrush. Therefore, while he prefers to begin a composition on location — "If I have to sit on the street to paint, I do,"[6] he once said — he does not feel compelled to complete it on site. In fact, Kingman contends that by remaining at the scene he might find himself mistakenly documenting the locale rather than creating a work of art. He therefore prefers to move to the studio, where he is free to make aesthetic rather than reportorial decisions.[7]

During the 1940s Kingman began to enjoy a great deal of success. In addition to receiving two Guggenheim Fellowships, he had several one-artist shows at the Midtown Galleries in New York, from which numerous museums and private collectors nationwide acquired his watercolors.[8] In the midst of this renown, fellow Midtown artist and MWP Arts Institute School of Art Director William Palmer invited Kingman to be a visiting artist at the school from March 8 to March 18, 1948. During this residency, Kingman worked with students, gave a demonstration, and had two exhibitions, one comprised of twelve watercolors and one called a "study exhibition" consisting of sketches, materials, and explanations of techniques.[9] In May of that year the Institute announced the purchase of *Chatham Square* for its fledgling permanent collection, along with works by the two visiting artists immediately preceding Kingman: Philip Guston's *Porch No. 2,* and Hugo Robus's *Woman Combing Her Hair.*[10]

INSCRIPTIONS

recto, lower right (dark blue paint): KINGMAN 47

PROVENANCE

Midtown Galleries, New York; to the Museum of Art, Munson-Williams-Proctor Institute, Purchase, 48.27

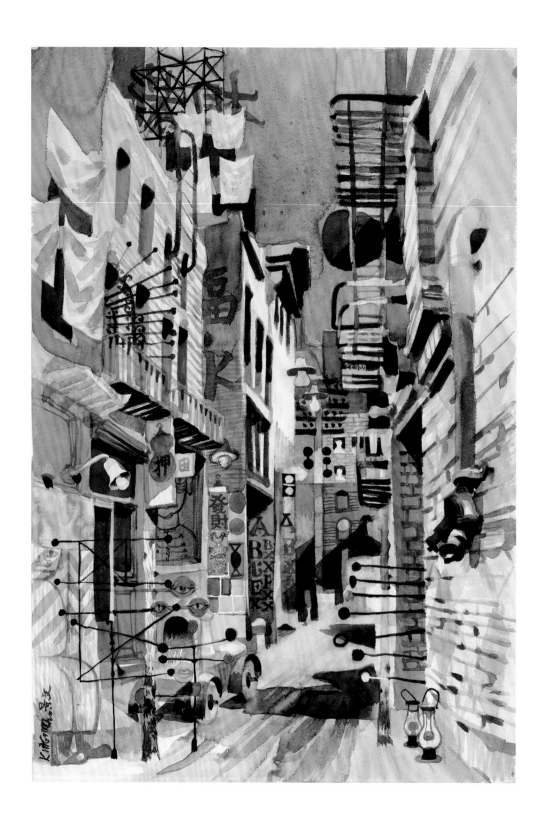

Dong Kingman (born 1911)

Side Street, Chinatown, ca. 1948

Transparent watercolor on thick, moderately textured, watercolor paper

22 13/16 x 15 1/4 in. (irregular)

Although he was born in Oakland, California, Dong Kingman moved with his family to Hong Kong in 1916. As a child he was taught traditional calligraphy — "you practice drawing the birds, the bamboo, the flowers … the landscape"[1] — excellent training that ensured his life-long facility with a paint brush. In addition to acquiring this fundamental technical skill, Kingman also attributed his success as a watercolor artist to two later influences. While a student in Hong Kong, Kingman attended Ling-nan University and studied with Sze-tu Wai, a Chinese artist who had lived in Paris during the early twentieth century. From him Kingman absorbed both European and Asian sensibilities that he would later felicitously combine in his mature paintings.[2] The second important factor in Kingman's artistic growth was his five-year tenure with the Depression-era National Recovery Act program, the Works Projects Administration. Kingman joined the WPA's Federal Art Project in 1936, after having returned to the Bay Area from Hong Kong in 1929. It was a prolific period for him; Kingman estimated that he produced a dozen paintings a week. This activity accelerated his education by years. "The project," Kingman said, "really gave me a chance to develop something."[3]

As a watercolorist, Kingman is a purist. He composes directly on the paper, allowing its brilliancy to shine through layers of transparent washes.[4] In *Side Street, Chinatown* Kingman sketched the composition in light blue-gray water-color, emphasizing strong perspective lines to create the sensation of entering a narrow street. He painted numerous washes to capture the plethora of visual information of domesticity and commercial enterprise. Here water pipes, lights, washing, and shop signs with text and pictures all vie for the viewer's attention. Notable is the trio of eyes at left. Allusions to sight and seeing — including circular forms, railroad signals, and lighting of all sorts — are found consistently in Kingman's urban imagery during the 1940s and 1950s, a period in which he honed his lively interpretations of city life. Although there are relatively few people inhabiting his paintings of the period, one always has a sense of watching and being watched. In Kingman's play-ful treatment, however, this seems less paranoid delusion than a symbol of the variety of visual stimulation at hand.

Although his style is always uniquely his own, Kingman's cityscapes from this period in his career invite comparisons to other artists' interpretations of the urban condition in twentieth-century United States. Like Reginald Marsh, Kingman adhered to an energized representational style but, unlike Marsh, he did not concentrate on the interaction of people. When Kingman did include figures, he often took great liberties with the human form by insert-ing cartoon-like characters or giants looming over a cityscape. In another vein, Kingman, like Stuart Davis, incorporated text from the city's relentless signage. But where Davis could reduce that text to a few letters to cre-ate a witty design, Kingman loaded his visual field to the point of oversaturation.[5] As in *Side Street, Chinatown,* how-ever, Kingman also consistently balanced frenzied urban busyness with a sweep of open sky.

INSCRIPTIONS

recto, lower left (blue paint, parallel to edge of paper): Kingman [and two Chinese characters]

PROVENANCE

[Midtown Galleries, New York]; to Dr. and Mrs. Stephen J. Walker, Utica, N.Y.; to the Museum of Art, Munson-Williams-Proctor Institute, Gift of Dr. and Mrs. Stephen J. Walker, 84.43

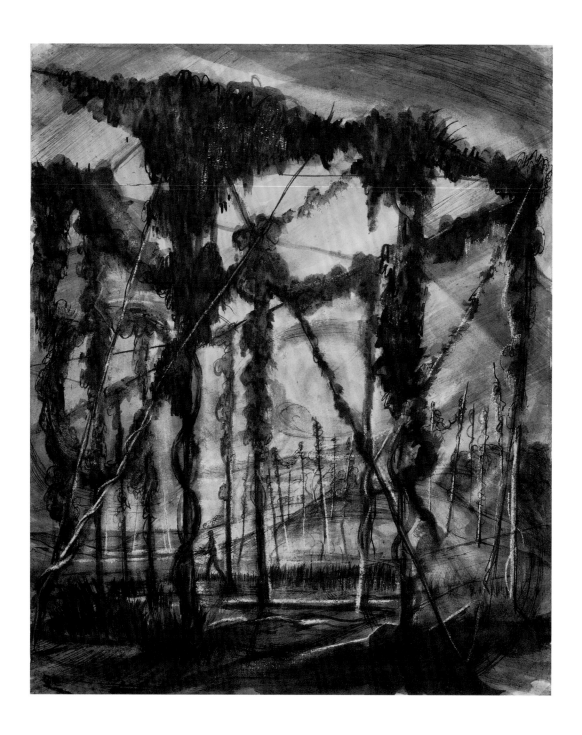

William Palmer (1906-87)
Hop Poles, ca. 1948

Black ink and watercolor on medium-weight, handmade Whatham wove paper
17 x 13 7/8 in.

In 1941 the trustees of the recently founded Munson-Williams-Proctor Institute invited William Palmer to become the first director of the Institute's School of Art. During the 1930s Palmer had taught at the Art Students League in New York City, where he had studied a decade earlier with Boardman Robinson, Thomas Hart Benton, and Kenneth Hayes Miller, his mentor. Palmer also distinguished himself as a muralist for the Works Projects Administration[1] and exhibited his tempera easel paintings, notably Iowan landscapes, regularly at the Midtown Galleries (Palmer joined the gallery at its inception in 1932 and remained with it his entire career). He participated as well in large national exhibitions, including the Whitney Museum's annuals, from which his painting *Dust, Drought, and Destruction* was acquired for the museum's permanent collection in 1934.

Palmer was primarily a landscape artist whose recurrent theme was the passage of time as reflected in the hours of the day and the changing seasons. He felt he had a genuine affinity for the genre, that it was second nature for him.[2] After he settled in central New York State, Palmer found the region infinitely paintable: "As long as I can remember, Nature and Weather have always been of interest to me. … Living as I have for the past 45 years in beautiful upstate New York, with its variable climate and eternal repetition of the seasons, has been the inspiration for all my work."[3] In the 1930s, prior to moving upstate, Palmer's landscapes had depicted cultivated spaces where people enjoyed leisure activities such as golf, skiing, or picnicking. Between 1943 and 1945, however, he served in the U. S. Army; the war affected his once-optimistic outlook. His work in the late 1940s and early 1950s has a decidedly dark, expressionist flavor; as Palmer stated, he lost interest in painting the figure "because I had become so discouraged about what man had done."[4] A gardener of considerable authority, Palmer and his wife, Catherine, had created extensive beds of perennials and vegetables, a walnut grove, a great lawn, and a wooded bird sanctuary behind Butternut Hill, their Clinton, N.Y., home. It was from this intimate relationship with flora that Palmer derived inspiration in the postwar period; in works such as *Columbine* or *Clematis Henryi* (both MWP Arts Institute), Palmer presented a new interpretation of the natural world. These works are characterized by a limited, usually somber, palette and very shallow space. Moreover, Palmer also began working with new media, such as watercolor, casein, and gouache on paper. He painted *Hop Poles,* a scene of central New York agricultural life, during this period.

Hops, the central ingredient for malt beverages, was a profitable crop in central New York counties during the last quarter of the nineteenth century. Palmer's image represents the vestiges of this yeasty past. Hops grow on vines that attach to poles placed in fields called hop yards. In his interpretation, Palmer selected a low point of view to emphasize the towering impressiveness of the plantings. He sketched with pen and ink an underdrawing of the poles, grass, distant hills, and the horizon, and used stop out or erasures to create white highlights. Over this Palmer washed the scene with transparent yellow paint; he concentrated it at the center of the composition in the form of the sun's orb, low in the late afternoon sky and casting a glow across the countryside. Palmer added yet another wash, in gray, for atmospheric effect; with this wash, he created a swirling dimension to the sky but also erased passages to enhance the effect of streaming sunlight. For the hops themselves, Palmer built up washes of fairly wet dark blue and gray pigment; he further scratched into the paint to allow the white of the paper to emerge, as if light were shining through the bunches of hops. As Palmer rendered them, the plantings have a dark, cruciform, and looming silhouette that ominously dwarfs the passing figure in the middle ground. In fact, in its totality, *Hop Poles* elicits contradictory moods. The golden warmth of Palmer's palette, as well as the abundance of the fruit, evoke a bountiful harvest but time, like the light of the day in this composition, is elegiacally fading.[5]

WATERMARK

left: "HAND MADE J WHATMAN 1920 ENGAND"

PROVENANCE

Museum of Art, Munson-Williams-Proctor Institute, Gift of the artist, 85.31

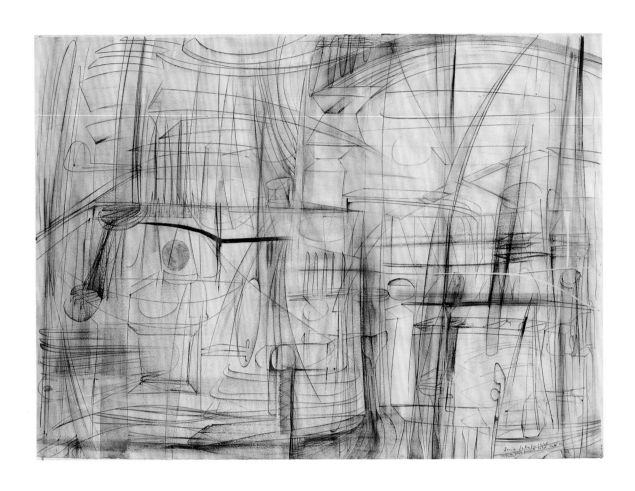

Sonja Sekula (Swiss, 1918-63)
When the People Had Left the Town, 1948
Black ink and opaque wash on heavy wove paper
22 1/4 x 30 3/8 in.

Without describing anything specifically, Sonja Sekula, in *When the People Had Left the Town,* evokes an imaginary cityscape replete with bridges, buildings, and arches. Swiss-born Sekula, who moved the United States in 1936, derived inspiration for this image from her loft on the Lower East Side of Manhattan overlooking the East River.[1] In the postwar period, the city symbolized hopefulness for Sekula, as she wrote to her mother in 1947:

> The new cities that are shooting up along the river, the new settlements in which humanity shall dwell, the new space in which children shall grow up and spread their arms and perform a new dance for a new time, a future that we begin to feel underneath the current of war and strife and uncertainty. … In Manhattan you can smell the big draft of the Northwind, and the Winter and the northern lights that dawn on such steel gray mornings as today … they speak of peace and of new global languages and many new bridges. When I paint bridges I believe to also add in symbols towards the peace and welfare of the universal future![2]

Sekula rendered *When the People Had Left the Town* with graceful control, creating an image that is at once airy and opaque. She used a heavy paper with a creamy tone that complements her warm, nearly monochromatic palette. With a very sure hand she made sweeping marks in ink that create the image's framework and describe multiple geometric patterns of circles, ovals, and squares. The quality of the ink line pulses from thin to thicker density. Sekula lent body to this ink scaffolding, as well as created fluctuating space, by applying very thin washes in shades of gray, taupe, and tan with a medium-wide brush. The ink and layers of wash eventually become interwoven. Onto this underdrawing, and particularly in the lower right quadrant of the composition, Sekula painted with thin white gouache to accent limited areas. The white gouache is transformed into a milky, opalescent veil that might be metaphorically autobiographical. Poet and André Bréton protégé Charles Duits observed, "An invisible cloud enveloped Sonja, lending her movements gentleness and slowness. She was caught in a transparency, isolating her from the world."[3]

Like many of her contemporaries living in New York during the 1940s, Sekula cited the Chilean artist Roberto Matta, and his advocacy of the Surrealist practice of automatic drawing, as an important influence. Sekula's work contains an eclectic array of other strains of inspiration, from Paul Klee to native Southwest and Mexican art. Sekula readily embraced this myriad; on an untitled gouache from 1957 she wrote, "I consciously work in different directions, thick and thin … the simple and manifold. My tendency is the simple-multiple."[4] Art historian Ann Gibson has observed that the multifaceted quality of Sekula's work signifies the artist's efforts at self-determination, regardless of prevailing social mores, for Sekula was not only European in the United States and a woman artist in the male-dominated Abstract Expressionist era, but she was also openly lesbian. Friends and acquaintances described her as spirited and intelligent, but Sekula nevertheless juggled more and less successfully several brands of "otherness." Gibson has written, "[Her] determined fusion of all these categories, male and female, European and American, 'primitive' and sophisticated, and fine and commercial techniques, suggests a strong desire to cancel or bring to null, the hierarchy of one term over the other that binary systems enforce."[5]

Sonja Sekula painted *When the People Had Left the Town* when she was at the height of her creative abilities, at a fruitful period during an otherwise troubled life. In the late 1940s and early 1950s Sekula exhibited regularly at the Betty Parsons Gallery along with artists Jackson Pollock, Mark Rothko, and other emerging Abstract Expressionists. Her work was included in the Brooklyn Museum's International Biennial of Water Colors (1949-55) and the 1950 Whitney Museum painting annual. Her gestural abstractions of the period, such as *When the People Had Left the Town,* compare favorably to those of contemporaries Mark Tobey, Jimmy Ernst, or Bradley Walker Tomlin, artists whose compositions simultaneously evoke chaos and a guarded order to contain it.

INSCRIPTIONS

recto, lower right (black ink): Sonja Sekula 1948/"When the people had left the/town;" verso, top center (graphite): 75

PROVENANCE

Betty Parsons Gallery, New York; to Edward W. Root, Clinton, N.Y. [D-47]; to the Museum of Art, Munson-Williams-Proctor Institute, Edward W. Root Bequest, 57.313

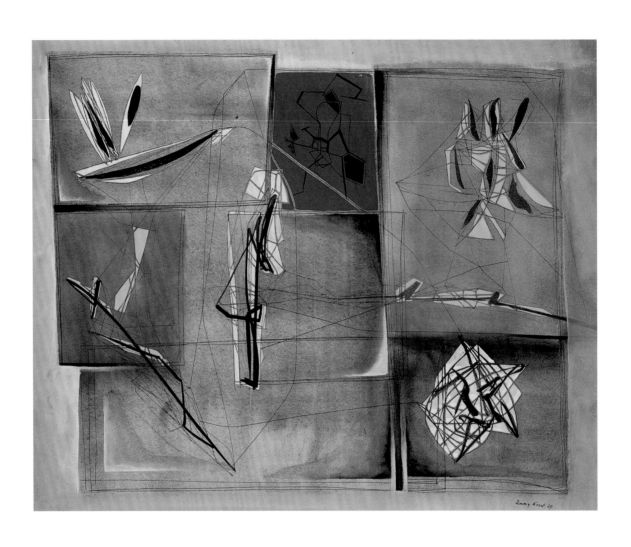

Jimmy Ernst (American, born Germany, 1920-84)
Several Shadows, 1949

Black ink over opaque and transparent watercolor on white, moderately thick wove paper
17 1/4 x 21 3/16 in.

As the son of artist Max Ernst and Lou Straus-Ernst, an art critic and historian, Jimmy Ernst was raised in Weimar Germany within the milieux of Dada and Surrealism. As a youth, however, he eschewed the life of the artist until 1937 when he had an epiphany standing before Picasso's *Guernica,* which was on view in the Spanish Pavilion of the World's Fair in Paris. Shortly thereafter, with the outbreak of the Second World War, he emigrated to the United States and began to paint seriously. In New York Ernst befriended artists Roberto Matta, William Baziotes, and Stanley William Hayter, all of whom influenced him. His painting developed in a linear, nonobjective style, about which he wrote, "Without any deliberate effort I found the content of my paintings shifting toward a more pronounced Abstraction. I don't know whether I did this as an act of growing rebellion against the overly literate dicta that had seemed such an essential part of the artistic world in which I grew up."[1]

Ernst began *Several Shadows* by painting the sheet of paper a middle-gray tone; over this wash he drew thin lines of black ink into a series of loosely interconnected rectangles reminiscent of a grid, a salient feature of Ernst's painting. Ernst subtly demarcated these rectangles with a shadowy gray-white, semi-opaque wash; the wash further defines the compositional framework and gives body to the three constellation forms that are diagonally positioned from upper left, through the center of the composition, to lower right. For these three forms Ernst manipulated ink and the opaque white by adding bolder black lines and volumetric highlights. In counterpoint to these three Ernst added selected notes of color (rather than the opaque white) to the remaining three forms. For the shimmery, transparent red at left Ernst first applied the color and then drew thin ink lines, upon which he inserted very selectively an opaque yellow. By contrast, the yellow transparent paint at right is applied over the black ink underdrawing. At the center of the composition Ernst painted a small square of opaque green onto which he drew ink-lined forms. The verso of this section indicates that Ernst may have corrected a flawed underdrawing by painting over the area as he did.

The overall affect of *Several Shadows* is, paradoxically, that of tempered spontaneity. It is a carefully crafted image, but Ernst also readily acknowledged that improvisation and experimentation were key to his painting (during the mid-1940s he also used jazz as a creative model).[2] Automatism as Matta and Baziotes practiced it affected him deeply; Ernst did not draw to discover forms for future compositions, for instance, but found those forms within the play of his materials, one image at a time. His intention, however, was never solely formal. Within this and other nonobjective compositions of the postwar period Ernst sowed profound feelings. Forced to flee Europe as a teenager, he had arrived in the United States alone, without speaking much English or knowing the status of his mother, who eventually died in a concentration camp. The grid at once suggests modernized societal structures into which he was thrust as well as an attempt to place order on the unmanageable morass that urban life can be. *Artnews* observed that Ernst "poised brittle, attenuated scaffoldings, perversely human in expression, before blurred, luminous plaques of atmosphere to suggest the endless rooms of an office building or … distances of city streets."[3] If Ernst's motivations were to place order on chaos, however, *Several Shadows* is also a very kinetic composition, one that implies imminent instability, or energy made visible. Some of the forms stretch and burst beyond confined spaces, and all of them hover in an unfixed orbit. The web of lines permeating the image does suggest tenuous connections within the isolating matrix of Ernst's loose grid format, but the title itself is potent in its allusions to multiple, elusive presences that hauntingly linger beyond one's grasp.

INSCRIPTIONS

recto, lower right (black ink): Jimmy Ernst 49

PROVENANCE

Laurel Gallery, New York; to Edward W. Root, Clinton, N.Y. [W-59]; to the Museum of Art, Munson-Williams-Proctor Institute, Edward W. Root Bequest, 57.143

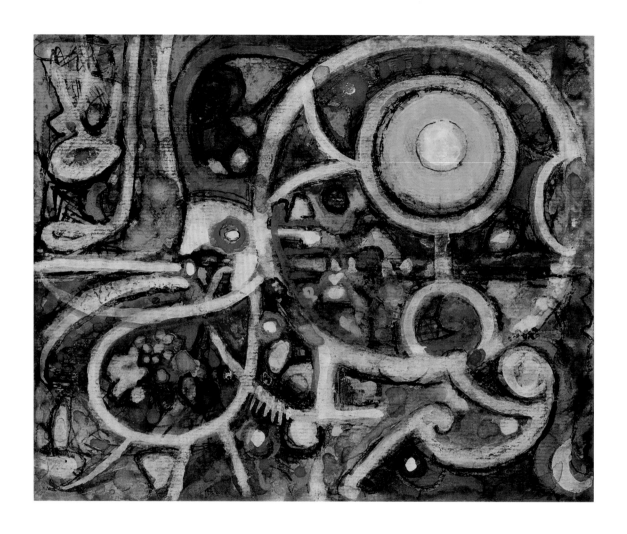

Richard Pousette-Dart (1916-92)
Composition, (1949)[1]

Transparent and opaque watercolor, black crayon, and black ink on machine-made paper with a laid texture
6-1/2 x 8 in.

As a young artist Richard Pousette-Dart drew from far-ranging artistic and literary sources — Oceanic, Native American, Northwest, and Byzantine art, as well as the writings of Russian novelists, the Transcendentalists, Walt Whitman, and Carl Jung — that he invested in his work.[2] By the early 1940s, Pousette-Dart worked in an automatic, nonobjective style, and, while he was not ideologically bound to abstraction, he admitted that "it was just the way I was. I've always been interested in forms in themselves, in relationships, lines, intersections of lines."[3] Critics often dismissed his work as being merely decorative, but in 1945 Clement Greenberg gave it qualified praise (probably because he felt Pousette-Dart was emulating Jackson Pollock). Pousette-Dart was moving from an "ornamental" style, Greenberg suggested, towards one of "boldness, breadth, and the monumental."[4] The artist wedded to these formal and aesthetic principles a deeply personal spirituality that was informed by Christianity, Taoism, and Buddhism. In his artist's statement for a solo 1947 Art of This Century show he wrote, "I strive to express the spiritual nature of the universe. Painting is for me a dynamic balance and wholeness of life; it is mysterious and transcending, yet solid and real."[5] Pousette-Dart's work of the 1940s, then, can be understood as a struggle to come to terms with the weighty events of the era, including the inexplicable horrors of human and nuclear holocausts, as well as with humankind's aspirations to higher consciousness in an effort to transcend its base instincts.

Having begun his career as a sculptor, Pousette-Dart's paintings from this period have a very physical presence (later in his career, his paintings became increasingly dematerialized). *Composition* has multiple layers of obsessive scratching, drawing, and painting that imbue it with an energetic, if unsettled, undercurrent.[6] The artist had drawn expressively with pen and crayon over which he layered dabs and washes of watercolor, transparent and opaque. The overpainting simplified the automatic drawing and unified the surface into a rich mosaic. The image is dominated by a radiating golden orb (perhaps a sign of hopefulness) in the upper right as well as the white gouache hieroglyphics of the artist's own making. The crackling nature of the work and the bold white gouache markings give *Composition* a great scale, although it is in fact a tiny painting.[7] It was important to the artist to make a bold, concise statement; to this end he acknowledged the importance of poetry to his work. "Poetry gets to the point of things," he once stated. "I'm not interested in elongated treatises of any kind. I'm interested in acute, penetrating observations of reality. ... Philosophers often go around, around, around ... and love avoiding coming to any point, but the poet goes to the point, and I like that."[8]

INSCRIPTIONS

verso, upper left (black ink): 49; verso, upper center (graphite): Top/Top

PROVENANCE

(Betty Parsons Gallery or Willard Gallery, New York) to Edward W. Root, Clinton, N.Y. [W-57]; to the Museum of Art, Munson-Williams-Proctor Institute, Edward W. Root Bequest, 57.209

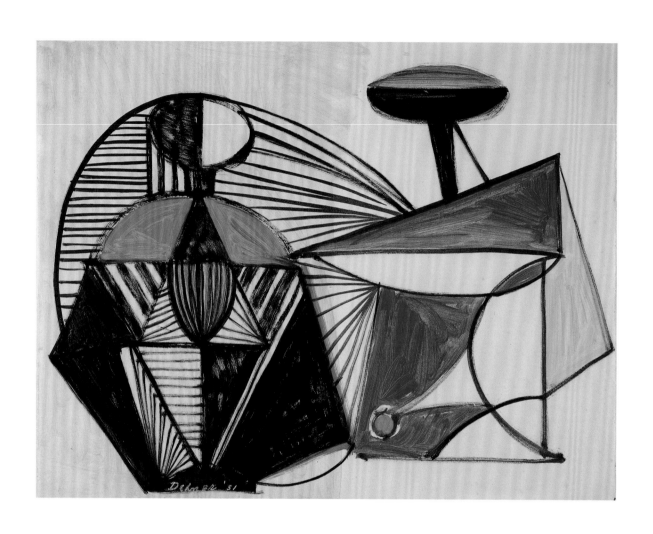

Dorothy Dehner (1901-94)

Untitled, 1951

Transparent and opaque watercolor on laid Arches paper

15 3/4 x 20 3/8 in.

Like other artists of the generation associated with the New York School, Dorothy Dehner acknowledged the power of abstract symbols to communicate a profound message — a personal iconography with universal implications.[1]

Born in Cleveland, Ohio, in 1901, Dehner enrolled in the Art Students League in New York in the fall of 1925. In 1926 she met sculptor David Smith, and they were married the following year. Thus began decades of creative interaction. Dehner's artistic production was eclipsed during her twenty-three years with Smith, and only in their final years together did she begin to show her work and win awards. Dehner considered her years at their farm and studio at Bolton Landing, New York (which the couple bought in 1929), a time of great elation and deep sorrow. Her art became her source of personal sustenance, her means to freedom from her troubled relationship with Smith.

In an interview Dehner once remarked, "I love to draw. It is very basic in all of my work, I think. It was one of my very first expressions."[2] A series of dramatic works on paper made in the 1940s are among the most provocative drawings of her career. The "Damnation" series consists of skillfully rendered pen and ink studies of nude figures, accompanied by vultures, bats, and other animals. "Suite Moderne" includes ghoulish figures dancing gigues, fandangos, and gavottes, all of which become "Dances of Death." Such images relate to postwar tensions but have more to do with her state of mind in these final years of her marriage to Smith.

Only a few times in the 1940s did Dehner exhibit her work. She was in a number of group exhibitions, and in 1948 the Audubon Artists awarded her a first prize for drawing. Skidmore College, Saratoga Springs, New York, organized a solo exhibition of her work in the same year. By the late 1940s Dehner was determined to devote herself to her artistic career. She found a copy of Ernst Haeckel's seminal study of natural forms of 1904, *Kunstformen der Natur,* and embarked on a series of drawings of microscopic organisms in gouache and ink. In these works on paper Dehner introduced a repertory of biomorphic forms that related to the work of Paul Klee, Joan Miró, and Mark Rothko, among others. Her imagery celebrated the animate energy of these unicellular forms of life.

In 1950 Dehner left Bolton Landing, and she was divorced from Smith two years later. She took classes at Skidmore College, and obtained a degree; then went to New York City where she taught at various schools.

The Institute's sheet is among a series of drawings that Dehner produced within months of her departure from Bolton Landing, probably while she was studying at Skidmore. This transitional work suggests her growing interest in abstracted figurative compositions and led to bronzes that feature similar shapes and striated patterns. The use of parallel lines and geometric forms suggests a close link with David Smith's steel constructions of the 1940s. His sculpture *Personage from Stove City,* 1946, and a related drawing in full color form a decided context for Dehner's drawing.[3] In addition to the use of parallel lines to form a schematic image of a seated figure, Smith constructed his sculpture of carbon steel painted white, blue, red, green, and yellow. Dehner also combined linear areas in black with geometric forms in blue and red.

In Dehner's drawing two figures are presented: the more angular — with triangular segments in blue — appears to be a male figure. The image on the left — with predominate diamond shapes and semi-circular wedges on the "shoulders" in red — suggests a female form. Such figures can be related to Dehner's sculptures of the next decade, which include schematic figurative representations composed of geometric elements and delineated with incised parallel lines or concentric linear patterns.[4]

In 1952 Dehner had her first solo exhibition in New York at the Rose Fried Gallery. She studied engraving at Stanley William Hayter's Atelier 17 in New York, where her desire to make sculpture returned. Earlier, while she was still living at Bolton Landing, she created a few small pieces in wax, but she never exhibited them, nor were they cast in bronze. In the early fifties she began experimenting with wax. Her imagery was derived from her earlier abstract drawings and paintings.

Smith wrote to Dehner in 1944, "I owe my direction to you."[5] The twenty-three years Dehner and Smith spent together were artistically productive ones. Both emerged as mature artists — Dehner, however, yet to fulfill the implications of those years of exploration with abstraction in their full, three-dimensional realization.

JOAN MARTER

INSCRIPTION

recto, lower left center (white crayon): Dehner '51

PROVENANCE

Artist's estate; to the Museum of Art, Munson-Williams-Proctor Institute, Gift of the Dorothy Dehner Foundation for the Visual Arts, 97.28.1

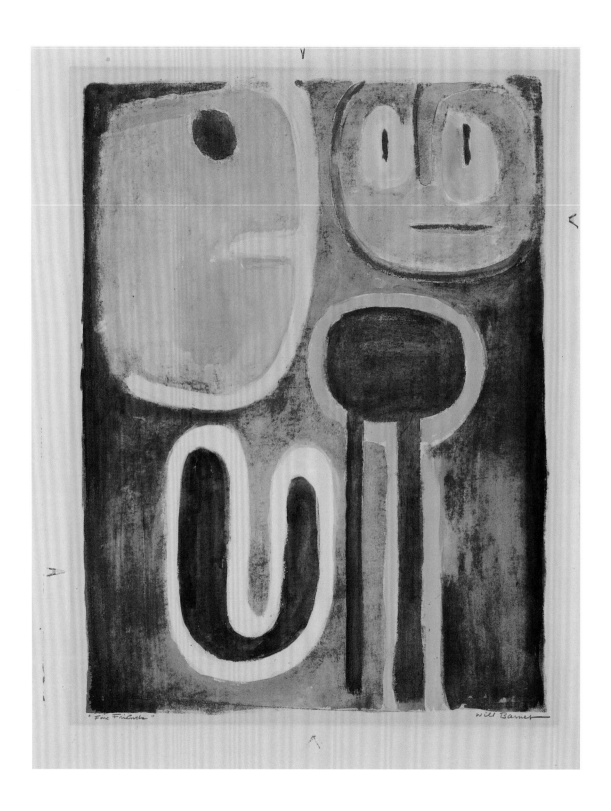

"Five Friends" Will Barnet

110

Will Barnet (born 1911)
Fine Friends, 1952

Transparent watercolor over lithograph on heavy wove Arches paper
29 7/8 x 22 1/4 in.

Will Barnet has an estimable reputation as a central figure in American twentieth-century printmaking, yet he always considered himself primarily a painter. He turned to print-making as a more direct response to contemporary needs, such as social issues, as well as for economic reasons.[1] Because he approached lithography as a painter, Barnet held no preconceived notions about it; he was therefore able to challenge its traditions and champion painterly techniques.[2] During the 1930s Barnet taught printmaking at the Art Students League. In addition to his own prolific output, he printed for other artists, including Louis Lozowick, José Clemente Orozco, Raphael Soyer, and Harry Sternberg. In the 1940s, however, Barnet did not exhibit his own prints because he wanted to heighten his reputation as a painter. Between 1950 and 1952, working with his friend Robert Blackburn at Blackburn's newly founded Printmaking Workshop, Barnet returned to printmaking in earnest, producing seventeen editions of technically challenging, multicolored lithographs, including *Fine Friends*.[3]

Barnet describes *Fine Friends* as a hallmark of change in imagery for him. During the late 1940s he struggled through a stylistic transition to an increasingly abstract mode. "My search … was to find forms that belonged to the pure matter of painting itself but which were equivalent to the substance and the forces that I felt in nature," he stated. "I eliminated realistic space and substituted a painting space based purely on the rectangle; the vertical and horizontal expansion of forms."[4]

While Barnet's spatial conceits flattened, he initially retained representational imagery (his work, however, would grow completely nonobjective as the 1950s progressed). At most stages of his career Barnet's figurative subjects have centered on his family members, and the work he produced in the late 1940s and early 1950s is no exception. The artist notes that his family is interwoven into his subject matter because he is interested in creating work that is at its heart a spiritual celebration of life.[5] The tone of the images from this period, however, assumes a bittersweet nostalgia, as it reflects the tumultuous changes in Barnet's personal life at the time, culminating in a 1952 divorce from his first wife.[6] *Fine Friends,* created at the depths of this emotionally taxing time, depicts the artist's youngest son, Todd, playing with his cat, Bagdiera. Barnet concedes that *Fine Friends* is not drawn from nature but is instead a reinterpretation of life around him. He wrote, "This is connected with my son and his black cat. Like many children he imitated the cat's feelings and actions as if he thought he was a cat. I tried to capture forms that would suggest their sympathetic closeness without being sentimental. To do this I kept the shapes light in weight and at the same time austere."[7]

Fine Friends was featured in the 1952 *Artnews* article, "Will Barnet Makes a Lithograph."[8] Author Dorothy Seckler described the artist's process of developing sketches into the lithograph, the subsequent printing, and refining of the image during the proofing stages. The MWP Arts Institute impression was acquired in 1954, when Barnet had a two-day visiting artist residency during the course of an exhibition of his paintings and prints at the School of Art.[9] This impression is a working color proof. The artist printed an initial key image in black ink (the paper has registrations marks in the margins for multiple-stone color printing) over which Barnet hand-painted the image in watercolors.

WATERMARK

left center (vertical): ARCHES

INSCRIPTIONS

recto, lower left (graphite): "Fine Friends"; lower right (graphite): Will Barnet

PROVENANCE

Bertha Schaefer Gallery, New York; to the Museum of Art, Munson-Williams-Proctor Institute, Purchase, 54.24

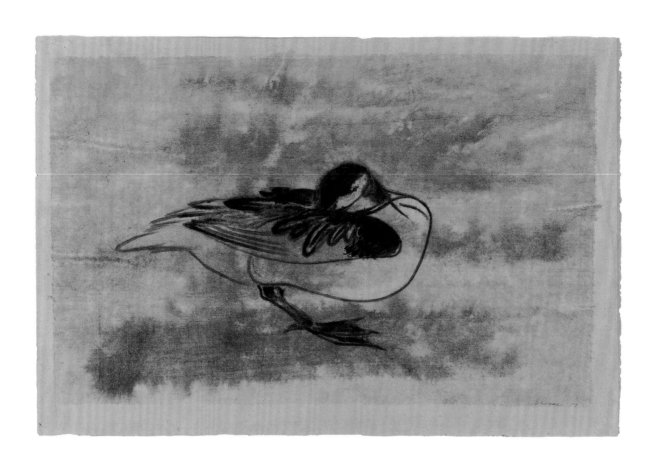

Morris Graves (born 1910)
Resting Duck, 1953
Sumi ink and wash on paper laminate
19 7/8 x 30 3/16 in.

Morris Graves used avian imagery from the earliest years of his career. His studies of a wide variety of species ranged from a poignant series of drawings of a dying pigeon to somewhat more fantastical representations laden with metaphorical associations, including the masked birds Graves exhibited at the Willard Gallery in 1953. Reviewing that show, Fairfield Porter found "the symbolism interesting and annoying,"[1] while James Fitzsimmons, who applauded Graves's superb draftsmanship, objected to anthropomorphizing birds as Graves had done in *Each Time You Carry Me This Way,* an image of a bird with a fish in its mouth.[2]

Resting Duck, created during this period, has less overt symbolic meaning, but the drawing's very simplicity, in imagery and materials, might nevertheless induce introspection. Graves once described the act of drawing as a meditation and that "painting is a way of knowledge."[3] Here, using a limited palette of monochromatic wash over black ink on warm, tan paper, Graves rendered an isolated figure within a larger undefined field. His brushwork is elegant in its ease. The sweeping line of the breast and the pattern of feathers on the wing are exercises in freedom and control in the manner of calligraphy derived from Zen Buddhism, a source of great inspiration for Graves. He sought to work in a state of presence from which painting could flow without false steps and without self-consciousness. In this respect, Graves's method was similar to that of his Abstract Expressionist contemporaries such as Jackson Pollock, who described being "in" his painting, in a virtual trance-like state, during the creative act.

Graves's preferred drawing support during this period was a three-ply sheet comprised of a paper core with thin oriental sheets laminated to either side. The thin papers created a delicate surface with additional texture and greater absorbency for his ink drawing and wash application. In addition to these textural qualities, Graves's materials also bore symbolic meaning in that their fragility and his careful handling of them evoked the preciousness and ephemeral, fleeting nature of life.[4]

INSCRIPTIONS

recto, lower right (brown ink): Graves '53; verso, lower left (graphite): No. 27 [circled] / "Resting Duck" / [erased]: reserved for / Lionel [Bries?]; upper left (graphite): 2 [circled] / 500 / B-408

PROVENANCE

Willard Gallery, New York; to Edward W. Root, Clinton, N.Y.; to Grace Root; to the Museum of Art, Munson-Williams-Proctor, Purchase, 59.13[5]

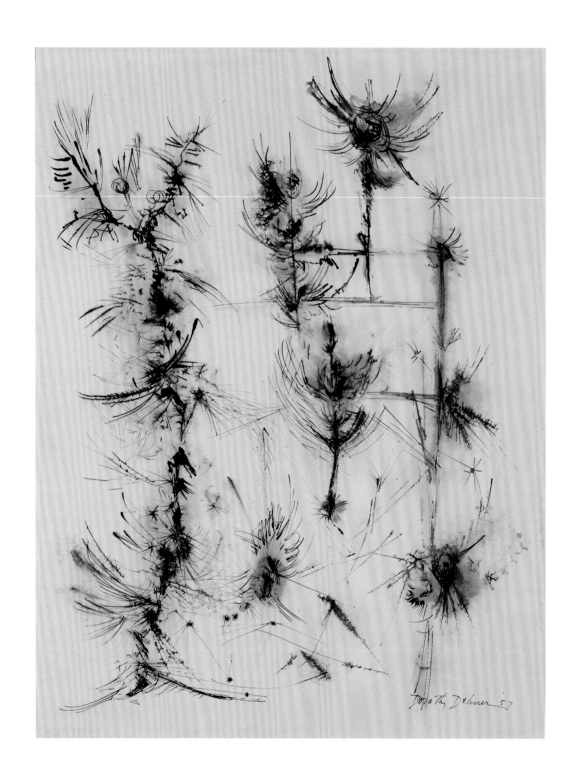

Dorothy Dehner (1901-94)
Dance, 1957

Black ink with transparent watercolor on wove paper
24 7/8 x 18 7/8 in.

By the mid-1950s Dorothy Dehner had taken her place among the artists associated with Abstract Expressionism. The chance effects and spontaneity of her works on paper were similar to the works of others of that group. Like Adolph Gottlieb, Lee Krasner, and Mark Rothko, who preferred working with water-soluble inks on paper, Dehner was a remarkable innovator among watercolorists of the 1950s.[1]

In 1950 Dehner left Bolton Landing, New York, where she had lived with David Smith since the late 1920s. During their decades spent together and in subsequent years apart, they developed themes, explored abstract imagery, and used improvisational methods that are identified with Abstract Expressionism.[2]

Divorced in 1952, Dehner moved to New York City. She began working at the Sculpture Center in 1955 and created a number of small sculptures in wax that were subsequently cast in bronze. Watercolor, pen and ink, and oilstick works on paper from the mid-1950s attest to Dehner's return to a bold abstract format in that decade and anticipate her later sculpture of counterpoised volumetric forms.

Dance is an abstract, improvisational work. Here Dehner applied brilliant color to a wet surface, thus encouraging the creation of amorphous shapes that were accentuated by an ink drawing in overlay. As in many of Dehner's drawings of this period, black ink applied with a pen helped to anchor the composition. Dehner produced a number of these spontaneous drawings in a wet-on-wet format. Some have figurative references, but many are simply splashes of brilliant color on a variable surface with pen and ink accents.[3]

The subject of dance had a long history for Dehner. Born in Cleveland to an affluent family, she was given art and ballet lessons from an early age; she saw the famous ballerina Pavlova perform, and she was sent to Europe in her early twenties. The dance theme continues in her art, particularly in drawings of the 1940s when Dehner produced a series of gavottes, fandangos, and *pas de deux*. Each featured female subjects dancing with skeletons as a modern rendition of the traditional "Dances of Death" theme.[4] By 1957 the subject of the dance assumes the exuberance of her spirit at that time and her confident mastery of the medium. Dehner's drawings found their way into museum collections and private collections in these years, and she was beginning to receive recognition for her sculpture as well.

Sculpture dominated Dehner's interest after 1955 and was complemented by drawings and prints. Some works from the late 1950s and 1960s share Smith's interest in totemic forms, but landscape and still life subjects are also present. Dehner's approach and imagery had by this time taken more personal directions. The surface of the bronze becomes all important — Dehner at times even incising hidden messages into her sculpture by working the surface both before and after the casting. By the late 1950s, however, her work had increased in scale, and her personal imagery had developed. Dehner's sculpture combines issues of monumentality with intimacy and spatial complexity from the outset. In the 1960s her work was scaled to human proportions; her later heroic sculptures in fabricated steel are twenty feet high. As in her works on paper, Dehner balanced formal issues with self-referential, metaphorical imagery.

JOAN MARTER

INSCRIPTIONS

recto, lower right (black ink): Dorothy Dehner '57

PROVENANCE

Willard Gallery, New York; to the Museum of Art, Munson-Williams-Proctor Institute, Purchase, 57.49

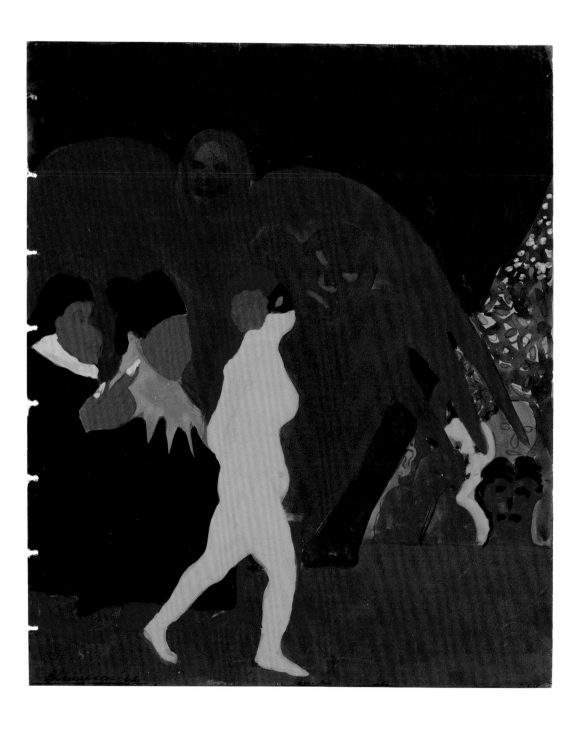

Bob Thompson (1937-66)
Stagedoom, 1962
Opaque watercolor and charcoal on wove paper
21 3/8 x 18 1/4 in.

In a 1965 interview Bob Thompson stated that he began copying compositional elements from old master European paintings, particularly by Piero della Francesca, Poussin, Titian, and Goya, because

> I began to think, my God, I look at Poussin and he's got it all there. Why are all of these people running around trying to be original when they should just go ahead and be themselves and that's the originality of it all. … You can't draw a new form … [the] human figure almost encompasses every form there is … it hit me that why don't I work with these things that are already there … because that is what I respond to most of all.[1]

Thompson appropriated partial and entire compositions but painted freely with hot, saturated colors to refashion the original work into a hypersensual, dreamlike image entirely his own. Thompson scholar Judith Wilson has compared the artist's creative reinterpretations of established painting compositions to that of the jazz musician's improvisations on standards.[2]

Thompson and his wife, Carol, traveled to Europe in 1962 and moved to the Spanish island of Ibiza in August of that year. In Spain Thompson's affinity for the work of Goya deepened. Scholars acknowledge that Goya's jaundiced perspective on humankind's basest instincts was bound to be compelling for the young American painter who was equally fearless in his examinations of the psychological complexities of family life and sexual tensions between men and women.[3] Thompson made a number of large gouache paintings on paper based on *Los Caprichos,* the Spanish master's scathing allegorical study, in eighty intaglio prints, of human weakness and depravity.[4] *Stagedoom,* one of these gouaches, is compositionally derived from *Los Caprichos'* second plate, "El si pronuncian y la mano alargan/Al primero que llega" ("They swear to be faithful yet marry the first man who proposes").[5]

Thompson painted *Stagedoom* on a sheet torn from a large sketchbook. He drew the composition in charcoal over which he painted large areas of flat color. While the composition is very close to that of Goya, Thompson took liberties that are consistent in his oeuvre, and his variations

alter the meaning of the original etching. Thompson's woman is naked (though he retained Goya's mask and placed a flower behind her ear) and her face has no individual features. She is escorted, as if she were a prisoner, by two stout, dwarfish figures with bird-like feet who wear dark robes and hats. Looming over these three are two bird creatures. The closer, blue one is made to look menacing as it leans to scowl at the woman's upraised face. The larger, purple figure hovers behind and spreads its wings in a wide span; Thompson's underpainting shows the face to be smiling, a feature borrowed from Goya's image.

While Goya's intentions about *Los Caprichos* can be cryptic, the players in the second plate all seem morally suspect. The young woman who marries for wealth (thereby selling herself to the highest bidder) parades with unsavory-looking handlers from the church and from the wealthy class above the poor rabble. In his rendition of the composition, however, Thompson typically made the characters' motivations paradoxically more blatant and equivocal. The naked woman, in particular, brazenly displays what she has to offer, but that also makes her look much more vulnerable, more a victim of the circumstances in which she finds herself. The bird-figures, which are virtually ubiquitous in Thompson's work, are interpreted as allegories for forces operating on humankind's actions. Perhaps the most notable change Thompson made was his manipulations of Goya's setting. In both compositions, the central female figure walks before an audience that stands below, but Thompson translated the dark atmosphere of Goya's image into an actual curtain, foregrounding issues about display and voyeurism. *Stagedoom,* then, directly manifests Thompson's belief in the power of drama and theatricality in painting. In 1965 he stated, "I think painting … should be like the theatre, a presentation of something, some activity. … Not only to expose the ability of the artist, but also for the viewer. To relate, like the painters of the Middle Ages, and the Renaissance … painters were employed to educate the people … they could walk into a cathedral, look at the wall and see what was happening. … I am not specifically trying to do that. … I have much more freedom, but in a certain way, I am trying to show what's happening, what's going on … in my own private way."[6]

INSCRIPTIONS

recto, lower left (brown ink, in script): B. Thompson '62; verso, center (felt tip ink, in script): B. Thompson '62/'Stagedoom'

PROVENANCE

Private collection; through Vanderwoude-Tananbaum Gallery, New York, to the Museum of Art, Munson-Williams-Proctor Institute, Purchase, 96.31

ENDNOTES

1 Everett Shinn

1 See Linda S. Ferber, "Stagestruck: The Theatre Subjects of Everett Shinn," *Studies in the History of Art, National Gallery of Art* 37 (1990): 50-67. See also Sylvia L. Yount, "Consuming Drama: Everett Shinn and the Spectacular City," *American Art* 6 (Fall 1992): 86-109, esp. 102-7.

2 The "Eight" were eight artists who exhibited together in 1908 at the MacBeth Galleries, New York, to protest the exclusive practice of juried exhibitions at the National Academy of Design, New York: Arthur B. Davies, William Glackens, Robert Henri, Ernest Lawson, George Luks, Maurice Prendergast, Everett Shinn, and John Sloan. The Eight represented a progressive approach in American art at the turn of the century; they painted with a perceived lack of finish and used urban subjects that were deemed inappropriate or coarse to the jurors of the Academy's annual exhibition.

3 For the American British Art Center, see microfilm 3977, Ala Story Papers, AAA-SI.

4 The Society of Independent Artists was an outgrowth of the Eight's efforts. It was formed by members of the Eight and other artists who created alternative exhibition opportunities that were outside mainstream venues, especially the National Academy.

The Armory Show, the official name for which was the "International Exhibition of Modern Art," was held at the former Sixty-ninth Regiment Armory in New York, from Feb. 17 to Mar. 15, 1913, after which it traveled to Chicago and Boston. Organized by the Association of American Painters and Sculptors, the exhibition included approximately 1300 works by European and American artists. It was a watershed for modern art in the United States and a cause célèbre because it introduced large numbers of Americans to then-radical experiments of modernism, including paintings by van Gogh and Picasso. See Milton W. Brown, *The Story of the Armory Show* (New York: Abbeville Press, 1988).

2 Maurice B. Prendergast

1 Edward Root, who bought *Canal* from Prendergast, dated the work 1912, but it should be noted that Prendergast to Root, May 16, 1912, stated that the watercolor had not been signed when he completed it in Venice. R.G. 13, Artists' Files, F-48A, Edward Root Papers, MWP Arts Institute Archives.

2 Maurice Prendergast to Charles Prendergast, Nov. 26, 1911, microfilm 4543, frame 80, Maurice and Charles Prendergast Papers, AAA-SI.

3 Dec. 14, 1911, frame 101, Prendergast Papers.

4 *Maurice Prendergast Memorial Exhibition* . (New York: Whitney Museum of American Art, 1934), cat. no. 101; the exhibition dates were Feb. 21-Mar. 22, 1934.

5 The Edward Root Papers in the MWP Arts Institute Archives contain four letters from Prendergast in Boston about this transaction: the first, dated May 7, 1912, is to the secretary of the American Water Color Society and instructs him to allow Root to take the painting at the exhibition's close; and there are three to Root in New York, dated May 8, 10 and 16, 1912. In addition there is Herman More's Dec. 15, 1933, request and Root's handwritten draft response. The authors of the catalogue raisonné describe Root as one of the first of the second wave of Prendergast patrons. See Clark et al., *Maurice Brazil Prendergast*, 52-53.

6 Prendergast's unfinished *Rialto Bridge*, on the verso of *Canal*, demonstrates the artist's painting technique.

7 Mathews has observed that Prendergast framed his compositions with Venice's strong architectural profiles and, in so doing, forged a new interpretation of the city, counter to the Whistlerian vignette view. See Nancy Mowll Mathews, *Maurice Prendergast* (Williamstown, Mass., and Munich: Williams College Museum of Art, in association with Prestel-Verlag, 1990), 17-18.

8 Ibid.

9 Addison Gallery of American Art, Phillips Andover Academy, Andover, Mass., catalogue raisonné number 722. The catalogue raisonné identifies this as the Ponte Apostoli, from the Sotto Portico de Magazen.

10 Mathews, *Maurice Prendergast*, 27.

11 Prendergast to Root, May 8, 1912, R.G. 13, Artists' Files, F-48A, Root Papers.

3 Stuart Davis

1 Stuart Davis, interview with Harlan Phillips, May, 1962, transcript, 29-30, AAA-SI.

2 Davis interview, 100. See Hills, *Stuart Davis*, 28-31, for commentary and reproductions of other Davis Armory Show entries; see also Brown, *Story of the Armory Show*, cat. nos. 813-817.

3 Lowery Stokes Sims, *Stuart Davis: American Painter* (New York: Metropolitan Museum of Art 1991), 121, and Hills, *Stuart Davis*, 52.

4 Reproduced in Hills, *Stuart Davis*, 34, fig. 20, and Rebecca Zurier, *Art for the Masses (1911-1917): A Radical Magazine and Its Graphics* (New Haven, Conn.: Yale University Art Gallery, 1985), cat. no. 11, fig. 102.

5 Davis noted, "It certainly was very lucky for me to see this stuff. ... I responded immediately to van Gogh and Gauguin. ... I thought, 'That's it! I have to do something like that.'" Davis interview, 66-68.

4 Marguerite Zorach

1 William Sommer was a Cleveland lithographer and watercolorist who was enthusiastic about the modernist style of painting that William Zorach brought back to him from Europe in 1912.

2 From 1911 to 1915, Thompson contributed pen-and-ink drawings and relief prints to *Rhythm*, an English avant-garde periodical founded by Rice and Fergusson and edited by John Middleton Murry and Katherine Mansfield.

3 See R. K. Tarbell, *Marguerite Zorach: The Early Years, 1908-20* (Washington, D.C.: National Collection of Fine Arts, Smithsonian Institution, 1973) and R. K. Tarbell, "Early Paintings by Marguerite Zorach," *American Art Review* 1 (March-April 1974): 43-57.

4 Tarbell, *Marguerite Zorach*, 29-34.

5 Antony Anderson, "Art and Artists," *Los Angeles Times*, Oct. 20, 1912. She exhibited eight etchings and twenty-five paintings at the Royar Gallery, Los Angeles, from Oct. 21 to Nov. 1, 1912. She used the term "Post-Impressionist" loosely to describe French and German expressionist paintings as British critic Roger Fry had for two shows in the Grafton Galleries, London-1910, "Manet and the Post-Impressionists," and 1912, "Second Post-Impressionist Exhibition."

6 Kandinsky's treatise was published in German in December 1911 and in English as "Extracts from 'The Spiritual in Art,'" *Camera Work* 39 (July 1912): 34. Zorach could read German. See also *The Spiritual in Art: Abstract Painting, 1890-1985* (New York: Abbeville Press and Los Angeles County Museum of Art, 1986).

7 Aloysius P. Levy, *New York American*, Feb. 22, 1913. William Zorach carried a letter of introduction from his Cleveland teacher, Henry G. Keller, to Walt Kuhn and Arthur B. Davies, the prime movers for the Armory Show.

8 Blindness had forced Mary Cassatt to give up painting. During 1914-15 Georgia O'Keeffe studied with Arthur Wesley Dow at Columbia University. Few if any of the American women painters of the Armory Show were exhibiting avant-garde works in New York City in 1914. See *1913 Armory Show: 50th Anniversary Exhibition 1963* (Utica, N.Y.: MWPI, 1963), and Brown, *Story of the Armory Show*.

9 *The Forum Exhibition of Modern Painters* (New York: Anderson Galleries, 1916), unpaginated. She published the poem in the important imagist journal, *Poetry: A Magazine of Verse* (September 1918).

5 Arthur B. Davies

1 Technical analysis was undertaken by James Martin, Director of Analytical Services and Research, Williamstown Art Conservation Center, Williamstown, Mass., to determine the composition of the paint media, but the analysis was incomplete when this catalog was published.

2 See cat. no. 1, note 4.

3 Walter Pach, to Richard B. K. McLanathan, Jan. 14, 1958, MWP Arts Institute Archives. This letter was published in *Arthur B. Davies, 1862-1928, A Centennial Exhibition* (Utica, N.Y.: Munson-Williams-Proctor Institute, 1962), 4-7.

4 There are no inscriptions or labels on the back of the picture, or documentary evidence in MWP Arts Institute's files, to indicate if this was Davies' original title for this work. It seems unlikely in view of Davies' preference for poetic titles.

5 For Davies' declining interest in Cubism around 1916, see Bennard B. Perlman, *The Lives, Loves, and Art of Arthur B. Davies* (Albany: State University of New York Press, 1998), 274, 275, 299. The stylistically similar shapes that overlay the nudes in both *Figures* and Davies' large decorative mural, *The Dances* (Detroit Institute of Arts), suggests the MWP Arts Institute work might actually have been made one or two years earlier. The Detroit picture is dated 1914-15 in Judith Zilczer, *"The Noble Buyer"–John Quinn, Patron of the Avant-Garde* (Washington, D.C.: Hirshhorn Museum and Sculpture Garden, 1978), 81, 154; and in Gail Levin, *Synchronism and American Color Abstraction: 1910-1925* (New York: George Braziller, 1978), 126, n. 33. A small preparatory study for *The Dances*, titled *Day of Good Fortune* (Whitney Museum of American Art, ex coll. Lillie P. Bliss), is dated by Levin to 1914.

6 Davies claimed this compositional device enabled him to preserve the purity of his subjective vision. See Perlman, *Davies*, 226, and Elisabeth S. Sussman, "Rhythm and Music in the Frieze Paintings of Arthur B. Davies," in *Dream Vision: The Work of Arthur B. Davies* (Boston, Mass.: Institute of Contemporary Art, 1981), unpaginated.

7 Perlman, *Davies*, 237-38, 249-55, 258-62. See also Nancy E. Miller, "The Bliss Music Room and Modernism," in *Dream Vision*.

8 The poses of the female figures in *Figures* also appear in Davies' oil painting, *Potentia* (Indiana University Art Museum, Bloomington, Ind.), which has been dated to 1913. The figures in the top half of the MWP Arts Institute work also appear (in reverse) in Davies' 1920 print, *Potentia* (see Frederic N. Price, *The Etchings and Lithographs of Arthur B. Davies* [New York and London: Mitchell Kennerley, 1929], cat. no. 16). Grateful acknowledgment is made to Mary Murray for pointing out that Davies reused the title of the Indiana Art Museum's painting for his 1920 print.

9 A similar arrangement of figures on different ground planes within a Cubist grid appears in the ca. 1914 canvas, *Intermezzo*, illustrated in Perlman, *Davies*, fig. 55.

10 For an illustration of a "simultaneous dress" by Delaunay-Terk, see Marilyn Stokstad et al., *Art History* (New York: Prentice Hall, Inc., and Harry N. Abrams, Inc., 1995), fig. 28-47.

6 George Luks

1 R.G. 13, Diaries and Notebooks, F-22, Edward Root Papers, MWP Arts Institute Archives.

2 See a diary from 1915 with two sketches, a visitor to the MacBeth Galleries and a baseball player, in R.G. 13, Diaries and Notebooks, F-129, Root Papers.

3 See art critic James Huneker's account of visiting Luks at this location, "George Luks, Versatile Painter of Humanity," *New York Times Magazine*, Feb. 6, 1916, 12.

4 See Judith Hansen O'Toole, *George Luks: Expressionist Master of Color, The Watercolors Rediscovered* (Canton, Ohio: Canton Museum of Art, 1994), 11.

5 Dyckman Street marks the northernmost edge of Highbridge Park, about twenty blocks above Luks' home.

6 R.G. 13, Artists' Files, F-89, F-90, Root Papers.

7 Microfilm D292, frames 896-97, Rehn Galleries Papers, AAA-SI. Luks had shown with the Kraushaar Galleries from 1913 to 1924.

8 The Luks material acquired from Mrs. Root also included a small oil sketch entitled *Dyckman Street Cottage*, not dated (MWP Arts Institute).

7 Charles Burchfield

1 Harry Yates Papers, Hamilton College Archives, Clinton, N.Y. Burchfield lived in Gardenville, New York.

2 Ibid.

3 Edward Root and Burchfield shared many passions, including art, music, and a fascination with natural phenomena. The artist's avocation as naturalist, as well as his spiritual affinity with the natural world, is well documented in his journals; see J. Benjamin Townsend, ed., *Charles Burchfield's Journals: The Poetry of Place* (Albany: State University of New York Press, 1993), especially Chaps. 4 and 5. Root, too, kept diaries of nature hikes, garden plantings, and weather reports; in an Apr. 24, 1915 entry, for example, he described an early spring walk through a forest which prompted him to muse philosophically about the pleasures of physical sensations and higher pursuits; see R.G. 13, Diaries and Notebooks, F-129, Edward Root Papers, MWP Arts Institute Archives.

4 Root quickly bought several pieces from the artist and continued to patronize him for several years. See also *Charles Burchfield: Early Watercolors* (New York: Museum of Modern Art, 1930). Root's loans were *Decorative Landscape: Shadow*, cat. no. 6; *Decorative Landscape: Hot Morning Sunlight*, cat. no. 7; *The Insect Chorus*, cat. no. 15; and *Childhood's Garden*, cat. no. 19. The Phillips Memorial Gallery, Washington, D.C., later staged the exhibition *Early Watercolors of Charles Burchfield* from Nov. 1933 to Feb. 1934.

5 See Burchfield's Feb. 6, 1929 letter, microfilm 4547, frames 13-15, Philadelphia Museum of Art Archives, AAA-SI. See also Burchfield's account of meeting Edward Root in *Edward Wales Root (1884-1956): An American Collector* (Utica, N.Y.: MWPI, 1957), unpaginated.

6 In spring 1916 Burchfield's journal entries reveal a serious bout of depression as he found himself at the crossroads of youth and adulthood and facing the conflicted realities of being an artist and making a living. The spiritually inclined young man resented his preoccupations with material and practical concerns. Of his confusion, an Apr. 24, 1916 entry is telling: "In [a] seeming [ly] endless chain, my mind thrashes out landscape problems; the advantages of matrimony; what is the value of friendship; whether to make a sketch or not; the hatred of dogmas; should an artist become a hermit; the futility of method; the sordidness in people['s] faces; self-detestation; composition of weird music; is there anything beautiful in love?–and finally what controls the mind?– ". See Townsend, *Burchfield's Journals*, 78.

7 See, for example, his Sept. 10 entry: "allow design motives in a scene to exist almost

alone — as in markings on tree bark — These designs only will be drawn, all other detail merely suggested." Ibid., 445.

8 Ibid., 443.

9 The color notes here are few and are limited to the lower right corner.

10 The catalogue raisonné lists at least seven 1916 paintings with "poplar" in the title and four for 1917; see Trovato, *Charles Burchfield: Catalogue of Paintings in Public and Private Collections*, nos. 53, 85, 133-35, 138-39, 261, 289, 317, and 324.

8 Charles Burchfield

1 Burchfield to Edward and Grace Root, July 18, 1931, microfilm 4547, frame 34, Philadelphia Museum of Art Papers, AAA-SI. Burchfield was referring specifically to his painting *Childhood's Garden* (ex. coll. Edward Root, now MWP Arts Institute), but the same sentiments apply to *The Insect Chorus*.

2 "Foreword," *Early Watercolors of Charles Burchfield: 1917-1918 Period* (New York: Frank K. M. Rehn Galleries, 1939), unpaginated.

3 A comparison between *The Insect Chorus* and other Aug.-Sept. 1917 paintings of the same subject reveals similar motifs and use of media. See, for example, *Insects at Twilight* (MoMA, Trovato 383), *Cricket Chorus in the Arbor* (priv. coll., Trovato 378), or *Insect Fantasy* (priv. coll., Trovato 384). See also Townsend, *Burchfield's Journals*, 20, n. 27.
 Burchfield recorded similar experiences in his journals over the years. See his Aug. 6, 1913 journal entry, Townsend, *Burchfield's Journals*, 224: "The crickets['] pulsing chorus had commenced. As I went along the stubbled hayfields … I heard some grasshoppers singing. I noticed two distinct kinds– one that gave a continuous song–a steady monotonous ztitzen sound; the other a more varied song– 'Tzt Tzt Tzt Tzt–Zeeeeeeeeee' at intervals. There was a whole fiendish chorus of them in an uncut hayfield near the orchard." See also Sept. 3, 1919 (ibid., 20): "The sulphurous twilight of August pours down from above, & turns all things a ghostly yellow,– Then vaguely the cricket chorus commences to make itself felt–steadily it grows, almost imperceptably [*sic*] till suddenly it is become the full throbbing pulse-like chorus of the late summer night, the dense black shadows form back of the house– The last light vanishes leaving the town to blackness & the crickets."
 As a boy, Burchfield collected insects, a hobby about which he wrote an extensive journal entry in 1911; see ibid, 197-216.

4 See Matthew Baigell, *Charles Burchfield* (New York: Watson-Guptill Publications, 1976), 26, 73-76.

5 Sept. 14, 1917, Townsend, *Burchfield's Journals*, 451.

9 Charles Demuth

1 These paintings provided Demuth with a relatively steady source of income. Jonathan Weinberg, "Demuth and Difference," *Art in America* 76 (April 1988): 191, notes that these commercially successful paintings were "suspect in the eyes of the avant-garde circle around Stieglitz" and were often compared unfavorably with the watercolors of Stieglitz's star, John Marin.

2 Microfilm 2385, frames 193-224, Charles Demuth Papers, AAA-SI.

3 Charles Demuth to Augusta Demuth, Oct. 15, 1921, frame 35, Demuth Papers.

4 The Demuth Foundation in Lancaster, Pa., restored the family garden in 1982-83, based on photographs, oral histories, Demuth's watercolors, and correspondence between the artist and his mother. Thanks to Sylvia Evans, archivist, and Corrine Woodcock, director, Demuth Foundation, for this information.

5 Emily Farnham, *Charles Demuth: Behind the Laughing Mask* (Norman: University of Oklahoma Press, 1971), 44.

6 Quoted in Kermit Champa, "Charlie Was Like That," *Artforum* 12 (March 1974): 54. See also Weinberg, "Demuth and Difference."

7 Farnham, *Charles Demuth*, 149-50, classifies nine types of Demuth still lifes.

8 See Weinberg, "Demuth and Difference," 191-92, and Barbara Haskell, *Charles Demuth* (New York: Whitney Museum of American Art in association with Harry N. Abrams, Inc., 1987), 125-26.

9 Maynard Walker was a dealer who founded galleries in New York and Hollywood during the 1930s.

10 Charles Demuth

1 R.G. 13, Artists' Files, F-7.19, Edward Root Papers, MWP Arts Institute Archives.

2 Ibid., DEM 1.2, DEM 1.3, and DEM 1.4. Demuth had eight one-artist shows at the gallery between 1914 and 1923.

3 Oliver Newberry Chaffee (1881-1944) was a modernist painter and former student of William Merritt Chase, Robert Henri, and Charles Hawthorne. He was a founder of the Provincetown Art Association and exhibited three oil paintings at the Armory Show (cat. nos. 852-834). See Milton W. Brown, *The Story of the Armory Show*, 2 ed. (New York: Abbeville Press and Joseph H. Hirshhorn Foundation, 1988), 254 and Solveiga Rush, *Oliver Newberry Chaffee (1881-1944)* (Cincinnati, Ohio: Taft Museum, 1991).

11 George B. Luks

1 Edward Root's inventory lists that Luks gave him the painting as an "Xmas" gift but incorrectly dates both the painting and the year of the gift as 1912. See R.G. 13, Inventories, Edward Root Papers, MWP Arts Institute Archives.

2 Luks to "John" [?], microfilm P11, frame 403, Philadelphia Museum of Art Papers, AAA-SI.

3 Ameen Rihani, "Luks and Bellows," *International Studio* 71 (August 1920): xxii.

4 According to Luks scholar Judith Hansen O'Toole, Luks first exhibited in the New York Water Color Society Annual in 1913 and won its Hudnut prize in 1916. See *George Luks: Expressionist Master of Color, The Watercolors Rediscovered* (Canton, Ohio: Canton Museum of Art, 1994), 11.

5 See Luks to John Clancy, Aug. 1, 1930, microfilm N70-40, frames 735-37, Rehn Galleries Papers, AAA-SI, in which the artist notified Clancy that he was sending many watercolors he produced that summer.

6 "The World of Art: Varied Exhibitions," *New York Times Magazine*, Nov. 15, 1925, 12.

7 John Loughery, "The Mysterious George Luks," *Arts Magazine* 62 (December 1987): 35. Loughery reviewed "George Luks: An American Artist." See Judith Hansen O'Toole et al., *George Luks: An American Artist* (Wilkes Barre, Pa.: Sordoni Art Gallery, Wilkes College, 1987).

8 See O'Toole, *George Luks: Expressionist Master of Color*. An earlier study, Ralph Clayes Talcott, "The Watercolors of George Luks," (M.A. thesis, Pennsylvania State University, 1970), is not widely accessible.

12 Edwin Dickinson

1 Helen Dickinson Baldwin to the author, Apr. 12, 1999. Ms. Baldwin notes that there are twelve known watercolors in addition to *Pamet River Valley, Truro — Portrait of Ben Atkins*, 1921, Metropolitan Museum of Art; *St. Tropez Yacht Basin in Winter*, 1920, Herbert F. Johnson Museum, Cornell University; *Antoinette Playing the Piano*, Tacoma Art Museum; and nine works in private collections. The Whitney Museum of American Art included only two

watercolors, of 144 objects, in its 1965 Dickinson retrospective; see Lloyd Goodrich, *Edwin Dickinson* (New York: Whitney Museum of American Art, 1965), cat. nos. 105-06.
 Most of Dickinson's watercolors date from 1920-22, but Helen Baldwin, to the author, Apr. 13, 1999, stated that Dickinson's 1930 journal reveals that he produced at least four more watercolors that year.

2 Dickinson stated, "I went there because I thought I would like it and I did" in Katharine Kuh, *The Artist's Voice: Talks with Seventeen Artists* (New York and Evanston, Ill.: Harper & Row, 1962), 77.

3 Elaine de Kooning, "Edwin Dickinson Paints a Picture (1949)," in *Elaine de Kooning: The Spirit of Abstract Expressionism, Selected Writings* (New York: George Braziller, Inc., 1994), 59. De Kooning also remarked that Dickinson was similar to Ryder in that his "abstract method is rooted in an intense view of nature." De Kooning, "Edwin Dickinson," 60.
 Although he traveled frequently, Provincetown was Dickinson's home until 1939, when he bought a house in Wellfleet. He summered there for the next twenty years and spent winters teaching at the Art Students League in New York.

4 Philip Malicoat in *Edwin Dickinson* (Provincetown, Mass.: Provincetown Art Association, 1976), [5].

5 Kuh, *Artist's Voice*, 70.

6 It is possible, however, that this watercolor was painted in the spring. The artist's diaries note that he was in Truro painting "aquarelles" in April 1921. Later entries note frequent trips to Truro but none that correspond with watercolor painting. See microfilm D93, frames 120-50, Edwin Dickinson Papers, AAA-SI.

7 Kuh, *Artist's Voice*, 79. Goodrich, *Edwin Dickinson*, 16, in addition, quoted Dickinson's friend Esther Sawyer: "To Dickinson perspective is a guiding star which lures him ever on to more difficult compositions. Capable draftsman that he is, he is never content to draw the easiest way, but tackles new angles of perspective with every new painting." See also de Kooning, "Edwin Dickinson," 62-63.

8 Jacob Getlar Smith, "Edwin Dickinson: American Mystic," *American Artist* 21 (January 1957): 54-59, 73-75.

13 George B. Luks

1 Luks first exhibited *Daughter* and three watercolors entitled *Mining Village* (nos. 1, 2, and 3) in Oct. 1923 in a group watercolor show at the Kraushaar Galleries; see "Exhibitions." In the exhibition brochure the watercolor is titled *A Daughter of the Mines*, but that has been shortened in subsequent publications to *Daughter of the Mines*. In addition, a 1940s inventory produced by the Rehn Galleries, of paintings and drawings Edward Root had acquired from them, refers to the work more prosaically as "A Miner's Wife." See R.G. 13, Artists' Files, F-88, Edward Root Papers, MWP Arts Institute Archives.
 The Frank K. M. Rehn Galleries later presented "Recent Paintings, Water-Colors and Drawings Done in the Anthracite Coal Regions of Pennsylvania," Nov. 7-18, 1925.

2 Luks, quoted in Charles DeKay, "George Benjamin Luks, Arch Impressionist," *New York Times*, June 5, 1905.

3 At the time of the artist's January 1923 Kraushaar Galleries retrospective, Royal Cortissoz, in "George Luks: A Retrospective of His Paintings," *New York Tribune*, Jan. 14, 1923, noted that Luks' "themes are humanized, always" and that the artist had "nothing anecdotal about him. He has no leaning toward the mood of Balzac or Dickens. … He is a recorder rather than an interpreter." Similarly, critic Peyton Boswell, "Luks Pictures Have Spirit of Hals," *New York American*, Jan. 30, 1927, 4CE, commented, "Nearly all the pictures have Luks types for their subjects. … The fourteen

run the gamut from the Luks urchin to the Luks old lady … [and are] handled with full sympathy, or … gentle Luks irony."

4 "The World of Art: Comments on Some Current Exhibitions," *New York Times Magazine*, Oct. 28, 1923, 10.

5 "The World of Art: Varied Exhibitions," *New York Times Magazine*, Nov. 15, 1925, 12.

6 Judith Hansen O'Toole, *George Luks: Expressionist Master of Color, The Watercolors Rediscovered* (Canton, Ohio: Canton Museum of Art, 1994), 13.

14 Arthur B. Davies

1 Duncan Phillips et al., *Arthur B. Davies: Essays on the Man and His Art* (Washington, D.C.: Phillips Memorial Gallery, 1924), viii, 3.

2 For Phillips's opinion of Davies' Cubist phase see Phillips et al., *Arthur B. Davies*, 3, 6-7, 17-18. For a discussion of the Bliss murals, see Bennard B. Perlman, *The Lives, Loves, and Art of Arthur B. Davies* (Albany: State University of New York Press, 1998), 258-62. See also Nancy E. Miller, "The Bliss Music Room and Modernism," in *Dream Vision: The Work of Arthur B. Davies* (Boston, Mass.: Institute of Contemporary Art, 1981), unpaginated.

3 For Davies' angina, see Perlman, *Davies*, 321; for his relationship with Edna Potter, see ibid., 128.

4 There is no evidence that Davies traveled to North Africa during these years, as was claimed in the version of Davies' obituary published in the *New York Herald Tribune*, Dec. 18, 1928. Bennard B. Perlman to the author, Apr. 1, 1999, MWP Arts Institute Artists' Files.

5 For mention of Davies' visit to Chambord and Loches and illustrations of watercolors painted at Chaumont and Chenonceaux, see "Arthur B. Davies: His Water Colors Done in the Chateau Country," *New York Herald Tribune*, Mar. 1, 1925, sec. 4. For Azay-le-Rideau, see Perlman, *Davies*, 329. From what is known of Davies' travels in France, this was the only summer he painted in the Loire Valley.

6 There is a possibility this work does not depict the château at Blois, for the profile of the building's roof appears less like the mansard roof that dominates that building and more like Chambord, with its conical tops, chimneys, turrets and dormers. The title of the watercolor originated with Hazel J. Lewis, William MacBeth, Inc., to Arthur J. Derbyshire, Oct. 8, 1941, MWP Arts Institute Artists' Files.

7 Davies' use of colored paper dates from the beginning of his career. See Perlman, *Davies*, 19, 253, 313, 322, 336. He shared this interest with his early teacher and life-long friend, Dwight Williams (1856-1932), one of whose pastels, executed on black paper, is in the MWP Arts Institute collection (ex coll. Edward W. Root). A large number of Williams's pastels on colored paper, in a private collection in Cazenovia, N.Y., were examined by the author in Sept. 1988.

8 The sky in the MWP Arts Institute picture may have been prepainted. Davies used this technique in other watercolors of this period. See Perlman, *Davies*, 336, 349.

9 *New York Herald Tribune*, Mar. 1, 1925, sec. 4. For the commercial success of this exhibition, see Perlman, *Davies*, 334. For Lillie Bliss's watercolor purchases at the Feragil Galleries exhibition (Mar. 25-Apr. 8, 1929), held shortly after Davies' death, see ibid., 366.

15 Charles Demuth

1 See Barbara Haskell, *Charles Demuth* (New York: Whitney Museum of American Art, 1987), 138-41.

2 See Anna Tobin D'Ambrosio, *Masterpieces of American Furniture from the Munson-Williams-Proctor Institute* (Utica: MWPI, 1999), 10-24, for a history of the Institute's founding family.

3 Biographical information on Mrs. Lowery is from her son, James, to whom I am very grateful. Mrs. Lowery donated more than one hundred engravings after William Barlett's views of New York State; *Siesta* by Alexander Brook; *Morewood Heights* by John Kane; a Tiffany vase and a nineteenth-century French silk table cover; a Diego Rivera lithograph; seventeenth-century Dutch etchings; and Japanese woodblock prints.

4 See Paul Schweizer et al., *Masterworks of American Art from the Munson-Williams-Proctor Institute* (Utica, N.Y.: MWPI, 1989), cat. no. 54, 120-21.

16 Edward Hopper

1 See Gail Levin, *Edward Hopper: An Intimate Biography* (New York: Alfred A. Knopf, 1995), 171-72.

2 Levin, *Edward Hopper: A Catalogue Raisonné*, 2:42, cat. no. W-72.

3 Ibid., 2:104, cat. no. W-135.

4 Ibid., 2:105, cat. no. W-136.

5 Ibid., 3:226-27, cat. no. O-288.

6 For recent photographs of the house and the view from the roof, see Gail Levin, *Hopper's Places* (Berkeley: University of California Press, 1998), xiv and 22.

7 See Levin, *Edward Hopper: A Catalogue Raisonné*, 2:309, cat. no. W-340.

17 Edward Hopper

1 Bernard Myers, ed., "Scribner's American Painters Series, No. 7," *Scribner's Magazine* 102, September 1937, 32.

2 See Levin, *Edward Hopper: A Catalogue Raisonné*, 2:119-2:122 and 2:125, cat. nos. W-150–W-153 and W-156.

3 See Roger Tory Peterson, *A Field Guide to the Birds* (Boston: Houghton Mifflin Company, 1947), 69.

4 Edward Hopper to Frank K. M. Rehn, July 6, 1926, quoted in Gail Levin, *Edward Hopper: An Intimate Biography* (New York: Alfred A. Knopf, 1995), 198.

5 Ibid.

18 George B. Luks

1 R.G. 13, Artists' Files, F-33, Edward Root Papers, MWP Arts Institute Archives. See also, "The World of Art: Varied Exhibitions," *New York Times Magazine*, Nov. 15, 1925, 12, and Perdita Pence Howell, "Trapped: Life in Coal Field Is Put on Canvas by Celebrated Painter," *Pottsville Journal*, Sept. 26, 1925, 1.

2 See Matthew Baigell, *Charles Burchfield* (New York: Watson-Guptill, 1976), 86-121.

19 John Marin

1 This painting was first published in E. M. Benson's 1935 monograph as *Abstraction, Lower Manhattan*. Since the MWP Arts Institute purchased the work it has been known as *Middle Manhattan Movement*. Sheldon Reich, in his Marin catalogue raisonné, used "*Middle Manhattan Movement* or *Abstraction, Lower Manhattan*." Ruth E. Fine, in *John Marin* (Washington, D.C.: National Gallery of Art, 1990), 146, fig. 137, conflates the two with *Middle Manhattan Movement Abstraction, Lower Manhattan*.

2 See Barbara Dayer Gallati's analysis of Marin as heir to Winslow Homer and leader of American watercolor painting in Linda S. Ferber and Barbara Dayer Gallati, *Masters of Color and Light: Homer, Sargent and the American Watercolor Movement* (Brooklyn, N.Y.: Brooklyn Museum of Art, 1998), 149-52.

3 Marin to Elizabeth Navas, undated, microfilm D251, frame 1050, Elizabeth Navas Papers, AAA-SI.

4 Marin to Charles Duncan, late Sept.-early Oct. 1948, microfilm 3134, frame 542, Charles Duncan Papers, AAA-SI.

5 See Fine's discussion of the work in *John Marin*, 146.

6 An inscription or possibly a previous signature has been erased approximately two inches above the signature. Marin probably changed the placement himself, as if the first were too high.

20 Henry E. Schnakenberg

1 In the 1930s Schnakenberg was also the secretary of the American Society of Painters, Sculptors and Gravers, and in the 1940s he was vice-president of the Artist's Equity Association. In 1951 he was elected to the American Institute of Arts and Letters.

Schnakenberg eventually donated his collections of Egyptian, ancient Greek, pre-Columbian, and Asian objects, works on paper, and paintings by French and American artists to the Wadsworth Atheneum in Hartford, Conn. During the 1950s and 1960s he also contributed money toward the purchase of contemporary art work and other museum projects. See the Charles C. Cunningham Papers, Wadsworth Atheneum Archives.

2 Schnakenberg, like so many aspiring artists in the United States, was deeply affected by the Armory Show, but he was less moved by European modernism than he was by paintings by Robert Henri and his followers (see cat. no. 1, note 2). He subsequently enrolled as a full-time student with Kenneth Hayes Miller at the Art Students League. See Charles C. Cunningham, *The Paintings of Henry Schnakenberg/The Sculptures of Henry Kreis* (Hartford, Conn.: Wadsworth Atheneum, 1955), 3.

3 Forbes Watson, "Young America — H. E. Schnakenberg," *Arts* 5 (March 1923): 223-24.

4 Margaret Breuning, "The Realism of H. E. Schnakenberg," *International Studio* 84 (August 1926): 58-62.

5 Lloyd Goodrich, *H. E. Schnakenberg*, American Artists Series (New York: Whitney Museum of American Art, 1931), 10.

6 Henry McBride, *New York Sun*, Nov. 23, 1935.

7 Royal Cortissoz, *New York Herald Tribune*, Nov. 17, 1935.

8 Goodrich, *Schnakenberg*, 7.

9 Cortissoz, "Schnakenberg Finds Subtlety," *Art Digest* 8 (Dec. 15, 1933): 12.

10 Cortissoz, "Schnakenberg Organizes and Records Truth," *Art Digest* 14 (Mar. 1, 1940): 17.

11 Edward Alden Jewell, *New York Times*, Nov. 19, 1933.

12 Schnakenberg to Elizabeth Navas, ca. 1950, microfilm D251, frame 1081, Elizabeth Navas Papers, AAA-SI.

13 It is possible that the image depicts Equinox Pond and Mount Equinox in Manchester.

21 Jacob Getlar Smith

1 See Jacob Getlar Smith, "Edwin Dickinson: American Mystic," *American Artist* 21 (January 1957): 73.

2 Smith wrote, "It was Edwin Dickinson who, in those early days of my own career made me realize the hidden potentialities of watercolor; that is was far more than a display of shallow mannerisms fit only for the trickster." See Smith, "Edwin Dickinson: American Mystic," 73.

The cape itself was a revelation to Smith. Three decades after his initial visit, he enthusiastically characterized the appeal the New England coast held for a landscapist: "What glorious holiday awaits the artist … visions of stately eighteenth century sea captain's homes, white clapboard cottages drowned in petunias and roses, fishing fleets … miles of quiet beaches and sand dunes … [and] the ever-present consciousness of a restless and tormenting sea." See Jacob Getlar Smith, "Sketching Grounds I Have Roamed," *American Artist* 20

(May 1956): 57; Smith regretfully observed, though, that Provincetown by the 1950s had become "arty." Smith's son, artist David Loeffler Smith, later wrote that a sensitive artist living on the cape could not escape the allure of Winslow Homer's watercolors. See David Loeffler Smith, "The Heritage of the Thirties," *American Artist* 26 (October 1962): 74.

3 See David Loeffler Smith, "Heritage of the Thirties," 27-31, 74-77.

4 See also *Jacob Getlar Smith Memorial Exhibition, Watercolors 1928-1956* (New York: Babcock Galleries, 1959), nos. 2 and 3; the exhibition dates were Oct. 26-Nov. 14, 1959.

5 Jacob Getlar Smith, "The Watercolors of Winslow Homer," *American Artist* 19 (February 1955): 22.

6 Review in Smith's scrapbook, microfilm 724, frame 5, Jacob Getlar Smith Papers, AAA-SI. Smith also exhibited work in the 1931 Carnegie International; the Art Institute of Chicago's 44th Annual; and the Pennsylvania Academy of the Fine Arts' 29th Annual Watercolor and 30th Miniature Exhibition.

7 Frame 27, Smith Papers.

8 Jacob Getlar Smith, *Watercolor Painting for the Beginner* (New York: Watson-Guptill, 1951). See also an excerpt from the book, "Approaching the Outdoor Subject," *American Artist* 16 (June 1952): 77-79.

9 In the 1950s Smith wrote extensively for *American Artist*, including a five-article series on American watercolorists: "Watercolors of Winslow Homer," 19 (February 1955): 18-23; "Watercolors of John Singer Sargent," 19 (March 1955): 26-31; "Watercolors of Charles Demuth," 19 (May 1955): 26-31; "Watercolors of Childe Hassam," 19 (November 1955): 50-53, 59-63; and "Watercolors of Maurice Prendergast," 20 (February 1956): 52-57, 68. See also "Edward Hopper," 20 (January 1956): 22-27; "George Inness," 20 (April 1956): 28-33; "The Enigma of Thomas Eakins," 20 (November 1956): 28-33; "British Masters of Watercolor," 21 (March 1957): 20-25; "Edwin Dickinson: American Mystic," 21 (January 1957): 54-59, 73-75; and "Frank Duveneck–Missionary," 21 (April 1957): 36-41.

22 Herman Trunk

1 See the reviews "Ten Years of Herman Trunk," *New York Sun*, Jan. 21, 1932, and Edward Alden Jewell, "Art," *New York Times*, Jan. 23, 1932.

2 The Trunk literature is very slim. The most complete biography to date is Meredith Ward, *Herman Trunk (1894-1963): Paintings and Watercolors* (New York: Hirschl & Adler Galleries, Inc., 1989).

3 *The World*, May 28, 1926. In a May 20, 1926, letter to Trunk, Leray Dudensing exclaimed, "Forbes Watson, one of the ablest art critics in New York City has BOUGHT one of your little water colors; that is a sale of considerable importance all around." Herman Trunk correspondence, C-29, Trunk notebook at the Hirschl & Adler Galleries, Inc., New York. My thanks to Eric Baumgartner of Hirschl & Adler for sharing the galleries' files with me.

4 *New York Sun*, Dec. 18, 1926.

5 *New York American*, Dec. 19, 1926.

6 *Brooklyn Daily Eagle*, Oct. 30, 1927.

7 In addition to *Haying* Edward Root also bought a small still life that he left to his wife Grace.

8 See also Trunk's *Summer Landscape*, ca. 1930 (Harn Museum of Art, University of Florida, Gainesville), in which he framed a similar landscape with two trees.

23 Charles Burchfield

1 Object file VIII-28 at the Burchfield-Penney Art Center at Buffalo State College, Buffalo, N.Y., notes that the painting's location is "Swamp on Jamison Rd. (East of Elma) [Gar-

denville]." See the schematic map of the region in Joseph S. Trovato, *Charles Burchfield: Catalogue of Paintings in Public and Private Collections* (Utica, N.Y.: MWPI, 1970), 100.

2 See Patricia Hamm and Nancy Weekly, "Beyond Imagery: An Overview of Charles Burchfield's Materials and Techniques," *Watercolor* 3 (Spring 1997): 116-28.

3 Townsend, *Burchfield's Journals*, Apr. 28, 1932, 345. At about the same time Burchfield painted the Utica image, he created *Study of Skunk Cabbage* [Trovato 772], which the artist called *Skunk Cabbage (Small)*, 15 x 22 in. See also *Life*, Dec. 28, 1936, which includes a photograph of the artist holding another *Skunk Cabbage* painting.

4 Burchfield to Edward and Grace Root, Apr. 25, 1932, microfilm 4547, frame 40, Philadelphia Museum of Art Papers, AAA-SI.

5 In 1982 the Williams College Museum of Art acquired Georgia O'Keeffe's 1922 painting *Skunk Cabbage (Cos Cob)* and subsequently produced the exhibition and catalog *Georgia O'Keeffe: Natural Issues*. The catalog includes an interesting essay by Charles C. Eldredge, "Skunk Cabbages, Seasons & Series," 26-43, that provides valuable context for the Burchfield painting. About the plant itself, Eldredge writes, "As early as February, often before the final melting of winter's mantle, it pierces the frozen ground, its tough hooded spathe literally melting its way through with its own living heat. Whereas in any other month the smelly, swampy *symplocarpus foetidus* might pass unnoticed but by naturalists and herbalists, its early blossoming brings annual proof of nature's rejuvenation and claims for the plant a special niche in the imagination" (30).

6 Townsend, *Burchfield's Journals*, Apr. 8, 1932, 484.

24 Stuart Davis

1 Stuart Davis, interview with Harlan Phillips, May 1962, transcript, 63, Stuart Davis Papers, AAA-SI.

2 Davis interview, 75.

3 Ibid., 63. According to Davis, his parents bought a small house in Gloucester and he spent "many summers" there. Ibid., 177.

4 Ibid.

5 "EL'L" could refer to Louis and Christine Ell, restauranteurs and members of the Greenwich Village-Provincetown crowd that dated from the 1910s; see Emily Farnharm, *Charles Demuth: Behind the Laughing Mask* (Norman: University of Oklahoma Press, 1971), 79, 81. Sharon Worley, curator of the Cape Ann Historical Association, to author, Aug. 6, 1999, also proposed that "EL'L" might refer to Gloucester waterfront business owners named Elwell or Ellis.

About this time Davis incorporated the gas pump into several paintings, including *Landscape with Garage Lights*, 1932 (Memorial Art Gallery, University of Rochester, Rochester, N.Y.) and *New York Mural*, 1932 (Norton Museum of Art, West Palm Beach, Fla.).

6 Worley notes that "Black Roofs" might refer to tar paper waterfront buildings of the area and that an elegant Eastern Point home owned by A. Piatt Andrew (1873-1936) was called "Red Roof."

7 Davis underscored the independent objectness of *Black Roofs* by framing the image in vibrant colors. Like Marin and other modernists, Davis had used various framing devices for several years on both oils and water-based paintings. For another example of multicolored margins, see *Summer Landscape*, 1930 (Museum of Modern Art, New York).

8 Davis to Elizabeth Navas, Aug. 16, 1944, microfilm D251, frame 1005, Elizabeth Navas Papers, AAA-SI.

9 Ibid.

10 Ibid.

25 John Marin

1 Marin to Charles Duncan, microfilm 3134, frames 544-45, Charles Duncan Papers, AAA-SI.

2 See Fine, *John Marin* 233, 237. Reich, *John Marin,* lists no other Lake Champlain subjects for 1931.

3 Examination report, Williamstown Art Conservation Center, Williamstown, Mass., MWP Arts Institute Artist's Files. Special thanks to Leslie Paisley, WACC Paper Conservator. See also Fine, *John Marin,* 201.

4 Quoted in Fine, *John Marin,* 201, 203.

26 Reginald Marsh

1 Lloyd Goodrich, *Reginald Marsh* (New York: Harry N. Abrams, Inc., 1972), 30.

2 Reginald Marsh, artist's statement, Feb. 24, 1947, microfilm N675, frames 612-13, Whitney Museum of American Art Papers, AAA-SI.

3 Ibid.

4 Felicia Marsh bequeathed five studies to the MWP Arts Institute Museum of Art, 79.16-79.20. The Marsh Estate Inventory lists Untitled (*Lower Manhattan*) as: "1931 Wc 31-2//Mrs. Reginald Marsh////Watercolor/13-15/16 x 19-15/16////Rehn Gallery." See microfilm 2233, frame 471, Marsh Papers, AAA-SI.

Prior to Felicia Marsh's bequest, the museum already owned four Marsh paintings and six works on paper; in 1984 it received two additional small paintings and a print from Dr. and Mrs. Stephen Walker, Utica collectors.

5 See, for example, drawings from sketchbook 100 in microfilm NRM-7, frames 377-78; sketchbook 104, frames 492-93; or sketchbook 157, microfilm NRM-10, frames 356-374, Marsh Papers.

6 See microfilm NRM-10, frames 647-77, Marsh Papers.

7 Ibid., frame 666.

8 Goodrich, *Reginald Marsh,* 161.

27 Edward Hopper

1 See, for example, Levin, *Edward Hopper: A Catalogue Raisonné,* 2:244, cat. no. W-275; 2:245, cat. no. W-276; and 3:210, cat. no. O-278.

2 See Gail Levin, *Edward Hopper: An Intimate Biography* (New York: Alfred A. Knopf, 1995), 258-64.

3 For reproductions of see Gail Levin, *Edward Hopper, The Complete Prints* (New York: W.W. Norton & Co., 1979).

4 For both the Jacob Jordaens painting and Vincent van Gogh's *Study of Cows, after Jacob Jordaens,* see the collection of the Museé des Beaux-Arts, Lille, France.

5 See Levin, *Edward Hopper: A Catalogue Raisonné,* 3:150, O-236.

6 See ibid., 3:182, cat. no. O-260 and 2:175, cat. no. W-206. Jo's record book entry identifies *Cape Ann Granite* as a "green pasture on hill with rocks."

7 See Levin, *Edward Hopper: An Intimate Biography,* 102-22, and Gail Levin, *Edward Hopper as Illustrator* (New York: W.W. Norton & Co., 1979).

8 Robert Frost, *North of Boston* (London: David Nutt, 1914).

9 Lewis Mumford, "Botched Cities," *American Mercury,* October 1929, 143-50. For more on Hopper's attitude toward urban life and his friendship with Mumford, see Levin, *Edward Hopper: An Intimate Biography.*

28 Howard N. Cook

1 Howard Cook, autobiographical note to Carl Zigrosser, microfilm 4617, frame 486, Carl Zigrosser Papers, AAA-SI. Zigrosser initially worked at the Weyhe Gallery, New York, which represented Howard Cook, and then became the curator of prints at the Philadelphia Museum of Art.

2 After more than a decade of renting, the Cooks bought a small spread in Talpa, five miles from Ranchos de Taos, in 1939. In the late 1950s and early 1960s Cook was diagnosed with multiple sclerosis, so the couple moved first to Roswell, then to Santa Fe, for better access to medical treatment.

3 Cook, Ranchos de Taos, to artist-illustrator James Allen, 1943, microfilm 324, frames 479-80, James Allen Papers, AAA-SI.

4 Cook to Zigrosser, Dec. 28, 1927, and Oct. 17, 1937, respectively. Frames 452 and 629, Zigrosser Papers.

5 Cook to Zigrosser, June 2, 1935, frame 589, Zigrosser Papers.

6 Cook to Zigrosser, Oct. 17, 1937, frame 631, Zigrosser Papers.

7 Cook to Zigrosser, Sept. 18, 1941, frames 703-04, Zigrosser Papers. Cook's self-reflection was inspired by having read about himself in Zigrosser's manuscript for *The Artist in America: Twenty-Four Close-ups of Contemporary Printmakers* (New York: Alfred A. Knopf, 1942).

8 Cook to Zigrosser, Oct. 29, 1940, frame 689, Zigrosser Papers.

9 Frame 1159, Zigrosser Papers. The other two watercolors are *Mesa in Spring* and *Rain on the Mesa.*

10 See, for example, "A Cook Tour," *Art Digest* (Feb. 15, 1937): 6, and "Critics Note Native Flavor in Cook Prints," *Art Digest* (Mar. 1, 1937): 24.

29 Federico Castellón

1 As a teenager and aspiring professional artist from Brooklyn, Castellón attracted the attention of Diego Rivera and Carl Zigrosser of the Weyhe Gallery. Through Zigrosser, Castellón had five works, cat. nos. 531a-535, exhibited in the Museum of Modern Art's 1936 *Fantastic Art, Dada, Surrealism;* he was included in the curious and eclectic section entitled "Artists Independent of the Dada and Surrealist Movements" along with others such as Alexander Calder, Arthur B. Dove, Walker Evans, Katherine S. Dreier, Walt Disney, Rube Goldberg, Isamu Noguchi, Georgia O'Keeffe, and James Thurber.

For more biographical information on Castellón, see August L. Freundlich, *Federico Castellón: His Graphic Works, 1936-1971* (Syracuse, N.Y.: Syracuse University Press, 1971); Jerald R. Green, "Federico Castellón: Reivindicacion para un surrealista español," *Goya* 240 (May/June 1994): 349-54; and the transcript of Paul Cummings' 1971 interview, the untranscribed taped 1967 interview with Karl Fortess, and microfilms D297 and 74, Castellón Papers, AAA-SI.

2 R.G. 13, Inventories, Edward Root Papers, MWP Arts Institute Archives.

3 Castellón interview with Cummings, 30.

4 Clark-Langager, *Order and Enigma,* 68-69.

5 Castellón interview with Cummings, 30. Castellón described the artists whose work he admired — Michelangelo, El Greco, and Blake — as mystics as well. As for the Surrealists, he found that they "purposely make it irrational in order to shock . . . it's almost as if to say that — if you're a poet, don't worry about writing good poetry, if you recite it loud enough it will be effective." Castellón interview with Cummings, 83.

6 Castellón interview with Fortess.

7 Castellón explained, for example, that a beautiful landscape held no artistic inspiration for him. "In my own work ... I've never done anything directly from anything and I felt that an artist is in his head and we're not interpretive, we're creative artists." Castellón interview with Cummings, 45; see also 31.

8 While the black paper is a natural choice for Castellón's subject matter, one gets the impression of a young artist experimenting with materials, particularly as one reviews the types of drawings listed for the 1936

Weyhe Gallery show. It is interesting to note that for another work from the museum's collection, *Growth Forms,* done in Paris earlier in 1936, Castellón painted a sheet of white paper black on the recto before creating a similar, Surrealist landscape.

9 Castellón interview with Cummings, 49.

10 Edward W. Root to Carl Zigrosser, May 10, 1938, microfilm 4639, frame 351, Carl Zigrosser Papers, AAA-SI.

30 Charles Howard

1 See Stacey Moss, *The Howards: First Family of Bay Area Modernism* (Oakland, Calif.: Oakland Museum, 1988). See also Susan M. Anderson, *Pursuit of the Marvelous: Stanley William Hayter, Charles Howard, Gordon Onslow Ford* (Laguna Beach, Calif.: Laguna Art Museum, 1990) for Charles Howard chronology, 56-57, and bibliography, 60-61.

2 Initially Howard found the bustling city ripe with easy subject matter for a painter — "You turned it on like a faucet. It was wonderful, and easy as pie" — but the move abroad jarred his complacency and stimulated a quest for deeper meaning in his work. Howard admitted, "It took a simple accident of displacement to indicate the existence of far richer ore, lying there for free and the taking. The following years of close work finding a way to mine the ore were worth it." Charles Howard, "What Concerns Me," *Magazine of Art* 39 (February 1946): 64.

3 See Susan Compton, ed., *British Art in the 20th Century* (Munich: Prestel-Verlag, 1986), esp., Charles Harrison, "Critical Theories and the Practice of Art," 56-57, Susan Compton, "Unit One — Towards Constructivism," 214-15, and Andrew Causey, "Unit One — Towards Surrealism," 216-17; and Charles Harrison, *English Art and Modernism, 1900-1939* (Bloomington: Indiana University Press, 1981), esp. Chaps. 9-11, 231-332.

4 Howard, "What Concerns Me," 64.

5 See Howard's statement in Dorothy C. Miller, ed., *Americans 1942: 18 Artists from 9 States* (New York: MoMA, 1942), 75, in which he acknowledged, "I have welcomed the influence of other painters. I don't believe in pure originality and in the elaboration of my work I have relied upon my own obsession. If that weren't strong enough to integrate its own expression, it seems to me it would be no use painting anyway."

6 Douglas MacAgy, in *Charles Howard: Retrospective Exhibition 1925-1946* (San Francisco: California Palace of the Legion of Honor, 1946), 111, reported that Howard had been described as an abstract artist and a Surrealist. Basil Taylor, in *Charles Howard* (London: Whitechapel Art Gallery, 1956), 9, described Howard's painting as belonging to "that sector of non-figurative painting which abuts upon the territory of the Surrealists, or ... upon the world of forms which belong beneath the surface of natural appearances ... the world of the unconscious mind."

7 See Susan M. Anderson, "Journey into the Sun: California Artists and Surrealism," in *On the Edge of America: California Modernist Art, 1900-1950,* ed. Paul J. Karlstrom (Berkeley and Los Angeles: University of California Press, 1996), 193: "[Howard's] Surrealism shared the abstract formalism of the work of Jean Arp and Alexander Calder, which favored the traditions of Cubism, Constructivism, and De Stijl."

8 *Charles Howard: Retrospective Exhibition 1925-1946,* 111. Basil Taylor wrote, as well, that Howard painted with "intuition which he slowly disciplined, clarified and brought under control. ... His work declares very explicitly a balance between reasoned construction and free intuition," in *Charles Howard,* 9.

9 These include the annuals of the Whitney Museum of American Art, the Art Institute of Chicago, and the San Francisco Museum of Art; *Americans 1942,* the Museum of Modern

Art; *Artists for Victory,* Metropolitan Museum of Art; and the inaugural *Art of This Century* exhibition, all 1942; culminating in a 1946 retrospective at the California Palace of the Legion of Honor.

10 In November of that year Howard had a one-artist show at Nierendorf, but it was typical of Root to study an artist's work through his/her first gallery exhibitions and Whitney Museum annuals before buying something according to his own schedule of understanding and appreciation of the artist's endeavors.

31 Adolf Dehn

1 For an overview of Dehn's career, see Carl Zigrosser, *The Artist in America: Twenty-four Close-Ups of Contemporary Printmakers* (New York: Alfred A. Knopf, 1942), 14-23; Richard Cox, "Adolf Dehn: The Life," in *The Prints of Adolf Dehn: A Catalogue Raisonné* (St. Paul.: Minnesota Historical Society Press, 1987), 1-25; and *Nature and Human Nature: The Art of Adolf Dehn* (Baton Rouge: Louisiana Arts and Science Center, 1995). See also the Dehn Scrapbooks, AAA-SI.

2 In 1952, for example, Dehn wrote, "Thinking abstractly of my picture, it should have balance, rhythm, form. The design should be the structure, should inextricably be part of my statement about the subject. It should aid and abet the excitement, the feeling which I wish to convey." *Contemporary American Painting* (Urbana: University of Illinois, 1952), 185.

3 Adolf Dehn, *Water Color Painting* (New York and London: The Studio Publications, 1945), 30-31. Dehn stated that he used a lithography crayon or soft pencil for his outdoor sketches, which he completed in "10 minutes or 2 hours," just enough time to capture the data for the watercolor. Moreover, he took liberties with local color, though he tried "to remember the big color scheme of the particular view."

4 *Chicago Evening Post Magazine of the [Arts],* Mar. 15 [1925, 1926, or 1927], Dehn Scrapbooks.

5 Weyhe Gallery, Mar. 27 to Apr. 15, 1939.

6 It is interesting to compare the published version of the text with Dehn's more colorful manuscript in the Dehn Papers, AAA-SI.

7 The Garden of the Gods, an 850-acre park owned by the city of Colorado Springs, is noted for its projecting sandstone rock formations that provide a gateway to Pike's Peak. Dehn's other compositions of this site include a watercolor, reproduced in his book, *Water Color Painting,* 71, and a lithograph in Zigrosser, *Artist in America,* opposite page 17.

8 See *Water Color Painting,* 21, in which Dehn describes his techniques for creating cloud formations.

Dehn exhibited his work from this initial excursion in "Watercolors by Adolf Dehn," Weyhe Gallery, Apr. 29 to May 18, 1940, which received wide publicity through a review in *Time,* May 13, 1940, 59. The review noted further that Dehn simultaneously exhibited twenty-two watercolors, in a gallery by themselves, at the *International Water Color Show* at the Art Institute of Chicago.

32 Jacob Getlar Smith

1 Smith, *Watercolor Painting,* 80.

2 Ibid., 37.

3 Ibid., 59.

4 Ibid., 61.

5 Kermit I. Lansner, "Reviews and Previews: Jacob Getlar Smith," *Artnews* 52 (January 1954): 67. See also "6 Varied Shows Here Varied in Styles," *New York Times,* Jan. 9, 1954: "Watercolors by Jacob Getlar Smith at the Babcock Galleries depict the contemporary American scene (ramshackle main streets, lordly Texan landscapes, etc.) with gusto and, when the occasion merits it, with much humor."

33 Alexander Calder

1 "Alexander Calder: Sculptures and Constructions," Sept. 29, 1943 to Jan. 16, 1944; catalog by James Johnson Sweeney.

2 Marla Prather, *Alexander Calder, 1898-1976* (Washington, D.C., New Haven, Conn., and London: National Gallery of Art and Yale University Press, 1998), 142.

3 Calder, undated, unpublished manuscript, microfilm 2520, frame 624, Agnes Rindge Claflin Papers, AAA-SI.

4 Calder, Oct. 1943 unpublished manuscript, frame 635, Claflin Papers.

5 Quoted in Jean Lipman, *Calder's Universe* (New York: Viking Press, in association with the Whitney Museum of American Art, 1976), 119. Lipman further observed that gouache suited Calder more than either "transparent watercolors (too pale) or oils (too slow)." By the early 1950s Calder established painting studios specifically for gouache. He typically closed up windows and painted in artificial light. About his method he wrote, "'I would moisten the paper with a flow of water and wait till it dried a bit but not too much. Then I would draw on it with a brush full of china ink.'" *Calder: An Autobiography with Pictures* (New York: Pantheon Books, 1966), 214.

6 Reproduced in *Alexander Calder, 1898-1976,* 223, pl. 188.

7 Katharine Kuh, *The Artist's Voice: Talks with Seventeen Artists* (New York and Evanston, Ill.: Harper & Row, 1962), 39.

8 Calder, Oct. 1943 unpublished manuscript, frame 635, Claflin Papers.

34 Lionel Feininger

1 See, for example, Margaret Breuning, "Feininger Continues His Inventive Way," *Art Digest* 20 (Feb. 15, 1946): 11, who praised the watercolors as "alluring" and found them superior to the oils. See also "Feininger: Two Angles in New Painting," *Artnews* 44 (February 1946): 89, and "Our Box Score of the Critics," *Artnews* 45 (March 1946): 58, synopses of newspaper critics' reviews; Carlyle Burrows of the *Herald-Tribune* is the only one quoted to find the work repetitious. Thomas B. Hess, in "Feininger Paints a Picture," *Artnews* 48 (Summer 1949): 48-50, 60-61, would later write that while watercolors for Feininger existed as a creative expression in themselves, the medium also served in the conceptual and formal development of an idea as a stage between charcoal drawing and oil painting.

2 See John Fabian Kienitz, *College Art Journal* 4 (May 1945): 237-39.

35 Attilio Salemme

1 Selected bibliography includes microfilm D228, Attilio Salemme Papers, AAA-SI; *The New Decade* (New York: Whitney Museum of American Art, 1955), 77-79; Thomas M. Messer and John I. H. Baur, *Attilio Salemme* (Boston: Institute of Contemporary Art, 1959); and *Attilio Salemme: Inhabitant of a Dream* (Washington, D.C.: National Collection of Fine Arts, 1978).

2 See *Art of This Century* (New York: Art of This Century, 1942), 147.

3 See also *Life Lines: American Master Drawings, 1788-1962, from the Munson-Williams-Proctor Institute* (Utica, N.Y.: MWPI, 1994), cat. no. 52.

4 Salemme to Miss Wagenet, Mar. 23, 1947, frame 818, Salemme Papers.

5 See *Attilio Salemme* (New York: Gallery 67, 1944).

6 From a 1949 statement quoted in Messer and Baur, *Attilio Salemme,* unpaginated.

7 The faint pale brown wash enveloping the figures probably has faded from its original color. James Martin, Director of Analytic Services and Research at the Williamstown Art

Conservation Center, tested a small sample, and, while the results can only be inconclusive without subjecting the watercolor to more invasive sample extraction, there is some suggestion that Salemme originally applied a red lake paint to the image.

36 Mark Tobey

1 For recent studies on Mark Tobey, see Kosme de Baranano and Matthias Bärmann, eds., *Mark Tobey* (Madrid: Museo Nacional Centro de Arte Reina Sofía, 1997) and Bert Winther-Tamaki, "Mark Tobey, White Writing for a Janus-faced America," *Word & Image* 13, 1 (January-March 1997): 77-91.

2 Dante Alighieri, *Vita Nuova,* introduction and translation by Dino S. Cervigni and Edward Vasta (Notre Dame, Ind., and London: University of Notre Dame Press, 1995), 47.

3 Frederick Muhs, "Mark Tobey, His Recent Work" in *Tobey* (New York: Willard Gallery, 1947), unpaginated.

4 Julia and Lyonel Feininger, "Comments by a Fellow Artist," in *Paintings by Mark Tobey* (Portland, Ore: Portland Art Museum and Press of F. W. Baltes, 1945), unpaginated.

5 Reproduced in Hans Hess, *Lyonel Feininger* (New York: Harry N. Abrams, 1959), cat. no. 471, 157.

6 Maye Harvey Gift and Alice Simmons Cox, *Race and Man* (Wilmette, Ill.: Bahá'í Publishing Co., 1943), xiv.

7 Mark Tobey, "The One Spirit," *The World Order* (published by the National Spiritual Assembly of the Bahá'í of the United States) 1, 5 (August 1935): 174-76.

37 Edward Christiana

1 See *Edward Christiana: Retrospective Exhibition,* unpaginated, for a chronology of the artist's career.

2 *Munson-Williams-Proctor Institute Bulletin* (May 1946), unpaginated.

3 Artist's statement, 1974, MWP Arts Institute Artist's File.

38 William Baziotes

1 See William Baziotes, "I Cannot Evolve Any Concrete Theory," *Possibilities* 1 (Winter 1947-48): 2, reprinted in *Fifteen Americans* (New York: MoMA, 1952), 12.

2 Undated statement transcribed by Ethel Baziotes in microfilm N 70/21, frame 41, William and Ethel Baziotes Papers, AAA-SI.

3 Harold Rosenberg, "The Shapes in a Baziotes Canvas," *Possibilities* 1 (Winter 1947-48): 2.

4 *Glass Form* shares with several 1946-47 compositions similar shapes that suggest stunted limbs and large orifices. See, for example, *Night Form,* 1947 (Washington Univ. Gallery of Art), *The Dwarf,* 1947 (Museum of Modern Art), or *Night Mirror,* 1947 (Frances Lehman Loeb Art Center, Vassar College).

5 Baziotes, "The Artist and His Mirror," *Right Angle* 3 (June 1949): 3-4, quoted in Stephen Polcari, *Abstract Expressionism and the Modern Experience* (Cambridge: Cambridge University Press, 1991), 216.

6 While on the WPA, Baziotes painted for himself "five or six gouaches a night." Baziotes, in an unpublished "literary portrait" written in 1951 (and revised in 1960) by Donald Paneth, frame 22, Baziotes Papers.

7 There were a dozen each listed in the exhibition brochure, although Edward Root's copy has handwritten notes indicating that paintings number 10 and 11, *Landscape* and *The Curtain,* were "not exhibited." Root wrote extensively on the brochure, commenting on color and the works' placement in the gallery. Next to *Glass Form* he noted "most ease." See R.G. 13, Artists' Files, F-7.3, Edward Root Papers, MWP Arts Institute Archives.

8 In a 1949 letter to Museum of Modern Art Director Alfred Barr, Baziotes explained the inspiration for some of his work; see frames 149-54, Baziotes Papers.

9 *Artnews* 44 (February 1946): 102.

10 Quoted in Paneth, frame 11, Baziotes Papers.

11 Ibid. In a ca. 1957 statement for an unbroadcast television program at Hunter College, Baziotes quoted Baudelaire: "I have a horror of being easily understood."

12 Frame 28, Baziotes Papers.

39 Charles Burchfield

1 See Townsend, *Burchfield's Journals,* 483.

2 Burchfield to Root, Mar. 13, 1933, microfilm 4547, frame 51, Philadelphia Museum of Art Papers, AAA-SI.

3 Aug. 19, 1959, transcribed interview with John D. Morse, Charles Burchfield Papers, AAA-SI.

4 Burchfield pieced sheets of paper to the original early watercolors and later carefully outlined this procedure in microfilm 2787, frames 736-38, Burchfield Papers; reproduced in *Extending the Golden Year,* 30-31.

5 Burchfield to Dr. Theodore Brausch, Mar. 14, 1956, Burchfield-Penney Art Center file number 14.22/77.

6 About his painting technique, Burchfield wrote, in a Feb. 10, 1938, letter to Edward Root, "my use of water-color is certainly not traditional, but I think my intent is based on what men have always sought to express. And I only am self-conscious about it, the novelty of my use of the medium because it has been told me so often. In the early days I was not conscious of being different. ... You would think I would remember when I switched from the pointed sable brush to the 'bright' sable oil brushes but I don't." Frames 84-85, Philadelphia Museum of Art Papers. Later, in a 1959 statement and interview, frame 720, Burchfield Papers, the artist commented that he typically used a dry painting technique– "the color put on with a brush containing as little water as possible"–and that he painted vertically. Burchfield, in a 1959 transcribed interview with John D. Morse, 13, Burchfield Papers, explained that he preferred this method over "the traditional method, which is light washes put on more or less wet paper [because] it's very hard to make a correction on that and not have it show" so that he could sponge away and repaint sections with which he was dissatisfied.

7 Burchfield to "Dear Friends," Oct. 20, 1959, Burchfield-Penney Art Center file number 14.62/77.

8 See Townsend, *Burchfield's Journals,* Aug. 13, 1945, 506-07.

9 See ibid., Aug. 19, 1946, 507.

10 See ibid., Aug. 22, 1946, 509, in which Burchfield described sketching all day and into the night, at which time he began drawing studies of the night sky. Other Burchfield constellation imagery includes *Orion in December,* 1959 (National Museum of American Art) and *Orion in Winter,* 1962 (Thyssen-Bornemisza Collection).

11 Ibid., Sept. 11, 1948, 573.

40 Dong Kingman

1 "Dong Kingman," *The New Yorker,* Oct. 10, 1942, 10.

2 Gruskin, *Watercolors of Dong Kingman,* 30. Kingman moved to Brooklyn after World War II.

3 Gruskin, ibid., found that Kingman was especially enamored of the elevated train and that his paintings of them "contribute vividly to the aesthetic record of a vanished era" in New York.

4 In the building at right, Kingman painted stylized figures looking out the windows. Kingman used this device frequently; see, for example, *Atlanta, Ga., House by a Railroad,* or *Brooklyn, U.S.A.,* in Gruskin, *Watercolors of Dong Kingman,* 75, 76, and 77, respectively.

5 Ibid., 129, 132.

6 Dong Kingman, untranscribed audiotape, interview with Karl Fortess, Dec. 23, 1971, AAA-SI.

7 Ibid. By way of example, Kingman described painting a Japanese pagoda one summer but, upon returning to the studio, decided that it would be a more effective image as a winter scene, with snow, which is how he painted it.

8 Kingman typically enjoyed favorable reviews for his Midtown shows. See, for example, Judith Kay Reed, "Dong Kingman," *Art Digest* 21 (Mar. 15, 1947): 11, who describes the artist as an "expert designer" and an "alert observer" with a good sense of humor. See also Reed, "New York Scenes by Dong Kingman," *Art Digest* 22 (Mar. 1, 1948): 13; "Dong Kingman," *Art News* 47 (April 1948): 51; Margaret Lowengrund, "Productive Year," *Art Digest* 23 (Apr. 1, 1949): 15.

9 See *Munson-Williams-Proctor Institute Bulletin* (March 1948), unpaginated.

10 Ibid.

41 Dong Kingman

1 Dong Kingman, interview with Harlan Phillips, Jan. 12, 1965 (transcribed), microfilm 3949, frame 758, AAA-SI.

2 In a 1971 interview with Karl Fortess, Kingman cited a ca. 1937 review by San Francisco art critic Alfred Frankenstein, who noted that Kingman painted landscapes in a Chinese mode and urban scenes in an American mode. Untranscribed audiotape interview, Dec. 23, 1971, AAA-SI. Kingman eventually felt, though, that his style was increasingly western.

3 Kingman interview with Phillips, frames 746, 750.

4 See, for example, his statement: "The white of the paper is important in painting a watercolor because of the transparency of the medium" in Alan D. Gruskin, *The Watercolors of Dong Kingman and How the Artist Works* (New York and London: Studio Publications, 1958), 121. See also an updated account of Kingman's technique in Dong Kingman and Helena Kuo Kingman, *Dong Kingman's Watercolors* (New York: Watson-Guptill Publications, 1980). As a young man Kingman had experimented with oil painting but abandoned it as a medium he did not understand.

5 Margaret Lowengrund, in "Dong Kingman's Productive Year," *Art Digest* 23 (Apr. 1, 1949): 15, generally found the artist's work "cheerful" and "very alive" but suggested that Kingman risked confusion if he were to crowd his compositions any further.

42 William Palmer

1 Palmer's murals include the multi-paneled *Development of Medicine* for the Queens General Hospital, 1933-34, Jamaica, N.Y., and the two-part *Opening of the West* mural, 1936, for the Post Office Department Building, Washington, D.C. See microfilm 290, William Palmer Papers, AAA-SI; William Palmer interview with Joseph Trovato, microfilm 3419, frames 686-95, AAA-SI Oral History Collection; and MWP Arts Institute Artist's Files.

2 Ernest W. Watson, "William Palmer," *American Artist* 12 (April 1948): 29, observed that Palmer's artistic periods corresponded to "his changes in residence — Iowa, Canada, the Southwest and now, Oneida County, New York. It is not merely that his pictures of these regions mirror their divergent visual aspect: each seems to have opened a new

door to perception, each appears to have radically reoriented his vision."

3 Artist's response to a National Museum of American Art questionnaire, Oct. 15, 1985; MWP Arts Institute Artist's Files.

4 David Sutherland, director, *William Palmer*, videotape (Utica, N.Y.: MWPI, 1989).

5 Critics responded enthusiastically to this material when Palmer showed it at the Midtown Galleries after a three-year hiatus. *Art News* 46 (October 1947): 27, reported, "No one knows better than he how to find the arabesques beneath nature's chaotic forms, to capture a delicate flood of sunlight filtered through the mist," while Alonzo Lansford, in "William Palmer Returns to Exhibition Arena," *Art Digest* 22 (October 1947): 15, described the show as "stunningly beautiful" with "representational landscapes ... now organized on intricate abstract foundations, with even greater dramatic qualities achieved through lush color and light, and firm rhythms."

43 Sonja Sekula

1 Sekula's building also housed composers Morton Feldman and John Cage, dancer Merce Cunningham, and artists Ray Johnson, Richard Lippold, and Joe Glasco. The atmosphere inspired Sekula, and she was very productive while she lived there, from late 1947 to spring 1949. At the time she aspired to be an "American" painter, free from the constraints of confining European traditions in which she was raised. On a French radio program in 1950 she stated, "I feel that in America, being more separated from the source [i.e., Europe] there is more scope for originality ... the old masters as well as the new Modern masters in Europe and France particularly must always be a source of inspiration but it must not lead to stagnation or mere imitation." Microfilm 4127, frame 748, Betty Parsons Papers, AAA-SI.

2 Quoted in Nancy Foote, "Who Was Sonia Sekula," *Art in America* 54 (September/October 1971): 76.

Sekula suffered from mental illness and had her first breakdown in 1938 (and was frequently hospitalized after 1955), so her expressions of hope for the future were also very personal. Selected Sekula bibliography includes: frames 740ff, Parsons Papers; Foote, "Who Was Sonia Sekula," 73-80; Schwarz, *Sonja Sekula, 1918-1963*; and Ann E. Gibson, *Abstract Expressionism: Other Politics* (New Haven, Conn.: Yale University Press, 1997), 127-30, 185.

3 Schwarz, *Sonja Sekula*, 64-65.

4 See ibid., frontispiece.

5 Ann E. Gibson, "Universality and Difference in Women's Abstract Painting: Krasner, Ryan, Sekula, Piper, and Streat," *Yale Journal of Criticism* 8 (1995): 119-20.

44 Jimmy Ernst

1 Jimmy Ernst, *A Not-So-Still-Life* (New York: St. Martin's Press, 1984), 248. Ernst also credited Gordon Onslow-Ford's prescience about Matta: "[He] looked to the future of painting with a particular emphasis on the events in Matta's canvases that left the narrow scope of figuration behind for a world of as-yet-unseen realities. His work, devoid of Old World elegances had biomorphic elements moving in and through strata of an unearthly landscape" (196).

As Ernst began to develop as an artist critical notice was generally supportive; see "Reviews and Previews," and "Our Box Score of the Critics," *Artnews* 45 (September 1946): 41, 47.

2 Jimmy Ernst, interview with Karl Fortess, 1976, AAA-SI.

3 "Reviews and Previews: Jimmy Ernst," *Artnews* 48 (April 1949): 48.

45 Richard Pousette-Dart

1 On the verso of this image is the inscription "49," which has been interpreted as the work's date. However, Edward W. Root bought two Pousette-Dart works on paper in the 1940s (both were bequeathed to the MWP Arts Institute). The second work, entitled *Composition (Transfiguring)*, bears a Willard Gallery label that dates the work to 1946. No documentation has been found yet about where and when Root bought the smaller *Composition*; the "49" date is therefore currently open to question. If Root did buy *Composition* in 1949, Pousette-Dart was then represented by Betty Parsons.

2 Richard Pousette-Dart, interview with Stephen Polcari, Mar. 9, 1992, Richard and Evelyn Pousette-Dart Papers, AAA-SI. In the interview Pousette-Dart diminished the influence (especially the spiritual import) of the art of North American indigenous cultures on his work, but his wife stated that she had written, on his behalf, a Guggenheim Fellowship application in the 1940s for travel and study of this material.

3 Pousette-Dart interview.

4 Clement Greenberg, "Art Notes," *Nation* 160 (Jan. 20, 1945): 82. See also Maude Riley, in "Pousette-Dart," *Art Digest* 19 (Jan. 15, 1945): 5, who wrote: "There is no doubt that these subjectless extravagancies are impulsively created;" Alonzo Lansford, "Pousette-Dart, the Younger," *Art Digest* 22 (Apr. 15, 1948): 20-21: "A year or so ago, I saw another exhibition of Pousette-Dart's paintings at Art of This Century, found them not only unrewarding but actively irritating. In the meantime, several *avant-garde* critics have numbered the artist among the 'three or four most significant contemporary American painters;'" Margaret Lowengrund, "Surface Manipulations," *Art Digest* 23 (Mar. 15, 1949): 15, "Abstractions by Richard Pousette-Dart ... are unusual in surface technique but seldom go beyond the decorative;" and *Art News* 47 (April 1948): 51: "Richard Pousette-Dart's recent paintings in oil and ink-and-watercolor ... take on more and more the qualities of fanatical elaborations. ... He emerges a sincere painter whose aptitude for bright, rather Byzantine decoration has been temporarily diverted."

5 "Richard Pousette-Dart," Art of This Century Gallery, New York, Mar. 4-22, 1947.

6 For Pousette-Dart the layers of his paintings were "an analogy to life itself." See *Transcending Abstraction: Richard Pousette-Dart, Paintings, 1939-1985* (Fort Lauderdale, Fla.: Museum of Art, 1986), 18.

7 *Composition* is interesting in its size because Pousette-Dart, in the early 1940s, was the first American artist of his generation to create monumental (non-mural) paintings such as *Symphony No. 1*, 1941-42 (Metropolitan Museum of Art, 90 x 120 in.), *Fugue No. 2*, 1943 (Museum of Modern Art, 41 1/8 x 106 in.), or *The Edge*, 1943 (priv. coll., 81 x 47 in.).

8 Pousette-Dart interview.

46 Dorothy Dehner

1 For a discussion of Dehner's links to Abstract Expressionism, see Ann E. Gibson, *Abstract Expressionism: Other Politics* (New Haven, Conn.: Yale University Press, 1997), 139-41, and Joan Marter, *Women and Abstract Expressionism, Painting and Sculpture, 1945-1959* (New York: Baruch College, CUNY, 1997), 3-8.

2 *Dorothy Dehner: Poetry of Line, A Retrospective of Work on Paper* (Boulder, Colo.: Boulder Art Center, 1994), 2.

3 For David Smith's *Personage from Stove City*, see Rosalind E. Krauss, *The Sculpture of David Smith: A Catalogue Raisonné* (New York: Garland, 1977), 40, and fig. 207. The related drawing appears in Trinkett Clark, *The Drawings of David Smith* (Washington, D. C.: International Exhibitions Foundation, 1985), color pl. 3.

4 See, for example, Dehner's *Three Figures*, 1960, in cast bronze in Dorothy Keane-White, *Dorothy Dehner, Sculpture and Works on Paper* (Allentown, Pa.: Muhlenberg College, 1988), illus. 10.

5 Karen Wilkin, *David Smith* (New York: Abbeville Press, 1984), 13.

47 Will Barnet

1 See *Will Barnet: An American Master, Print Retrospective* (Loretto, Pa.: Southern Alleghenies Museum of Art, 1998). See also Una E. Johnson and Jo Miller, *Will Barnet: Prints 1932-1964* (Brooklyn: Brooklyn Museum, 1965), and the Montclair (N.J.) Art Museum's forthcoming retrospective exhibition catalog, Gail Stavitsky, curator.

2 Interview with the artist, Sept. 20, 1997. Barnet's teaching notes, moreover, confirm his painterly perspective; he constantly admonishes students to transcend technical virtuosity for deeper content. See microfilm N68-35, frames 57-58, and 60, Will Barnet Papers, AAA-SI.

3 See *Will Barnet · Bob Blackburn: An Artistic Friendship in Relief* (LaGrange, Ga.: Cochran Collection, 1995), and David Acton, *A Spectrum of Innovation: Color in American Printmaking, 1890-1960* (New York: W. W. Norton & Co., in association with the Worcester Art Museum, 1990), cat. no. 69.

4 Quoted in Robert Doty, *Will Barnet* (New York: Harry N. Abrams, Inc., 1984), 38.

5 Interview with the artist.

6 Doty, *Will Barnet*, 43-46.

7 Will Barnet, "Ideas on Art," microfilm N70-48, frame 54, Barnet Papers.

8 Dorothy Seckler, "Will Barnet Makes a Lithograph," *Artnews* 51 (April 1952): 38-41. In October 1952 the American Federation of Arts announced its year-long touring exhibition, "Will Barnet Makes a Color Lithograph" (AFA no. 52-26), an educational show of Barnet's prints with step-by-step photography panels designed to explicate the technical aspects of multistone printing. See press release and contact photographs, microfilm N68-35, frames 278-279, Barnet Papers.

9 During the 1940s and the 1950s the Institute invited artists such as William Zorach, Burgoyne Diller, David Smith, Philip Guston, Hugo Robus, and Dong Kingman to Utica for short visiting artist residencies. For Barnet, see the Institute's *Bulletin* (February 1954), reproduced in microfilm N68-35, frames 238-241, Barnet Papers, and "Barnet, Versatile Artist, Visits M-W-P for Concours, and Lectures," Utica *Observer-Dispatch*, Feb. 7, 1954.

48 Morris Graves

1 Fairfield Porter, "Reviews and Previews: Morris Graves," *Artnews* 52 (December 1953): 42.

2 James Fitzsimmons, "Graves' Aviary of the Inner Eye," *Art Digest* 28 (Dec. 1, 1953): 14, 31. Five years earlier Graves had shown similarly themed paintings at the Willard Gallery and at the *59th Annual American Exhibition* at the Art Institute of Chicago. Graves enjoyed generally favorable reviews: the Willard show drew praise from Margaret Breuning, in "Avian Graves," *Art Digest* 23 (Nov. 15, 1948): 29, while C. J. Bulliet, in "More Integrated Modernism Marks Chicago Watercolor Biennial," *Art Digest* 23 (Nov. 15, 1948): 24-25, declared Graves's birds more Poe- than Audubon-inspired and described the artist himself as "a genius, albeit circumscribed and minor." See also George Michael Cohen, "The Bird Paintings of Morris Graves," *College Art Journal* 18 (Fall 1958): 2-16.

3 Katharine Kuh, *The Artist's Voice: Talks with Seventeen Artists* (New York and Evanston, Ill.: Harper & Row, 1962), 116-17.

4 Kuh, *Artist's Voice*, 105.

5 MWP Arts Institute owns six Morris Graves works, five of which are from the Edward Root Collection.

49 Dorothy Dehner

1 For an assessment of Dehner's links to other Abstract Expressionists in her innovative use of watercolor and ink, see Esther T. Thyssen, "Bone Music #1: A Dehner Ideograph," *Yale University Art Gallery Bulletin* (1997-98): 69-75.

2 Joan Marter, *Dorothy Dehner and David Smith: Their Decades of Search and Fulfillment* (New Brunswick, N.J.: Zimmerli Art Museum, 1984).

3 See, for example, Douglas Dreishpoon, *Between Transcendence and Brutality: American Sculpture Drawings from the 1940s and 1950s* (Tampa, Fla.: Tampa Museum of Art, 1994), 26-33; pl. II.

4 These drawings are unpublished and remain in the collection of the Dorothy Dehner Foundation for the Visual Arts, New York.

50 Bob Thompson

1 Jeanne Siegel, "Robert Thompson and the Old Masters," *Harvard Art Review* 2 (Winter 1967): 12.

2 Judith Wilson, "Garden of Music: The Art and Life of Bob Thompson," in *Bob Thompson* (New York: Whitney Museum of American Art, in association with University of California Press, 1998), 63-64. It should be noted that Thompson was not the only artist in the early 1960s appropriating old master imagery (though artists' motivations for doing so differed). See, for example, Larry Rivers' work of the period; similarly, Rico Lebrun created paintings and drawings after works by Goya, Rembrandt, Velázquez, among others. George Ortman adapted Botticelli's *Primavera* for a large composition of emblematic cutouts; see Suzy Gablik's review, *Artnews* 63 (May 1964): 12.

3 Siegel, "Robert Thompson," 14, and Wilson, "Garden of Music," 63. Siegel curiously described Thompson's Goya-derived renderings of sexual demons as "benevolent" and "playful," while Wilson perceptively described the darker spirit guiding Thompson.

4 For other gouaches based on *Los Caprichos*, see *Novae: William H. Johnson and Bob Thompson* (Los Angeles, Calif.: California Afro-American Museum Foundation, 1990), fig. 40, *Dr. Bird* (based on *Los Caprichos* pl. 40) and fig. 41, Untitled (*Bird Flight*), (*Los Caprichos* pls. 42 and 43); and the Whitney Museum of American Art's 1998 catalog, pl. 85 (*Los Caprichos* pl. 11), pl. 86 (*Los Caprichos* pl. 55), and pls. 104a-o, Thompson's untitled sketchbook from 1963 with multiple *Los Caprichos*-inspired images, including 104k, another version of *Stagedoom*.

Wilson, "Garden of Music," 64 and 79, n. 196, stated that Thompson's Goya-inspired gouaches were exhibited in New York during the summer 1962 at the Friendly Art Store gallery and perhaps in May 1963, as well. See also Jill Johnston, "Reviews and Previews: Bob Thompson," *Artnews* 61 (September 1962): 11, who described the artist's Friendly Art Store show as exhibiting "a private vision ... in his most recent work in gouache" and his fantastical figures that "loom and hover in a space that might be a spectacle, a performance in which elements of an audience may appear and in which a naked girl (reclining, falling, upside down, stricken, leaning) is a force of centrifugal attraction." Lawrence Campbell's brief notice of Thompson's Drawing Shop show in fall 1963, *Artnews* 62 (December 1963): 50, stated that it was comprised of Ensor-esque "small gouache cartoons for paintings on symbolist themes."

5 Reproduced in *The Complete Etchings of Goya* (New York: Crown Publishing, 1943), unpaginated.

6 Siegel, "Robert Thompson," 14; see also Wilson, "Garden of Music," 62.

1 Everett Shinn

EXHIBITIONS

"Everett Shinn," M. Knoedler & Co., New York, March 1903; "Paris-New York Personal by Everett Shinn," Feragil Galleries, New York, January 18 - February 1, 1943; "Everett Shinn," Feragil Galleries, November 8 - 28, 1943; "Paintings and Drawings by Everett Shinn of Paris and New York, 1900 to 1945," American British Art Center, New York, February 13 – March 3, 1945 (cat. no. 17); "Paintings from 1904-1946 of Circus, Stage, and Streets by Everett Shinn," American British Art Center, November 19 – December 7, 1946 (cat. no. 5, dated 1907); "The Edward Root Collection," Metropolitan Museum of Art, New York, February 12 – April 12, 1953 (catalog, 3); "Edward Wales Root Bequest," Munson-Williams-Proctor Institute, November 5, 1961 – February 24, 1962 (catalog); "Graphic Styles of the American Eight," Utah Museum of Fine Arts, University of Utah, Salt Lake City, February 29 – April 11, 1976 (cat. no. 101, illus. 56); "American Works of Art on Paper 1850-1925," Schenectady Museum, Schenectady, N.Y., January 12 – April 6, 1980 (cat. no. 83); "Edward W. Root: Collector and Teacher," Fred L. Emerson Gallery, Hamilton College, Clinton, N.Y., October 1 – November 14, 1982 (catalog, 46, illus.)

PUBLICATIONS

Paintings, Drawings & Sculptures in the Museum of Art (Utica, N.Y.: Munson-Williams-Proctor Institute, 1961), 35.

2 Maurice B. Prendergast

EXHIBITIONS

"American Water Color Society Exhibition," National Academy of Design, New York, April – May 1912 (cat. no. 215); "Maurice B. Prendergast: Paintings in Oil and Watercolors," Carroll Galleries, New York, February 15 – March 6, 1915 (cat. no. 34); "Maurice Prendergast Memorial Exhibition," Whitney Museum of American Art, New York, February 21 – March 22, 1934 (cat. no. 101); "The Prendergasts: Retrospective Exhibition of the Work of Maurice and Charles Prendergast," Addison Gallery of American Art, Philips Andover Academy, Andover, Mass., September 24 – November 6, 1938; "The Edward Root Collection," Metropolitan Museum of Art, New York, February 12 – April 12, 1953 (catalog, 3); "Five Decades of American Painting," Union College, Schenectady, N.Y., September 27 – October 23, 1959; "Paintings, Drawings & Sculptures in the Museum of Art," Munson-Williams-Proctor Institute, October 15 – December 31, 1960 (catalog, 31); "Edward Wales Root Bequest," MWPI, November 5, 1961 – February 24, 1962 (catalog); "The Figure in 20th-Century Painting and Drawing," Edward W. Root Art Center, Hamilton College, Clinton, N.Y., April 15 – May 6, 1962; "Ashcan School," Arnot Art Gallery, Elmira, N.Y., February 1 – 28, 1965; "American 20th-Century Watercolors from Munson-Williams-Proctor Institute, Utica," Albany Institute of History and Art, Albany, N.Y., September 10 – October 4, 1967; "Selections from the Edward W. Root Collection," Root Art Center, May 11 – June 8, 1969; "Picture of the Month," MWPI, March 1974; "American Drawings and Watercolors from the Munson-Williams-Proctor Institute," E.B. Crocker Art Gallery, Sacramento, Calif., October 25 – November 25, 1974 (cat. no. 52); "Watercolors: Historic and Contemporary," Hathorn Gallery, Skidmore College, Saratoga Springs, N.Y., February 4 – 20, 1977 (cat. no. 45); "Five Decades of Collecting: Edward W. Root," MWPI, April 2 – May 28, 1978; "American Works of Art on Paper 1850-1925," Schenectady Museum, Schenectady, N.Y., January 12 – April 6, 1980 (cat. no. 78); "Maurice Prendergast," Williams College Museum of Art, Williamstown, Mass., October 6 – December 16, 1990 (traveling exhibition, Williamstown and Los Angeles venues only, catalog, 71, illus.)

PUBLICATIONS

American Art in Upstate New York (Buffalo, N.Y.: Buffalo Academy of Fine Arts, 1974), 43. Carol Clark, Nancy Mowll Mathews, and Gwendolyn Owens, *Maurice Brazil Prendergast, Charles Prendergast: A Catalogue Raisonné*

(Williamstown, Mass., and Munich: Williams College Museum of Art in association with Prestel-Verlag, 1990), 53, fig. 4, and 462, cat. no. 1018, illus. Richard J. Wattenmaker, *Maurice Prendergast* (New York and Washington, D.C.: Harry N. Abrams, in association with the National Museum of American Art, Smithsonian Institution, 1994), 104, illus. fig. 80.

3 Stuart Davis

EXHIBITIONS

"International Exhibition of Modern Art," Sixty-ninth Infantry Regiment Armory, New York, February 17 – March 15, 1913 (traveling exhibition, cat. no. 813); "The Armory Show: 50th Anniversary Exhibition," Munson-Williams-Proctor Institute, February 17 – March 31, 1963, and Sixty-ninth Infantry Regiment Armory, New York City (under auspices of Henry Street Settlement), April 6 – 28, 1963 (cat. no. 813, illus.); "American Drawings and Watercolors from the Munson-Williams-Proctor Institute," E. B. Crocker Art Gallery, Sacramento, Calif., October 25 – November 25, 1974 (cat. no. 18); "American Works of Art on Paper 1850-1925," Schenectady Museum, Schenectady, N.Y., January 11 – April 6, 1980 (cat. no. 24); "Twenty-five Years of Acquisitions," MWPI, November 9, 1985 – March 9, 1986; "Stuart Davis: American Painter," Metropolitan Museum of Art, New York, November 23, 1991 – February 16, 1992 (cat. no. 10, illus.)

PUBLICATIONS

Milton W. Brown, *The Story of the Armory Show* (New York: Abbeville Press, 1988), 260, no. 813. Patricia Hills, *Stuart Davis* (New York: Harry N. Abrams, 1996), 31-32, pl. 18.

4 Marguerite Zorach

EXHIBITIONS

"Exhibition of Paintings, Watercolors, Embroideries by William and Marguerite Zorach," Daniel Gallery, New York, November 1916; "Awash in Nature," Munson-Williams-Proctor Institute, July 17 – August 18, 1993

5 Arthur B. Davies

EXHIBITIONS

"Recent Additions to the Institute Collections," Munson-Williams-Proctor Institute, October 6 – 27, 1957; "Paintings, Drawings & Sculptures in the Museum of Art," MWPI, October 15 – December 31, 1960 (catalog, 14); "Arthur B. Davies, 1862-1928, A Centennial Exhibition," MWPI, July 8 – August 26, 1962 (traveling exhibition, catalog, illus. fig. 59); "Roots of Abstract Art in America 1910-1930," National Collection of Fine Arts, Smithsonian Institution, Washington D.C., December 1, 1965 – January 9, 1966; Everson Museum of Art, Syracuse, N.Y., October 25 – December 31, 1966; "Arthur B. Davies," Tucson Arts Center, Tucson, Ariz., March 4 – 26, 1967 (traveling exhibition); "American Paintings," Schenectady Museum, Schenectady, N.Y., March 20 – April 30, 1970; "20th-Century American Painting," Executive Mansion, Albany, N.Y., September 9 – November, 1974; "Synchronism and American Color Abstraction, 1910 – 1925," Whitney Museum of American Art, New York, January 24 – March 26, 1978 (traveling exhibition, catalog, illus. pl. 157); "Dream Vision: The Work of Arthur B. Davies," Institute of Contemporary Art, Boston, Mass., March 17 – May 10, 1981 (traveling exhibition, catalog); "Over Here: Modernism, The First Exile, 1914-1919," Bell Gallery, Brown University, Providence, R.I., April 15 – May 29, 1989 (catalog, illus.)

PUBLICATIONS

Lawrence Campbell, "An Idealist Who Changed History: Arthur B. Davies," *Artnews* 61 (October 1962): 42, fig. 5.

6 George Luks

EXHIBITIONS

"Selections from the Munson-Williams-Proctor Institute Collection from the Bequest of Edward W. Root," Edward W. Root Art Center, Hamilton College, Clinton, N.Y., December 9, 1962 – January 6, 1963; State University College, Oneonta, N.Y., December 2 – 20, 1963; "American 20th-Century Watercolors from Munson-Williams-

Proctor Institute, Utica," Albany Institute of History and Art, Albany, N. Y., September 10 – October 4, 1967; "George Luks," MWPI, April 1 – May 20, 1973 (cat. no. 80)

PUBLICATIONS

Paintings, Drawings & Sculptures in the Museum of Art (Utica, N.Y.: Munson-Williams-Proctor Institute, 1961), 25. *American Art in Upstate New York* (Buffalo, N.Y.: Buffalo Academy of Fine Arts, 1974), 33.

7 Charles Burchfield

EXHIBITIONS

"Paintings, Drawings & Sculptures in the Museum of Art," Munson-Williams-Proctor Institute, October 15 – December 31, 1960 (catalog, 9); "Edward Wales Root Bequest," MWPI, November 5, 1961 – February 24, 1962 (catalog); "Paintings by Charles E. Burchfield," Edward W. Root Art Center, Hamilton College, Clinton, N.Y., May 13 – June 10, 1962 (cat. no. 9); "American 20th-Century Watercolors from Munson-Williams-Proctor Institute, Utica," Albany Institute of History and Art, Albany, N.Y., September 10 – October 4, 1967; "The Nature of Charles Burchfield – A Memorial Exhibition," MWPI, April 9 – May 31, 1970 (cat. no. 65); "American Watercolors," Herbert F. Johnson Museum of Art, Cornell University, Ithaca, N.Y., May 17 – July 5, 1977; "Burchfield Watercolors," MWPI, June 5 – August 29, 1982; "Nature Framed," MWPI, March 15 – August 15, 1985; "Nature in Art," MWPI, January 17 – February 15, 1987; "Charles Burchfield: A Centenary Exhibition," MWPI, March 20 – May 2, 1993

PUBLICATIONS

Joseph S. Trovato, *Charles Burchfield: Catalogue of Paintings in Public and Private Collections* (Utica, N.Y.: MWPI, 1970), 46, cat. no. 135. *American Art in Upstate New York* (Buffalo, N.Y.: Buffalo Academy of Fine Arts, 1974), 6. Matthew Baigell, *Charles Burchfield* (New York: Watson-Guptill Publications, 1976), 60, illus.

8 Charles Burchfield

EXHIBITIONS

"Charles Burchfield: Early Watercolors," Museum of Modern Art, New York, April 1930 (cat. no. 15); "Freshness of Vision in Paintings: Where the Spirit of the Expression Invents Its Own Means: Loan Exhibition of Early Water Colors by Charles Burchfield," Phillips Memorial Gallery, Washington, D.C., November 5, 1933 – February 15, 1934 (catalog); "Exhibition of Water Colors by Charles Burchfield," Fogg Art Museum, Harvard University, Cambridge, Mass., 1940; "The Edward Root Collection," Metropolitan Museum of Art, New York, February 12 – April 12, 1953 (catalog, 1); "Paintings, Drawings & Sculptures in the Museum of Art," Munson-Williams-Proctor Institute, October 15 – December 31, 1960 (catalog, 9); "Edward Wales Root Bequest," MWPI, November 5, 1961 – February 24, 1962 (catalog); "Paintings by Charles E. Burchfield," Edward W. Root Art Center, Hamilton College, Clinton, N.Y., May 13 – June 10, 1962 (cat. no. 13, illus.); "Charles Burchfield: Early Watercolors," Albright-Knox Art Gallery, Buffalo, N.Y., April 24 – May 19, 1963 (cat. no. 18); New York State Exposition, Syracuse, September 1964; "American 20th-Century Watercolors from Munson-Williams-Proctor Institute, Utica," Albany Institute of History and Art, Albany, N.Y., September 10 – October 4, 1967; "Eight American Masters of Watercolor," April 23 – June 16, 1968, Los Angeles County Museum of Art, Los Angeles, Calif., June 28 – August 18, 1968 (traveling exhibition, cat. no. 87, illus.); "The Root Bequest," Root Art Center, May 11 – June 8, 1969; "The Nature of Charles Burchfield – A Memorial Exhibition," MWPI, April 9 – May 31, 1970 (cat. no. 81); "Charles Burchfield: Hymn to Nature," Charles Burchfield Center, State University College, Buffalo, N.Y., April 30 – June 30, 1972 (cat. no. 9); ""Five Decades of Collecting: Edward W. Root," MWPI, April 2 – May 28, 1978; "Burchfield Watercolors," MWPI, June 5 – August 29, 1982; "Charles Burchfield: A Retrospective Exhibition," Metropolitan Museum of Art, January 30 – March 25, 1984 (traveling exhibition); "Nature Framed," MWPI, July 16 –

August 15, 1985; "Nature in Art," MWPI, January 17 – February 15 and June 2 – September 1, 1987; "The Early Works of Charles E. Burchfield, 1915-1921," Columbus Museum of Art, Columbus, Ohio, December 13, 1987 – February 7, 1988 (traveling exhibition, Columbus venue only, cat. no. 49, illus.); "The Art Triangle," MWPI and the Charles Burchfield Center, March 18 – June 25, 1989 (cat. no. 11); "The Modernist Tradition American Watercolors: 1911-1939," Mary and Leigh Block Gallery, Northwestern University, Evanston, Ill., April 4 – June 22, 1991 (cat. no. 7, misdated 1912, illus.); "Charles Burchfield: A Centenary Exhibition," MWPI, March 20 – May 2, 1993; "Charles E. Burchfield: The Scared Woods," Burchfield Art Center (traveling exhibition, Drawing Center venue only, June 12 – July 30, 1993, catalog, 37, 116, illus. fig. 9); "The Paintings of Charles Burchfield: North by Midwest," Columbus Museum of Art (traveling exhibition, National Museum of American Art venue only, September 26, 1997 – January 25, 1998, catalog, 173, illus. fig. 49)

PUBLICATIONS

Joseph S. Trovato, *Charles Burchfield: Catalogue of Paintings in Public and Private Collections* (Utica, N.Y.: MWPI, 1970), cat. no. 382, illus. frontispiece. *American Art in Upstate New York* (Buffalo, N.Y.: Buffalo Academy of Fine Arts, 1974), 6. Miriam Soffer, "Charles Burchfield, Romantic Realist," *NAHO* [New York State Museum Bulletin] 8 (Summer 1975): 3-5, illus. 3. John I. H. Baur, *Life and Work of Charles Burchfield, 1893-1967: The Inlander* (Cranbury, N.J.: Associated University Presses, 1982), 70, illus. pl. XII. Christopher Finch, *American Watercolors* (New York: Abbeville Press, 1986), 221, illus. pl. 283. J. Benjamin Townsend, ed., *Charles Burchfield's Journals: The Poetry of Place* (Albany, N.Y.: State University of New York Press, 1993), 225, illus. fig. 44. Holland Cotter, "Back to Innocence in Burchfield's Spiritual Landscapes," *New York Times*, July 9, 1993, illus. "Charles Burchfield: The Centenary," *American Art Review* 5 (Spring 1993): 107, illus. Nannette V. Maciejunes and Norine S. Hendricks, "Charles Burchfield's Painted Memories," *The Magazine Antiques* 151 (March 1997): 458-69, illus. pl. V. Stephen May, "Charles Burchfield," *American Artist* (November 1997): 235, illus.

9 Charles Demuth

EXHIBITIONS

"Selected American Paintings, 1900 – 1950," Munson-Williams-Proctor Institute, April 30 – May 21, 1950, "Eight Paintings from the Museum of Art," MWPI School of Art, February 6 – 28, 1951; "Paintings from the MWPI Collection," Sherburne Public Library, Sherburne, N.Y., April 9 – 22, 1951; "20th-Century American Paintings from the Institute Collection," MWPI, July 1 – September 23, 1951; "Sixteen Paintings from the Institute Collection," MWPI School of Art, December 3 – 31, 1951; "Twentieth-Century American Painting from the Institute Collection," MWPI, July 3 – August 31, 1952; "Painting and Sculpture from the Collection of the MWPI," Joe and Emily Lowe Art Center, Syracuse University, Syracuse, N.Y., February 9 – 28, 1954; "From the Munson-Williams-Proctor Institute Collection," Skidmore College, Saratoga Springs, N.Y., March 1 – April 2, 1955 (traveling exhibition); "Contemporary American Watercolors and Drawings," Smithsonian Institution, Washington, D.C., May 1959 – May 1960 (traveling exhibition); "Charles Demuth," Pennsylvania Historical and Museum Commission, Harrisburg, Pa., September 24 – November 6, 1966; "American 20th-Century Watercolors from Munson-Williams-Proctor Institute, Utica," Albany Institute of History and Art, Albany, N.Y., September 10 – October 4, 1967; "Charles Demuth," Akron Art Institute, Akron, Ohio, April 1 – June 1, 1968 (cat. no. 58); "American Drawings and Watercolors from the Munson-Williams-Proctor Institute," E. B. Crocker Art Gallery, Sacramento, Calif., October 25 – November 25, 1974 (cat. no. 21); "Flowers in Painting, Prints, and Drawing," MWPI, April 20 – May 25, 1980; "Nature in Art," MWPI, January 17 – September 1, 1987

PUBLICATIONS

Paintings, Drawings & Sculptures in the Museum of Art (Utica, N.Y.: Munson-Williams-Proctor Institute, 1961), 15. *American Art in Upstate New York* (Buffalo, N.Y.: Buffalo Academy of Fine Arts, 1974), 17.

10 Charles Demuth
EXHIBITIONS

"Charles Demuth Memorial Exhibition," Whitney Museum of American Art, New York, December 15, 1937 – January 16, 1938 (traveling exhibition, cat. no. 11); "Charles Demuth," Museum of Modern Art, New York, March 8 – June 11, 1950 (cat. no. 79); "The Edward Root Collection," Metropolitan Museum of Art, New York, February 12 – April 12, 1953 (catalog, 1); "Five Decades of American Painting," Union College, Schenectady, N.Y., September 27 – October 23, 1959; "American Watercolors and Drawings from the Root Bequest, Munson-Williams-Proctor Institute," Edward W. Root Art Center, Hamilton College, Clinton, N.Y., April 9 – May 7, 1961; "Edward Wales Root Bequest," MWPI, November 5, 1961 – February 24, 1962 (catalog); "The Root Bequest," Root Art Center, May 11 – June 8, 1967; "American 20th-Century Watercolors from Munson-Williams-Proctor Institute, Utica," Albany Institute of History and Art, Albany, N.Y., September 10 – October 4, 1967; "Paintings and Drawings: Selections from the Edward W. Root Bequest," Root Art Center, April 7 – May 5, 1968; "Picture of the Month," MWPI, August 1969; "American Paintings," Schenectady Museum, Schenectady, N.Y., March 20 – April 30, 1970; "Charles Demuth: The Mechanical Encrusted on the Living," Art Galleries, University of California, Santa Barbara, October 5 – November 14, 1971 (traveling exhibition, cat. no. 52); "American Drawings and Watercolors from the Munson-Williams-Proctor Institute," E. B. Crocker Art Gallery, Sacramento, Calif., October 25 – November 25, 1974 (cat. no. 22, illus.); "Watercolors: Historic and Contemporary," Hathorn Gallery, Skidmore College, Saratoga Springs, N.Y., February 4 – 20, 1977 (cat. no. 16); "American Watercolors," Herbert F. Johnson Museum of Art, Cornell University, Ithaca, N.Y., May 17 – July 3, 1977; "Five Decades of Collecting: Edward W. Root," MWPI, April 2 – May 28, 1978; "Flowers in Painting, Prints, and Drawing," MWPI, April 20 – May 25, 1980; "Painters of the Humble Truth: Masterpieces of American Still Life," Philbrook Art Center, Tulsa, Okla., September 27 – June 1982 (traveling exhibition, catalog, illus. fig. 11.10); "Nature in Art," MWPI, January 17 – September 1, 1987

PUBLICATIONS

Paintings, Drawings & Sculptures in the Museum of Art (Utica, N.Y.: Munson-Williams-Proctor Institute, 1961), 15. *American Art in Upstate New York* (Buffalo, N.Y.: Buffalo Academy of Fine Arts, 1974), 17.

11 George B. Luks
EXHIBITIONS

"American 20th-Century Watercolors from Munson-Williams-Proctor Institute, Utica," Albany Institute of History and Art, Albany, N.Y., September 10 – October 4, 1967; "George Luks," Munson-Williams-Proctor Institute, April 1 – May 20, 1973 (cat. no. 52); "American Art in Upstate New York," Albright-Knox Gallery, Buffalo, N.Y., July 12 – August 25, 1974 (traveling exhibition, catalog, 33, illus.); "American Works of Art on Paper 1850-1925," Schenectady Museum, Schenectady, N.Y., January 12 – April 6, 1980 (cat. no. 63); "George Luks: An American Artist," Sordoni Art Gallery, Wilkes College, Wilkes-Barre, Pa., May 3 – June 14, 1987 (traveling exhibition, cat. no. 42, illus.); "George Luks: Expressionist Master of Color, The Watercolors Rediscovered," Canton Museum of Art, Canton, Ohio, November 25, 1994 – January 29, 1995 (traveling exhibition, catalog, illus.)

PUBLICATIONS

Christopher Finch, *American Watercolors* (New York: Abbeville Press, 1986), 306, 238-40, illus. pl. 306.

13 George B. Luks
EXHIBITIONS

"Watercolors by Gifford Beal, Maurice Prendergast, William Zorach, Reynolds Beal, and George Luks," C. W. Kraushaar Art Galleries, New York, October 15 – November 3, 1923 (cat. no. 4); "The Edward Root Collection," Metropolitan Museum of Art, New York, February 12 – April 12, 1953 (catalog, 2); "George Luks," Edward W. Root Art Center, Hamilton College, Clinton, N.Y., April 4 – May 7, 1961; "Edward Wales Root Bequest," Munson-Williams-Proctor Institute, November 5, 1961 – February 24, 1962 (catalog, illus.); "The Figure in 20th-Century Paintings and Drawings," Root Art Center, April 15 – May 6, 1962; "American Traditionalists of the 20th Century," Columbus Museum of Arts and Crafts, Columbus, Ga., February 1963 (cat. no. 109, illus.); "American 20th-Century Watercolors from Munson-Williams-Proctor Institute, Utica," Albany Institute of History and Art, Albany, N.Y., September 10 – October 4, 1967; "Paintings and Drawings from the Edward W. Root Bequest," Root Art Center, April 7 – May 5, 1968; "The Root Bequest," Root Art Center, May 11 – June 8, 1969; "George Luks," MWPI, April 1 – May 20, 1973 (cat. no. 58, illus.); "American Drawings and Watercolors from the Munson-Williams-Proctor Institute," E. B. Crocker Art Gallery, Sacramento, Calif., October 25 – November 25, 1974 (cat. no. 37); "Graphic Styles of the American Eight," Utah Museum of Fine Arts, University of Utah, Salt Lake City, February 29 – April 11, 1976 (cat. no. 68, illus.); "The Machine Image in 20th-Century Art," MWPI, November 5, 1983 – February 5, 1984; "Woman," Terra Museum of American Art, Evanston, Ill., February 21 – April 22, 1984; "George Luks: An American Artist," Sordoni Art Gallery, Wilkes College, Wilkes-Barre, Pa., May 3 – June 14, 1987 (traveling exhibition, cat. no. 48, illus.); "George Luks: Expressionist Master of Color, The Watercolors Rediscovered," Canton Museum of Art, Canton, Ohio, November 25, 1994 – January 29, 1995 (traveling exhibition, catalog, 13, illus.)

PUBLICATIONS

"The World of Art: Comments of Some Current Exhibitions," *New York Times Magazine,* October 28, 1923, 10. *Paintings, Drawings & Sculptures in the Museum of Art* (Utica, N.Y.: Munson-Williams-Proctor Institute, 1961), 25. *American Art in Upstate New York* (Buffalo, N.Y.: Buffalo Academy of Fine Arts, 1974), 33. John Loughery, "The Mysterious George Luks," *Arts Magazine* 62 (December 1987): 34-35, illus.

14 Arthur B. Davies
EXHIBITIONS

Possibly Feragil Galleries, New York, February – March 1925; Everson Museum of Art, Syracuse, N.Y., October 25 – December 31, 1966; "Awash in Nature," Munson-Williams-Proctor Institute, July 17 – August 18, 1993; "Arthur B. Davies: 'Through the Prism,'" MWPI, August 17 – October 13, 1996

PUBLICATIONS

Paintings, Drawings & Sculptures in the Museum of Art (Utica, N.Y.: Munson-Williams-Proctor Institute, 1961), 14. *American Art in Upstate New York* (Buffalo, N.Y.: Buffalo Academy of Fine Arts, 1974), 13.

15 Charles Demuth
EXHIBITIONS

"Flowers in Painting, Prints, and Drawing," Munson-Williams-Proctor Institute, April 20 – May 25, 1980; "Twenty-five Years of Acquisitions," MWPI, November 9, 1985 – March 9, 1986; "Nature in Art," MWPI, January 16 – September 1, 1987

16 Edward Hopper
EXHIBITIONS

"Fourth Exhibition of Watercolors and Pastels," Cleveland Museum of Art, Cleveland, Ohio, February 17 – March 13, 1927; "Exhibition of Watercolors and Pastels by Eleven American Artists from a Distinguished Private Collection," Munson-Williams-Proctor Institute, October 1938; "The Edward Root Collection," Metro-

politan Museum of Art, New York, February 12 – April 12, 1953 (catalog, 2); "The Edward Root Collection," Strathmont Museum, Elmira, N.Y., June – September 1959; "Five Decades of American Painting," Union College, Schenectady, N.Y., September 27 – October 23, 1959; "American Watercolors and Drawings from the Root Bequest," Edward W. Root Art Center, Hamilton College, Clinton, N.Y., April 9 – May 4, 1961; "Art Exhibition Program," State University of New York, Oswego, October 1961; "Edward Wales Root Bequest," MWPI, November 5, 1961 – February 24, 1962 (catalog); "Edward Hopper, Oils, Watercolors, Prints," Root Art Center, May 10 – June 7, 1964; "Learning about Pictures with Mr. Root," Root Art Center, January 4 – 31, 1965; "The Twenties Revisited," Gallery of Modern Art, New York, June 29 – September 5, 1965 (catalog); "American 20th-Century Watercolors from Munson-Williams-Proctor Institute, Utica," Albany Institute of History and Art, Albany, N.Y., September 10 – October 4, 1967; "Paintings and Drawings from the Edward W. Root Bequest," Root Art Center, April 7 – May 5,1968; "The Root Bequest," Root Art Center, May 11 – June 8, 1969; "Edward Hopper, Charles Burchfield," Katonah Gallery, Katonah, N.Y., September 7 – 30, 1969; "Edward Hopper, 1882-1967: Oils, Watercolors, Etchings," William A. Farnsworth Library and Art Museum, Rockland, Me., July 9 – September 5, 1971 (traveling exhibition, cat. no. 17, illus.); "American Drawings and Watercolors from the Munson-Williams-Proctor Institute," E. B. Crocker Art Gallery, Sacramento, Calif., October 25 – November 25, 1974 (cat. no. 32, illus.); "Watercolors: Historic and Contemporary," Hathorn Gallery, Skidmore College, Saratoga Springs, N.Y., February 4 – 20, 1977 (cat. no. 30, illus.); "American Works of Art on Paper 1850-1925," Schenectady Museum, Schenectady, N.Y., January 11 – April 6, 1980 (cat. no. 53); "Edward Hopper: The Art and the Artist," Whitney Museum of American Art, New York, September 23, 1980 – January 12, 1981 (traveling exhibition, catalog, illus. pl. 238); "Insights," MWPI, January 7-October 15, 1986; "The Art Triangle," MWPI and the Charles Burchfield Center, State University College, Buffalo, N.Y., March 18 – June 25, 1989 (cat. no. 40)

PUBLICATIONS

Munson-Williams-Proctor Institute Bulletin (December 1957), unpaginated, illus. *Paintings, Drawings & Sculptures in the Museum of Art* (Utica, N.Y.: Munson-Williams-Proctor Institute, 1961), 20. *American Art in Upstate New York* (Buffalo, N.Y.: Buffalo Academy of Fine Arts, 1974), 27. Christopher Finch, *American Watercolors* (New York: Abbeville Press, 1986), 254-55, illus. pl. 329. Christopher Finch, *Twentieth-Century Watercolors* (New York: Abbeville Press, 1988), 209, illus. pl. 253. Gail Levin, *Edward Hopper: A Catalogue Raisonné* (New York: Whitney Museum of American Art, in association with W.W. Norton & Co., 1995), 2:98, cat. no. W-129.

17 Edward Hopper
EXHIBITIONS

"A History of American Watercolor Painting," Whitney Museum of American Art, New York, January 27 – February 25, 1942 (cat. no. 186); "Selections from the Munson-Williams-Proctor Institute Collection from the Bequest of Edward W. Root," Edward W. Root Art Center, Hamilton College, Clinton, N.Y., December 9, 1962 – January 6, 1963; "Edward Hopper Retrospective Exhibition," Whitney Museum of American Art, September 29 – November 29, 1964 (traveling exhibition, WMAA venue only, cat. no. 84); "Edward Hopper," Root Art Center, May 10 – June 7, 1964; Art Exhibition, New York State Exposition, Syracuse, August 31 – September 6, 1965; "American Painting from 1830," Everson Museum of Art, Syracuse, N.Y., December 3, 1965 – January 16, 1966 (cat. no. 53, as "Beam Trawler"); "Edward Hopper, Charles Burchfield," Katonah Gallery, Katonah, N.Y., September 7 – 30, 1969; "American Paintings," Schenectady Museum, Schenectady, N.Y., March 20 – April 30, 1970; "The Thirties Decade: American

Artists and Their European Contemporaries," Joslyn Art Museum, Omaha, Neb., October 10 – November 28, 1971 (cat. no. 86); "American Art in Upstate New York," Albright-Knox Gallery, Buffalo, N.Y., July 12 – August 25, 1974 (traveling exhibition, catalog, 27); "American Watercolors," Herbert F. Johnson Museum of Art, Cornell University, Ithaca, N.Y., May 17 – July 3, 1977 (catalog); "American Realism of the Twentieth Century," Morris Museum of Arts and Sciences, Morristown, N. J., April 14 – May 31, 1980 (catalog)

PUBLICATIONS

Gail Levin, *Edward Hopper: A Catalogue Raisonné* (New York: Whitney Museum of American Art, in association with W.W. Norton & Co., 1995), 2:124, cat. no. W-155.

18 George B. Luks
EXHIBITIONS

"Selections from the Edward Root Collection," Smithsonian Institution, Washington, D.C., 1959-60 (traveling exhibition, cat. no. 25); "Edward Wales Root Bequest," Munson-Williams-Proctor Institute, November 5 – February 24, 1962 (catalog); "The Twenties Revisited," Gallery of Modern Art, New York, June 29 – September 5, 1965 (catalog); "The Ashcan School," Edward W. Root Art Center, Hamilton College, Clinton, N.Y., September 10 – October 12, 1967; "George Luks," MWPI, April 1 – May 20, 1973 (cat. no. 64, illus. 12); "George Luks: Expressionist Master of Color, The Watercolors Rediscovered," Canton Museum of Art, Canton, Ohio, November 25, 1994 – January 29, 1995 (traveling exhibition, catalog, illus. 42)

PUBLICATIONS

Paintings, Drawings & Sculptures in the Museum of Art (Utica, N.Y.: MWPI, 1961), 25. *The Art Gallery* (May 1973), 21, illus. *American Art in Upstate New York* (Buffalo, N.Y.: Buffalo Academy of Fine Arts, 1974), 33.

19 John Marin
EXHIBITIONS

"Abstract Painting in America," Whitney Museum of American Art, New York, February 12 – March 22, 1935 (cat. no. 72, illus.); "Paintings and Drawings by John Marin: New York, 1910-44," Downtown Gallery, New York, August 10 – September 3, 1948 (cat. no. 17); "John Marin," University of Miami, Coral Gables, Fla., October 2 – 23, 1951 (cat. no. 17); "Formal Organization in Modern Painting," Munson-Williams-Proctor Institute, November 1 – 29, 1953 (cat. no. 19); "From the Munson-Williams-Proctor Institute Collection," Skidmore College, Saratoga Springs, N.Y., March 1 – 18, 1955; "Accessions 1954-55," MWPI, June – August 1955; Colgate University, Hamilton, N.Y., March 12 – 26, 1956; "From the Institute Collection," MWPI, April 1 – 22, 1956 and June 24 – September 12, 1957; "The Edward Root Collection," Strathmont Museum, Elmira, N.Y., June – September 1959; "Five Decades of American Painting," Union College, Schenectady, N.Y., September 27 – October 23, 1959; "John Marin in Retrospect: An Exhibition of His Oils and Watercolors," Corcoran Gallery of Art, Washington, D.C., March 2 – April 15, 1962 and Currier Gallery of Art, Manchester, N.H., May 9 – June 24, 1962 (cat. no. 63, illus. frontispiece; also United States Information Agency traveling exhibition 63-003; "John Marin, 1870-1953: Ölbilder und Aquarelle," Amerika Haus, Berlin, West Germany, September 15 – October 13, and Hamburg, October 26 – November 21, 1962, cat. no. 45); "John Marin: America's Modern Pioneer. A Retrospective Exhibition of the Watercolors and Oil Paintings from 1903-1953," Montclair Art Museum, Montclair, N.J., February 23 – March 29, 1964 (cat. no. 26); "New Jersey and the Artist," New Jersey State Museum, Trenton, N.J., October 17 – November 27, 1965; "American 20th-Century Watercolors from Munson-Williams-Proctor Institute, Utica," Albany Institute of History and Art, Albany, N.Y., September 10 – October 4, 1967; "American Paintings," Schenectady Museum, Schenectady, N.Y., March 20 – April 30,

1970; "American Drawings and Watercolors from the Munson-Williams-Proctor Institute," E. B. Crocker Art Gallery, Sacramento, Calif., October 25 – November 25, 1974 (cat. no. 42); "Watercolors: Historic and Contemporary," Hathorn Gallery, Skidmore College, February 4 – 20, 1977 (cat. no. 37, illus.); "Order and Enigma: American Art between the Two Wars," MWPI, October 13 – December 2, 1984 (traveling exhibition, catalog, illus. fig. 5); "Selections and Transformations: The Art of John Marin," National Gallery of Art, Washington, D.C., January 28 – April 15, 1990

PUBLICATIONS

E. M. Benson, "John Marin: The Man and His Work," *American Magazine of Art* 27 (October 1935): 597-611, 632-33, and (November 1935): 655-70. E. M. Benson, *John Marin: The Man and His Work* (Washington, D.C.: American Federation of Arts, 1935), 80-81, illus. fig. 38 (titled *Abstraction, Lower Manhattan*). "MWP Painting and Sculpture," *Munson-Williams-Proctor Institute Bulletin* (April 1956), unpaginated, illus. *Paintings, Drawings & Sculptures in the Museum of Art* (Utica, N.Y.: MWPI, 1961), 26. Sheldon Reich, *John Marin: A Stylistic Analysis and Catalogue Raisonné* (Tucson: University of Arizona Press, 1970), 594, cat. no. 28.38, illus. *American Art in Upstate New York* (Buffalo, N.Y.: Buffalo Academy of Fine Arts, 1974), 33. Ruth E. Fine, *John Marin* (Washington, D.C.: National Gallery of Art, Abbeville Press, 1990), 146, illus. fig. 137.

22 Herman Trunk

EXHIBITIONS

"40 Americans," Dudensing Gallery, New York, date unknown (ca. 1930-31); "Herman Trunk," Dudensing Gallery, New York, January – February 1932; "Edward Wales Root Bequest," Munson-Williams-Proctor Institute, November 5, 1961 – February 24, 1962 (catalog)

PUBLICATIONS

"Presenting the Case Decoratively," *New York Sun*, January 27, 1932, illus. *Paintings, Drawings & Sculptures in the Museum of Art* (Utica, N.Y.: Munson-Williams-Proctor Institute, 1961), 38.

23 Stuart Davis

EXHIBITIONS

"Stuart Davis Retrospective Exhibition: Gouaches, Watercolors, Drawings 1912 – 1941," Downtown Gallery, New York, January 29 – February 16, 1946 (cat. no. 20); "Paintings from the Collection of Edward W. Root," Munson-Williams-Proctor Institute, September 29 – October 30, 1946; "Contemporary American Watercolors and Drawings," Smithsonian Institution, Washington, D.C., May 1959 – May 1960 (traveling exhibition); "American Painting from 1830," Everson Museum of Art, Syracuse, N.Y., December 3, 1965 – January 16, 1966 (cat. no. 45); "On Paper," American Federation of Arts, September 1966 – September 1967 (traveling exhibition); "American Drawings and Watercolors from the Munson-Williams-Proctor Institute," E. B. Crocker Art Gallery, Sacramento, Calif., October 25 – November 25, 1974 (cat. no. 19, illus.); "The American Scene 1920 – 1940," Neue Gessellschaft für Bildende Kunst, Berlin, West Germany, October – December 1980

PUBLICATIONS

Paintings, Drawings & Sculptures in the Museum of Art (Utica, N.Y.: Munson-Williams-Proctor Institute, 1961), 15. *American Art in Upstate New York* (Buffalo, N.Y.: Buffalo Academy of Fine Arts, 1974), 13.

24 Charles Burchfield

EXHIBITIONS

"Exhibition of Water Colors by Charles Burchfield," Frank K. M. Rehn Galleries, New York, October 26 – November 14, 1931; "Paintings, Drawings & Sculptures in the Museum of Art," Munson-Williams-Proctor Institute, October 15 – December 31, 1960 (catalog, 10); "Edward Wales Root Bequest," MWPI, November 5, 1961 – February 24, 1962 (catalog); "Paintings by Charles E. Burchfield," Edward W. Root Art

Center, Hamilton College, Clinton, N.Y., May 13 – June 10, 1962 (cat. no. 19, illus.); "American 20th-Century Watercolors from Munson-Williams-Proctor Institute, Utica," Albany Institute of History and Art, Albany, N.Y., September 10 – October 4, 1967; "The Nature of Charles Burchfield – A Memorial Exhibition," MWPI, April 9 – May 31, 1970 (cat. no. 170); "20th-Century American Painting," Executive Mansion, Albany, N.Y., September – November 1974; "Burchfield Watercolors," MWPI, June 5 – August 29, 1982; "The Art Triangle," MWPI and Charles Burchfield Center, State University College, Buffalo, N.Y., March 18 – June 25, 1989 (cat. no. 23); "Charles Burchfield: A Centenary Exhibition," MWPI, March 20 – May 2, 1993; "The Paintings of Charles Burchfield: North by Midwest," Columbus Museum of Art, Columbus, Ohio (traveling exhibition, National Museum of American Art, Washington, D.C., venue only, September 26, 1997 – January 25, 1998, catalog, 223, illus. fig. 113)

PUBLICATIONS

Joseph S. Trovato, *Charles Burchfield: Catalogue of Paintings in Public and Private Collections* (Utica, N.Y.: MWPI, 1970), 146, cat no. 773, illus. *American Art in Upstate New York* (Buffalo, N.Y.: Buffalo Academy of Fine Arts, 1974), 7. Charles C. Eldredge, "Skunk Cabbages, Seasons & Series," in *Georgia O'Keeffe: Natural Issues, 1918-1924* (Williamstown, Mass.: Williams College, 1992), 38, illus. fig. 12. J. Benjamin Townsend, ed., *Charles Burchfield's Journals: The Poetry of Place* (Albany, N.Y.: State University of New York Press, 1993), 345, illus. fig. 74.

25 John Marin

EXHIBITIONS

"John Marin: Watercolors, Oil Paintings, Etchings," Museum of Modern Art, New York, October 1936 (cat. no. 139); "45th Annual Watercolor and Print Exhibition," Pennsylvania Academy of the Fine Arts, Philadelphia, Pa., November 9 – December 14, 1947 (cat. no. 331); "John Marin: Watercolors, Oils, Prints, and Drawings," Munson-Williams-Proctor Institute, December 2 – 30, 1951 (cat. no. 19); "European and American Paintings of the 20th Century from the Institute Collection," MWPI, June 27 – Oct. 3, 1954; "Ten Years of Collecting," MWPI, October 10 – November 15, 1954; "John Marin Memorial Exhibition," Art Galleries, University of California, Los Angeles, March 1, 1955 – March 20, 1956 (traveling exhibition, cat. no. 49, illus.); "John Marin: Paintings, Water-colours, Drawings, and Etchings," Arts Council Gallery, London, England, September 22 – October 20, 1956 (cat. no. 72); "From the Institute Collection," MWPI, December 2 – 30, 1956; "20th-Century Moderns," Albany Institute of History and Art, Albany, N.Y., February 1 – 23, 1957; "From the Institute Collection," MWPI, June 24 – September 12, 1957; "The New Landscape in Art and Science," American Federation of Arts, October 1958 – May 1960 (traveling exhibition, cat. no. 22); "Masters of American Watercolor," American Federation of Arts, January 7, 1962 – January 27, 1963 (traveling exhibition, cat. no. 25); "Masters of Landscape: East and West," MWPI, September 15 – October 13, and Memorial Art Gallery, University of Rochester, Rochester, N.Y., November 1 – December 1, 1963 (cat. no. 72, illus.); "Yesterday and Today," Oswego Art Gallery, Oswego, N.Y., May 30 – June 14, 1964; "Paintings, Drawings, and Sculpture by Charles Demuth, Arthur Dove, and John Marin," Pennsylvania Academy of the Fine Arts, February 2 – March 12, 1967 (cat. no. 27); "American 20th-Century Watercolors from Munson-Williams-Proctor Institute, Utica," Albany Institute of History and Art, September 10 – October 4, 1967; "American Drawings and Watercolors from the Munson-Williams-Proctor Institute," E. B. Crocker Art Gallery, Sacramento, Calif., October 25 – November 25, 1974 (cat. no. 43, illus.); "Nature Framed," MWPI, March 15 – May 20, 1985; "Selections and Transformations: The Art of John Marin," National Gallery of Art, Washington, D.C., January 28 – April 15, 1990

PUBLICATIONS

"Exhibitions," *Munson-Williams-Proctor Institute Bulletin* (December 1956), unpaginated, illus. *Paintings, Drawings & Sculptures in the Museum of Art* (Utica, N.Y.: MWPI, 1961), 27. Sheldon Reich, *John Marin: A Stylistic Analysis and Catalogue Raisonné* (Tucson: University of Arizona Press, 1970), 638, cat. no. 31.42, illus. *American Art in Upstate New York* (Buffalo, N.Y.: Buffalo Academy of Fine Arts, 1974), 33. Ruth E. Fine, *John Marin* (Washington, D.C.: National Gallery of Art, Abbeville Press, 1990), 236, illus. fig. 228.

27 Edward Hopper

EXHIBITIONS

"Edward Hopper, Oils, Watercolors, Prints," Edward W. Root Art Center, Hamilton College, Clinton, N.Y., May 10 – June 7, 1964; Art Exhibition, New York State Exposition, Syracuse, August 31 – September 6, 1965; "On Paper," American Federation of Arts, September 1966 – September 1967 (traveling exhibition); "20th-Century American Painting," Executive Mansion, Albany, N.Y., September – November 1974; Rome Community Art Center, Rome, N.Y., September 14 – November 9, 1975; "Watercolors: Historic and Contemporary," Hathorn Gallery, Skidmore College, Saratoga Springs, N.Y., February 4 – 20, 1977 (cat. no. 29); "Twenty-five Years of Acquisitions," Munson-Williams-Proctor Institute, November 9, 1985 – March 9, 1986

PUBLICATIONS

American Art in Upstate New York (Buffalo, N.Y.: Buffalo Academy of Fine Arts, 1974), 27. Gail Levin, *Edward Hopper: A Catalogue Raisonné* (New York: Whitney Museum of American Art, in association with W.W. Norton & Co., 1995), 2:261, cat. no. W-292.

28 Howard N. Cook

PUBLICATIONS

Paintings, Drawings & Sculptures in the Museum of Art (Utica, N.Y.: Munson-Williams-Proctor Institute, 1961), 12.

29 Federico Castellón

EXHIBITIONS

"Order and Enigma: American Art between the Two Wars," Munson-Williams-Proctor Institute, October 13 – December 2, 1984 (traveling exhibition, catalog, 68-69, 88, illus. fig. 48)

PUBLICATIONS

Paintings, Drawings & Sculptures in the Museum of Art (Utica, N.Y.: MWPI, 1961), 11.

30 Charles Howard

EXHIBITIONS

"The Edward Root Collection," Metropolitan Museum of Art, New York, February 12 – April 12, 1953 (catalog, 2); "Edward Wales Root Bequest," Munson-Williams-Proctor Institute, November 5, 1961 – February; 24, 1962 (catalog); "American Drawings and Watercolors from the Munson-Williams-Proctor Institute," E. B. Crocker Art Gallery, Sacramento, Calif., October 25 – November 25, 1974 (cat. no. 33)

PUBLICATIONS

Charles Howard: Retrospective Exhibition, 1925-1946 (San Francisco, Calif.: California Palace of the Legion of Honor, 1946), 119. *Paintings, Drawings & Sculptures in the Museum of Art* (Utica, N.Y.: Munson-Williams-Proctor Institute, 1961), 20.

31 Adolf Dehn

EXHIBITIONS

"Watercolors by Adolf Dehn," Weyhe Gallery, New York, April 29 – May 18, 1940

PUBLICATIONS

Paintings, Drawings & Sculptures in the Museum of Art (Utica, N.Y.: Munson-Williams-Proctor Institute, 1961), 15.

32 Jacob Getlar Smith

EXHIBITIONS

"Twenty-first International Watercolor Exhibition," Art Institute of Chicago, Chicago, Ill., May 14 – August 23, 1942 (cat. no. 492)

PUBLICATIONS

Jacob Getlar Smith, *Watercolor Painting for the Beginner* (New York: Watson-Guptill Publications, Inc., 1951), 80, illus.

33 Alexander Calder

EXHIBITIONS

"American Art in Upstate New York," Albright-Knox Gallery, Buffalo, N.Y., July 12 – August 12, 1974 (traveling exhibition, catalog, 8); "Watercolors: Historic and Contemporary," Hathorn Gallery, Skidmore College, Saratoga Springs, N.Y., February 4 – 20, 1977 (cat. no. 7)

34 Lionel Feininger

EXHIBITIONS

"Lyonel Feininger: Recent Paintings, Watercolors," Buchholz Gallery, New York, January 29 – February 23, 1946 (cat. no. 33); "Lyonel Feininger Exhibition Arranged in Celebration of the Artist's Birthday," Curt Valentin Gallery, New York, March 18 – April 12, 1952 (cat. no. 44); "In Memoriam," American Federation of Arts, November 1957 – November 1958 (traveling exhibition, cat. no. 9); "Contemporary American Watercolors and Drawings," Smithsonian Institution, Washington, D.C., May 1959 – May 1960 (traveling exhibition); "Edward Wales Root Bequest," Munson-Williams-Proctor Institute, November 5, 1961 – February 24, 1962 (catalog); "American 20th-Century Watercolors from Munson-Williams-Proctor Institute, Utica," Albany Institute of History and Art, Albany, N.Y., September 10 – October 4, 1967; "Paintings and Drawings from the Edward W. Root Bequest," Edward W. Root Art Center, Hamilton College, Clinton, N.Y., April 7 – May 5, 1968; "American Paintings," Schenectady Museum, Schenectady, N.Y., March 20 – April 30, 1970; "American Drawings and Watercolors from the Munson-Williams-Proctor Institute," E. B. Crocker Art Gallery, Sacramento, Calif., October 25 – November 25, 1974 (cat. no. 24); "Watercolors: Historic and Contemporary," Hathorn Gallery, Skidmore College, Saratoga Springs, N.Y., February 4 – 20, 1977 (cat. no. 22)

PUBLICATIONS

Paintings, Drawings & Sculptures in the Museum of Art (Utica, N.Y.: Munson-Williams-Proctor Institute, 1961), 17. *American Art in Upstate New York* (Buffalo, N.Y.: Buffalo Academy of Fine Arts, 1974), 19 (incorrectly noted "undated").

35 Attilio Salemme

EXHIBITIONS

"Attilio Salemme," 67 Gallery, New York, December 31, 1944 – January 15, 1945 (cat. no. 34); "Contemporary American Watercolors and Drawings," Smithsonian Institution, Washington, D.C., May 1959 – May 1960 (traveling exhibition); "Paintings, Drawings & Sculptures in the Museum of Art," Munson-Williams-Proctor Institute, October 15 – December 31, 1960 (catalog, 32); "New Trends in 20th-Century American Painting," Union College, Schenectady, N.Y., March 5 – 26, 1961; "American Watercolors and Drawings from the Root Bequest," Edward W. Root Art Center, Hamilton College, Clinton, N.Y., April 9 – May 7, 1961; "Edward Wales Root Bequest," MWPI, November 5, 1961 – February 24, 1962; "The Figure in 20th-Century Paintings and Drawings," Root Art Center, April 15 – May 6, 1962; "Abstract Drawings from the Root Bequest," Root Art Center, September 11 – October 9, 1966; "Paintings and Drawings from the Edward W. Root Bequest," Root Art Center, April 7 – May 5, 1968; "The Root Bequest," Root Art Center, May 11 – June 8, 1969; "Edward W. Root: Collector and Teacher," Fred L. Emerson Gallery, Hamilton College, October 1 – November 14, 1982 (catalog, 46)

36 Mark Tobey

EXHIBITIONS

"Mark Tobey Paintings, 1944-45," Willard Gallery, New York, November 13 – December 8, 1945 (cat. no. 15); "Mark Tobey Retrospective

Exhibition," Whitney Museum of American Art, New York, October 4 – November 4, 1951 (cat. no. 39); "Mark Tobey," Museum of Decorative Arts, Louvre, Paris, France, October 18 – December 1, 1961 (traveling exhibition, catalog. illus.); "American 20th-Century Watercolors from Munson-Williams-Proctor Institute, Utica," Albany Institute of History and Art, Albany, N.Y., September 10 – October 4, 1967; "American Drawings and Watercolors from the Munson-Williams-Proctor Institute," E. B. Crocker Art Gallery, Sacramento, Calif., October 25 – November 25, 1974 (cat. no. 62, illus.); "Figuratively Speaking," MWPI, April 11 – November 10, 1985; "Mark Tobey," MWPI, August 1991 – January 1992

PUBLICATIONS

"Tobey: A City's Magic in White Writing," Art News 44 (December 1 – 14, 1945): 24, illus. 35. Paintings, Drawings & Sculptures in the Museum of Art (Utica, N.Y.: Munson-Williams-Proctor Institute, 1961), 37. Edward Wales Root Bequest (Utica, N.Y.: MWPI, 1961), unpaginated [published in catalog, but not in the exhibition]. American Art in Upstate New York (Buffalo, N.Y.: Buffalo Academy of Fine Arts, 1974), 53.

37 Edward Christiana
EXHIBITIONS
"Paintings by Edward Christiana," Community Arts Program, Munson-Williams-Proctor Institute, May 5 – 26, 1946; "Upstate New York Artists from the Institute's Collection," MWPI, July 1 – September 23, 1951; "Genre Paintings from the Institute's Collection," MWPI School of Art Gallery, November 5 – 30, 1951; "Watercolor Paintings from the Institute's Collection," MWPI School of Art Gallery, December 3 – 31, 1951; "Artists of Central New York," MWPI, June 22 – August 31, 1952; "Lending Library of Pictures from the Collection of the MWPI," Colgate University, Hamilton, N.Y., September 30 – October 14, 1952; "Seventh Annual Festival of Contemporary Arts," Cornell University, Ithaca, N.Y., April 16 – 26, 1953; "Paintings by Artists of Central New York," MWPI, June 28 – September 13, 1953; "Ten Years of Collecting," MWPI, October 10 – November 15, 1954; "Artists of Central New York," MWPI, June – August 1973; "Selections from the Artists of Central New York Collection," MWPI, November 13, 1985 – February 16, 1986; "Edward Christiana: Retrospective Exhibition," MWPI School of Art Gallery, June 18 – July 9, 1989 (cat. no. 5, illus.); "Utica in the Fifties," Oneida County Historical Society, Utica, N.Y., April 17 – December 31, 1996

PUBLICATIONS
Munson-Williams-Proctor Institute Bulletin (May 1946) unpaginated, illus.

38 William Baziotes
EXHIBITIONS
"William Baziotes: Paintings, Watercolors," Samuel M. Kootz Gallery, New York, February 12 – March 12, 1946 (cat. no. 22); "Current Trends in British and American Painting," Munson-Williams-Proctor Institute, December 3 – 31, 1950; "Contemporary American Watercolors and Drawings," Smithsonian Institution, Washington, D.C., May 1959 – May 1960 (traveling exhibition); "Edward W. Root Bequest," MWPI, November 5, 1961 – February 24, 1962 (catalog); "On Paper," American Federation of Arts, September 1966 – September 1967 (traveling exhibition); "American Art in Upstate New York," Albright-Knox Gallery, Buffalo, N.Y., July 12 – August 25, 1974 (traveling exhibition, catalog, 3); Rome Community Art Center, Rome, N.Y., September 14 – November 9, 1975; "Watercolors: Historic and Contemporary," Hathorn Gallery, Skidmore College, Saratoga Springs, N.Y., February 4 – 20, 1977 (cat. no. 1)

39 Charles Burchfield
EXHIBITIONS
"1947 Annual Exhibition of Contemporary American Sculpture, Watercolors and Drawings," Whitney Museum of American Art, New York, March 11 – April 17, 1947 (cat. no. 85); "45th Annual Watercolor and Print Exhibition," Pennsylvania Academy of the Fine Arts, Philadelphia, Pa., November 9 – December 14, 1947 (cat. no. 358, illus., awarded the Dawson Memorial Medal, for distinction in painting or drawing of flowers or of gardens); "20th-Century American Artists," Munson-Williams-Proctor Institute Community Arts Program, July 3 – September 6, 1949; "Contemporary Art: Great Britain, United States, France 1899-1950," Art Gallery of Toronto, Toronto, Ontario, November 4 – December 25, 1949; "Selections from the Permanent Collection," MWPI, April 4 – 26, 1950; "New Accessions," Colorado Springs Fine Arts Center, Colorado Springs, Colo., July 2 – August 4, 1950; "The First Biennial," Museum of Modern Art, São Paulo, Brazil, October – December, 1951; "20th-Century American Painting from Institute Collection," MWPI, July 3 – August 31, 1952; "Charles Burchfield," Whitney Museum of American Art, January 10 – February 26, 1956 (traveling exhibition, shown at WMAA only, cat. no. 68, illus. fig. 37); "From the Institute Collection," MWPI, December 2 – 30, 1956; "20th-Century Moderns," Albany Institute of History and Art, Albany, N.Y., February 1 – 23, 1957; "Painting in America, The Story of 450 Years," Detroit Institute of Arts, Detroit, Mich., April 23 – June 9, 1957 (traveling exhibition, cat. no. 167); "American Painting of the Last Twenty-five Years," United States Information Agency, June 1, 1959 – August 1, 1960 (traveling exhibition in Europe); "Art across America," MWPI, October 15 – December 31, 1960 (cat. no. 28, illus.); "Ninth Annual Exhibition: Paintings, Water Colors, and Drawings by Charles Burchfield," Ogunquit Museum of Art, Ogunquit, Me., July 1 – September 9, 1961 (cat. no. 15, illus. cover); "Between the Fairs: Twenty-five Years of American Art, 1939-1964," Whitney Museum of American Art, June 24 – September 23, 1964 (cat. no. 14); "Masterpieces of Art," World's Fair, 1964, Seattle, Wash. (catalog, 48); "The White House Festival of the Arts," National Gallery of Art, Washington D.C., June 15 – July 11, 1965; "The Nature of Charles Burchfield: A Memorial Exhibition," MWPI, April 9 – May 31, 1970 (cat. no. 218); "Charles Burchfield: Mystical Landscapes, The Later Years, 1944-67," Sloan Galleries of American Paintings, Valparaiso University, Valparaiso, Ind., February 10 – March 2, 1976 (cat. no. 7); "Burchfield Watercolors," MWPI, June 5 – August 29, 1982; "Charles Burchfield: A Retrospective Exhibition," Metropolitan Museum of Art, New York, January 30 – March 25, 1984 (traveling exhibition); "The Art Triangle," MWPI and Charles Burchfield Art Center, State University College, Buffalo, N.Y., March 18 – June 25, 1989 (cat. no. 29); "Extending the Golden Year: Charles Burchfield Centennial," Fred L. Emerson Gallery, Hamilton College, Clinton, N.Y., March 6 – April 25, 1993 (cat. no. 6, illus.); "Charles E. Burchfield: The Scared Woods," Burchfield Art Center (traveling exhibition, Hunter Museum of Art, Chattanooga, Tenn., venue only, April 3 – May 22, 1994; catalog, 117, illus. fig. 48); "The Paintings of Charles Burchfield: North by Midwest," Columbus Museum of Art, Columbus, Ohio (traveling exhibition, National Museum of American Art, Washington, D.C., venue only, September 26, 1997 – January 25, 1998; catalog, 178, illus. fig. 55)

PUBLICATIONS
Munson-Williams-Proctor Institute Bulletin (December 1956), unpaginated, illus. Paintings, Drawings & Sculptures in the Museum of Art (Utica, N.Y.: MWPI, 1961), 10. Paintings by Charles E. Burchfield (Clinton, N.Y.: Edward W. Root Art Center, Hamilton College, 1962), [illus. in cat., but not in show, May 13 – June 10, 1962, because it was on loan to Seattle World's Fair]; Joseph S. Trovato, Charles Burchfield: Catalogue of Paintings in Public and Private Collections (Utica, N.Y.: MWPI, 1970), 218, cat. no. 1009, illus. 219. American Art in Upstate New York (Buffalo, N.Y.: Buffalo Academy of Fine Arts, 1974), 7. Matthew Baigell, Charles Burchfield (New York: Watson-Guptill Publications, 1976), 109, illus. pl. 28. Arlette Klaric, "Charles Burchfield's Migration of Butterflies by Moonlight: A Vision of Fantasy and Revelation," Elvehjem Museum of Art Bulletin (1978-1980): 26-37, illus. 31. John I. H. Baur, Life and Work of Charles Burchfield, 1893-1967: The Inlander (Cranbury, N.J.: Associated University Presses, 1982), 198, 213, illus. fig. 164. Christopher Finch, American Watercolors (New York: Abbeville Press, 1986), 229, illus. pl. 295. Christopher Finch, Twentieth-Century Watercolors (New York: Abbeville Press, 1988), 215-216, illus. pl. 263. J. Patrick Harrington, "The Moon, The Stars, and the Artist: Astronomy in the Works of Charles E. Burchfield," American Art Journal 22 (1990): 33-59, illus. fig. 19. J. Benjamin Townsend, ed., Charles Burchfield's Journals: The Poetry of Place (Albany: State University of New York Press, 1993), illus. pl. XVI. "Extending the Golden Year," American Art Review 5 (Spring 1993), illus. 112. Henry Adams, "A Heartland Artist Who Broke the Old Regionalist Mold," Smithsonian, May 1997, 68, illus. 69.

40 Dong Kingman
EXHIBITIONS
"Dong Kingman: Exhibition of Watercolors," Midtown Galleries, New York, March 11 – 29, 1947 (cat. no. 5); "45th Annual Watercolor and Print Exhibition," Pennsylvania Academy of the Fine Arts, Philadelphia, Pa., November 9 – December 14, 1947 (cat. no. 334); "Dong Kingman: 10 Year Retrospective Exhibition of Watercolors," Midtown Galleries, May 1 – 26, 1951 (cat. no. 2, incorrectly dated 1943); "Dong Kingman," Witte Memorial Museum, San Antonio Art League, San Antonio, Tex., May 12 – June 30, 1968 (cat. no. 11, illus.); "American Drawings and Watercolors from the Munson-Williams-Proctor Institute," E. B. Crocker Art Gallery, Sacramento, Calif., October 25 – November 25, 1974 (cat. no. 34)

PUBLICATIONS
"Kingman Watercolors," Art Digest 21 (March 15, 1947): 11. Munson-Williams-Proctor Institute Bulletin (March 1948), unpaginated, illus. cover. MWPI Bulletin (May 1948), unpaginated, illus. MWPI Bulletin (December 1949), unpaginated. Alan D. Gruskin, The Watercolors of Dong Kingman (New York and London: The Studio Publications, Inc., 1958), 72, illus. Paintings, Drawings & Sculptures in the Museum of Art (Utica, N.Y.: Munson-Williams-Proctor Institute, 1961), 22.

42 William Palmer
EXHIBITIONS
"Twenty-five Years of Acquisitions," Munson-Williams-Proctor Institute, November 9, 1985 – March 9, 1986

43 Sonja Sekula
EXHIBITIONS
"Sekula: Drawings – Gouaches," Betty Parsons Gallery, New York, February 21 – March 3, 1949; "Edward Wales Root Bequest," Munson-Williams-Proctor Institute, November 5, 1961 – February 24, 1962 (catalog); "Sonja Sekula (1918-1963): A Retrospective," Swiss Institute, New York, September 12 – October 26, 1996

PUBLICATIONS
Paintings, Drawings & Sculptures in the Museum of Art (Utica, N.Y.: Munson-Williams-Proctor Institute, 1961), 34. Dieter Schwarz, Sonja Sekula, 1918-1963 (Winterthur, Switzerland: Kunstmuseum, 1996), illus, pl. 29.

44 Jimmy Ernst
EXHIBITIONS
"Current Trends in British and American Painting," Munson-Williams-Proctor Institute, December 3 – 31, 1950 (traveling exhibition); "Selections from the Edward Root Collection," Smithsonian Institution, Washington, D.C., 1959 – 1960 (traveling exhibition, cat. no. 19); "Edward Wales Root Bequest," MWPI, November 5, 1961 – February 24, 1962 (catalog); "Abstract Paintings and Drawings from the Root Bequest," Edward W. Root Art Center, Hamilton College, Clinton, N.Y., September 11 – October 9, 1966; "American 20th-

Century Watercolors from Munson-Williams-Proctor Institute, Utica," Albany Institute of History and Art, Albany, N.Y., September 10 – October 4, 1967; "Watercolors: Historic and Contemporary," Hathorn Gallery, Skidmore College, Saratoga Springs, N.Y., February 4 – 20, 1977 (cat. no. 20)

PUBLICATIONS
Paintings, Drawings & Sculptures in the Museum of Art (Utica, N.Y.: Munson-Williams-Proctor Institute, 1961), 17.

45 Richard Pousette-Dart
EXHIBITIONS
"New Trends in 20th-Century American Painting," Union College, Schenectady, N.Y., March 5 – 26, 1961; "Edward Wales Root Bequest," Munson-Williams-Proctor Institute, November 5, 1961 – February 24,1962 (catalog); "Abstract Paintings and Drawings from the Edward W. Root Bequest," Edward W. Root Art Center, Hamilton College, Clinton, N.Y., September 11 – October 9, 1966; Kirkland Art Center, Clinton, N.Y., Oct. 16 – Nov. 16, 1974; "American Drawings and Watercolors from the Munson-Williams-Proctor Institute," E. B. Crocker Art Gallery, Sacramento, Calif., October 25 – November 25, 1974 (cat. no. 51); " Watercolors: Historic and Contemporary," Hathorn Gallery, Skidmore College, Saratoga Springs, N.Y., February 4 – 20, 1977 (cat.no. 42)

PUBLICATIONS
Paintings, Drawings & Sculptures in the Museum of Art (Utica, N.Y.: Munson-Williams-Proctor Institute, 1961), 30.

47 Will Barnet
EXHIBITIONS
"American Drawings and Watercolors from the Munson-Williams-Proctor Institute," E. B. Crocker Art Gallery, Sacramento, Calif., October 25 – November 25, 1974 (cat. no. 2)

PUBLICATIONS
Munson-Williams-Proctor Institute Bulletin (February 1954), unpaginated, illus. Paintings, Drawings & Sculptures in the Museum of Art (Utica, N.Y.: MWPI, 1961), 6.

48 Morris Graves
EXHIBITIONS
"Selections from the Edward Root Collection," Smithsonian Institution, Washington, D.C. 1959-60 (traveling exhibition, cat. no. 22); Union Carbide Corporation, New York, March 27 – October 31, 1961; "American 20th-Century Watercolors from the Munson-Williams-Proctor Institute, Utica," Albany Institute of History and Art, Albany, N.Y., September 10 – October 4, 1967; "Carnival of Animals," MWPI, December 10 – 31, 1972; "American Drawings and Watercolors from the Munson-Williams-Proctor Institute," E. B. Crocker Art Gallery, Sacramento, Calif., October 25 – November 24, 1974 (cat. no. 27); "Watercolors: Historic and Contemporary," Hathorn Gallery, Skidmore College, Saratoga Springs, N.Y., February 4 – 20, 1977 (cat. no. 27); "The Animal Kingdom in American Art," Everson Museum of Art, Syracuse, N.Y., February 5 – April 2, 1978 (traveling exhibition, cat. no. 99, illus.)

PUBLICATIONS
Paintings, Drawings & Sculptures in the Museum of Art (Utica, N.Y.: Munson-Williams-Proctor Institute, 1961), 19. American Art in Upstate New York (Buffalo, N.Y.: Buffalo Academy of Fine Arts, 1974), 24.

49 Dorothy Dehner
EXHIBITIONS
"Dorothy Dehner," Willard Gallery, New York, May 7 – 31, 1957 (cat. no. 15)
PUBLICATIONS
Paintings, Drawings & Sculptures in the Museum of Art (Utica, N.Y.: Munson-Williams-Proctor Institute, 1961), 15.

50 Bob Thompson
EXHIBITIONS
"Collectors' Show and Sale," Arkansas Arts Center, Little Rock, Ark., December 10, 1993 – January 3, 1994 (cat. no. 233)

INDEX OF ARTISTS